THE UFFIZI

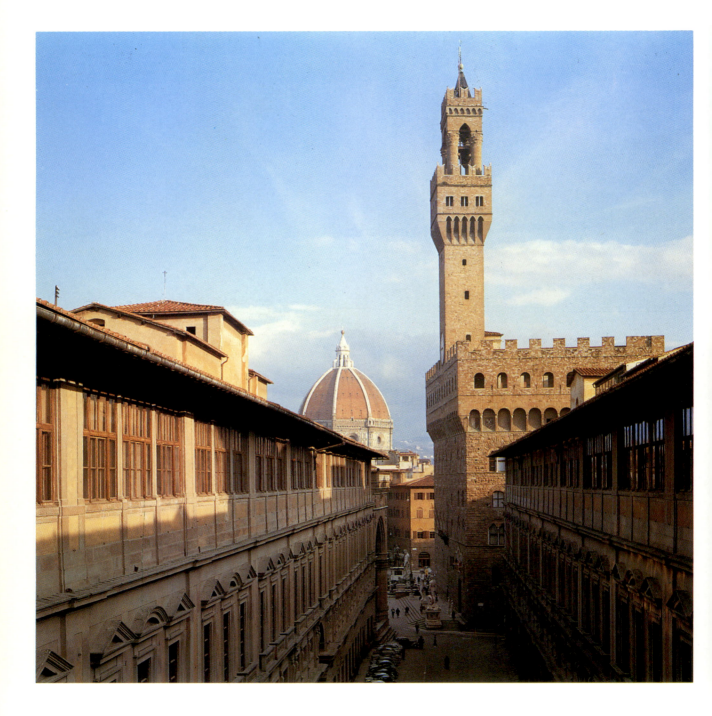

The Uffizi

Luciano Berti, Anna Maria Petrioli Tofani, Caterina Caneva

SCALA BOOKS

© Scala Publications 1992
Text © Luciano Berti, Anna Maria Petrioli Tofani, Caterina Caneva

First published 1993
by Scala Publications Ltd
3 Greek Street
London W1V 6NX
Distributed in the USA and Canada by
Rizzoli International Publications, Inc.
300 Park Avenue South
New York
NY 10010

ISBN 1 870248 81 3

Designed by Alan Bartram
Translated from Italian by Jennifer Condi
Captions prepared by Alison Wright
Photographs by Tosi, Florence
Produced by Scala Publications
Filmset by August Filmsetting, St Helens, England
Printed and bound in Italy by Sfera/Garzanti, Milan

Note on the text:
The introductions to the sections on Tuscan art were written by
Luciano Berti, with the exception of the introduction to Piero della
Francesca. This and the introductions to the remainder of the
collections, beginning with 'Italian painting (outside Tuscany)
in the 14th and 15th centuries', were written by Caterina Caneva.
The captions were contributed by Alison Wright.

FRONTISPIECE:
The courtyard of the Uffizi
with the Palazzo Vecchio.

Contents

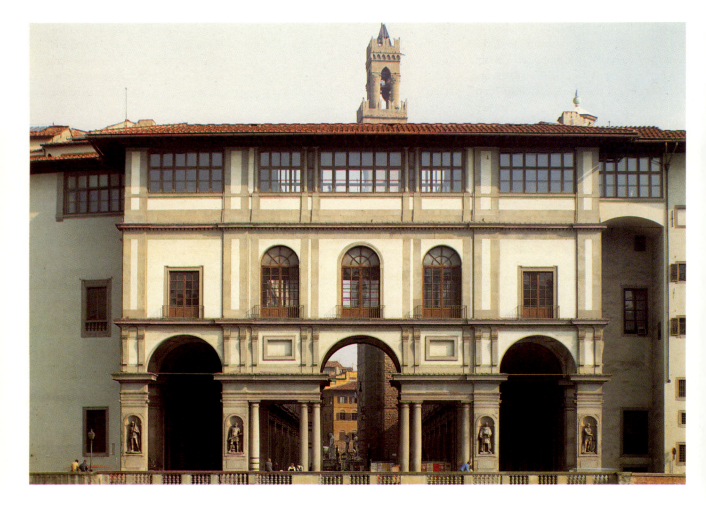

The loggia and façade of The Uffizi
facing the Arno.

Introduction

Today the Uffizi is famous above all as a magnificent picture gallery, comprising works from the thirteenth century by the 'founding father' of Florentine art, Cimabue, and on through the centuries up to Tiepolo, Canaletto and Guardi, Liotard and Chardin, or the two Goya portraits of 1783 and 1800. The more recent history of art is represented by the self-portraits in the Corridoio Vasariano by Canova and David, Ingres, Corot and Delacroix, the Tuscan Macchiaioli, Boldini, Puvis de Chavanne, Böcklin, Ensor, Denis, and Carrà and Severini. It is a museum with an international range, therefore, but is incomparably rich in works of the Florentine Renaissance in particular: suffice it to mention its twenty-seven Botticellis, including the *Primavera* and the *Birth of Venus*.

On his death in 1574, Giorgio Vasari could never have imagined that a few years later (in 1581) the top floor of the magnificent building he had designed to house the *magistrati*, or public offices in the 1560s would see the establishment of a *galleria*. Were he to rise from the grave today and pay a visit to the gallery, he would find represented there almost all of the major painters, Italian as well as Florentine, whose lives he chronicled in his *Lives of the Artists* of 1550 and in the later edition of 1568.

The links between this pioneering work of art history and the formation of the gallery's extraordinary collection of sculpture and paintings — many of them masterpieces — are profound. What has happened in fact is that museology has adopted the historical and critical system brilliantly devised by Vasari. Naturally, it has been developed over the several centuries that have elapsed since his time, affected by all sorts of changes in habits of collecting, in connoisseurship, and in museum organization.

In the 1568 edition of his *Lives*, Vasari had inserted wood-cuts of artists' portraits (or presumed portraits). The idea was taken up again by Leopoldo de' Medici who initiated a collection of artists' self-portraits, this time including non-Italians. Cosimo III inherited the collection in 1675, continuing to add to it until the works totalled 180, and dedicating a large new room in the Uffizi especially to their display. Over the years, the collection continued to grow, albeit at a more irregular pace; it already consisted of more than one thousand paintings when, on the occasion of the gallery's hundredth anniversary in 1981, a further 230 self-portraits, representing the twentieth century, were donated from around the world. Chagall had made an exemplary gesture when he came in person to Florence in 1976 to deliver his self-portrait.

Another collection begun by the Medici of the sixteenth century is the Iconographic Collection of historical figures, and again this includes non-Italians. These works had, from the outset, been allotted a place high up on the walls of the Uffizi's three corridors, and in a reorganization of 1971 they were restored to their original site. Altogether, the collection comprises over a thousand works: some of those remaining in the Uffizi may be found at the end of the Corridoio Vasariano while the others, of which no thorough study has been made, have over the years ended up in various places outside the gallery.

The overall picture would be incomplete without mention of the collection of miniatures, also begun by Leopoldo de' Medici. Today these number 1,392, forming a body of works which of its kind is second only to that of the Victoria and Albert Museum in London. There is, furthermore, the magnificent archaeological collection displayed on the stairways and halls and ranged majestically along the corridors to form a counterpart to the Uffizi's collection of paintings. Other antique works are to be found in the Sala Archeologica, in the Tribuna and in the specially designed and sumptuously decorated Sala della Niobe. Such an arrangement would also have appeared to Vasari to constitute an excellent complement to the picture gallery. We need only recall the intense dialectic of revival, emulation and comparison with the antique among artists who, especially in Italy, had manifested a decidedly classicizing tendency from the beginnings of the Renaissance.

The picture gallery was not at the outset the most important part of the Uffizi, being confined to Giovio's 'iconography' of historic figures in the corridors, and to the collection of prize works of art in the Tribuna. The first inventory of the latter, begun in 1589, lists one painting presumed to be by Leonardo, seven by Raphael, four by Giulio Romano, two by Fra Bartolomeo, nine by Andrea del Sarto, two by Pontormo and one by Beccafumi; Northern painters were represented by one Herri Met de Bles and one Sustris.

Commercial and banking activities conducted by the Florentines in northern Europe from the fourteenth century had resulted in an awakening of interest in the work of Northern painters, with a consequent absorption of certain Northern stylistic influences. The magnificent van der Goes in the Uffizi and several works by Memling were purchased in 1900 from the Spedale di Santa Maria Nuova in Florence, which had acquired them in the fifteenth century. The continuing popularity of works by foreign masters meant that a component of non-Italian painting entered the gallery. By 1635, the Tribuna could boast Cranach's *St George*, joined shortly afterwards by Dürer's *Two apostles*, a gift to the Grand Duke from the Emperor. By 1704, the Tribuna had a particularly rich collection of works by Venetian painters, including Titian, Tintoretto and Veronese; Holbein, Van Dyck and those seventeenth-century Dutch painters for whom Cosimo III had a special admiration were also represented. As early as the

eighteenth century, a room of the gallery was set aside for the Flemings and Germans.

In 1793 it was decided to create a section of French painting, beginning with the seventeenth century, and a number of works were bought in Paris for this purpose. Unfortunately, the selection criteria tended to favour the Classical style, ignoring the brilliant works of the period of Louis XV. Contemporaneously, a shrewd exchange with the gallery in Vienna resulted in the acquisition (in addition to some excellent Venetian works) of Dürer's *Adoration of the Magi* and the *Bacchanal* by Rubens. Other works by Rubens, including the two large-scale history paintings, the *Triumphal entry of Henry IV* and *Henry IV at the battle of Ivry*, had entered the Uffizi in 1773. The eighteenth century also saw the addition of further works by Cranach, while the two paintings by Altdorfer only arrived in 1914. The El Greco and the Goya portraits were bought in 1974-76. Latterly, the Contini Bonacossi donation (1969) and the works which were retrieved by the Siviero Commission (1988) include paintings of the Fontainebleau school and others by El Greco, Velázquez, Zurbarán and Goya. Nor is the collection without some examples of English painting, above all in the form of self-portraits.

The richest and most distinctive parts of the gallery's collections are the Italian and specifically Florentine schools of the Golden Age – the 'Paradise' of the Renaissance as Berenson called it – and what we might call the Silver Age that followed it. Italian art of the seventeenth and eighteenth centuries continued to enjoy a considerable prestige, especially in its role of promoting the Baroque style, which spread throughout the whole of Europe until checked by the rise of Neoclassicisim in the later eighteenth century.

Surprising though it might seem, this earlier part of the collection had by far the longest gestation period. In this context, it should be remembered that the gallery was only created at the beginning of the seventeenth century, at a time when sixteenth-century art continued to be greatly admired but when the artistic values of preceding centuries – still appreciated by Vasari – had been rapidly eclipsed and were perceived as 'primitive' in comparison with the firmly identified modern style of the day.

These early years of its development were, however, of extreme importance for the Uffizi, for this was the period in which a succession of Medici rulers and cadet princes demonstrated a truly extraordinary passion for collecting. The spoils of such activities were in the meantime distributed among their palaces and villas, but a good selection of them was destined one day to enter the Uffizi. Ferdinando I (died 1609) had received gifts of paintings by Caravaggio, while Cosimo II (died 1621) acquired works by painters working in the style

of Caravaggio, and from 1620, many works by seventeenth-century Bolognese painters, who were then enjoying considerable success, found their way into the Medici collections. At his Villa della Petraia, Don Lorenzo de' Medici collected mainly contemporary Florentine works, among which Giovanni da San Giovanni's *capricci*, painted on matting, are today in the Uffizi. The two large battle scenes by Borgognone were owned by the 'warrior' prince, Mattias. Cardinal Carlo owned the *Battle of San Romano* by Paolo Uccello, and the spectacular *Harbour scene with the Villa Medici* was commissioned by him from Claude Lorrain; he also owned the van der Weyden now in the Uffizi, which was probably painted in Florence in 1450. When, in 1631, Ferdinando II's wife Vittoria della Rovere inherited her family's priceless art collection from Urbino, she brought it first to Poggio Imperiale; later the collection, including works by Raphael, Titian and Barocci as well as Piero della Francesca's portrait diptych of the Duke and Duchess of Urbino, passed into the Uffizi.

In later years too, the family produced more extraordinary collectors, this time in the shape of Prince (later Cardinal) Leopoldo (died 1675) and the Grand Prince Ferdinand (died 1713), who alone accumulated around a thousand paintings. Mention has already been made of Leopoldo's grandiose scheme for a systematic ordering of the drawings and self-portraits; in addition, about half of the works by Venetian painters today in the Uffizi once belonged to him. Ferdinand's taste inclined rather towards the work of more recent Italian painters such as Crespi, Magnasco and Ricci, but he also bought Andrea del Sarto's '*Madonna of the Harpies*' and Parmigianino's '*Madonna of the Long Neck*'.

The longest and most complex process, however, was in the creation of that part of the collection which is today considered to form its very core, the section which, as we have said, 'mirrors' Vasari's *Lives*. This was not a task for the later Medici, who were less interested in things of the past; they sprung, after all, from a devoutly Catholic dynasty and would never have dreamed of depriving the church – which was the largest repository of the art of earlier epochs – of its assets. It took the appearance of two important new factors to transform the situation: on the one hand a renewed interest in the works of the early painters (which only came about in the late eighteenth century, under the Lorena), and on the other, the works themselves being made available as a result of the suppression of religious bodies, a process that began with the Enlightenment reforms of Pietro Leopoldo of Lorraine (who reigned from 1765) and continued throughout the Napoleonic period and with the establishment of the Kingdom of Italy.

However, the 'Gabinetto di pitture antiche' created by Pietro Leopoldo when he reorganized the Uffizi in 1782 was

The Tribuna was designed by Bernardo Buontalenti in 1584 to display the Medici collection of antique statues and contemporary paintings.

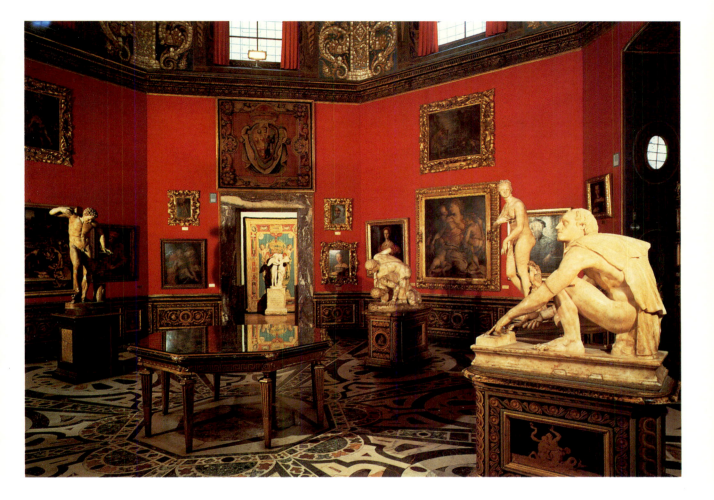

only conceived in order to document what were considered to be the initial, immature phases of a progressive artistic development, and the result was a hotchpotch of works by artists who included Cimabue and fourteenth-century painters as well as the Pollaiolo and Botticelli. More than a century would pass before these works were evaluated on the basis of their intrinsic aesthetic qualities rather than according to an idea of artistic progression, a critical revolution which had its beginnings in the Romantic movement and has continued up to the present day. It has taken just as long – perhaps not until the reorganization of 1919, when the first six rooms of the gallery were dedicated to the years up to and including Botticelli – for these works to be given pride of place in the Uffizi. It is written, 'The last shall be the first' (or *vice versa*). Today, with the exception of the Tribuna, the transition to the sixteenth century and beyond is made only as the visitor reaches the second half of the gallery.

The very best arrangement would be to have a large area dedicated to the history of the Uffizi itself, from 1581 to the present day, in which all the various organizational criteria and attitudes towards connoisseurship that have gone to shape it might be made plainly visible. But the Uffizi has suffered increasingly from lack of space, having outgrown its top-floor site long ago. In the first years of this century 2,400 paintings were exhibited, crowded together in a fashion that would no longer be considered acceptable today. In the years after the War this number was cut drastically, to as few as 500; by 1973, however, it had again risen to about 1,700, with another 1,400 being stored in the museum deposits where they continue to be accessible to visitors. The transfer of the state archives in 1989, however, has meant that the whole of Vasari's building has been made available for the art collection. It is with such a fitting prospect that the Uffizi approaches the year 2000: plans are underway and work has already begun.

The early painters and 14th-century Florentine art

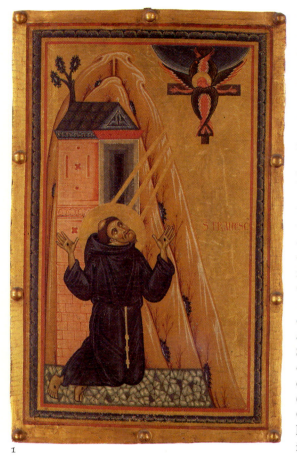

1
Master of San Francesco Bardi
Active between 1240 and 1270
St Francis receiving the stigmata
Tempera on panel, 81 × 51 cm
Inv.no.8574
The panel shows St Francis receiving
the mark of Christ's wounds, though
in this quite early example emphasis
has been placed on the spiritual power
emanating from the Crucifix rather
than, as later, on the stigmata them-
selves. The panel probably formed
one wing of a portable diptych used
for private devotions.

Florentine and Tuscan artists of the thirteenth century before Cimabue
were referred to by Vasari as 'Greek' painters, working that is in the
medieval Byzantine tradition. Yet their works show the first stirrings
of something new: the smaller scenes in a *Christus triumphans* by an
early thirteenth-century painter of the Pisan school have a calm
elegance coupled, however, with narrative liveliness; of an altogether
different nature is the racked and tormented *Christus patiens*, painted
fifty years later by the Master of San Francesco Bardi. The elaborate
mannerism of Meliore's 1271 dossal, with its two perfectly
symmetrical attendant saints, shows links with the mosaics in the
Florentine Baptistery.

The three great *Maestà* by Cimabue, Duccio and Giotto, gathered
together in one room of the Uffizi and thus affording an extraordinary
opportunity for comparison, no longer evoke the contemplative
austerity of Romanesque churches, but rather the grandiose
complexity of the new Gothic cathedrals, in which their monumental
forms would originally have dominated the surroundings. In
Cimabue's *Maestà*, painted for the high altar of Santa Trinita between
1260 and 1280, spatial recession is suggested by the incipient three-
dimensionality of the throne, while the tiered ranks of angels produce
a choral effect. The Virgin has a communicative air as she holds her
Son up to the viewer, His hand raised in benediction. Below is a row
of pensive and visionary Prophets, painted with the dramatic
expression that was Cimabue's hallmark. In the Rucellai *Madonna*
(1285), an early work by the Sienese painter Duccio, the severity of
Cimabue has given way to a more generous gracefulness; the figures
have an aristocratic ease and a sinuous line derived from French Gothic
illuminated manuscripts.

Giotto's *Maestà*, painted in the early fourteenth century, takes us
much further on, into a quite different realm of concreteness and
rationality. His pictorial language is translated back from Greek into
Latin: the image no longer has a ceremonial remoteness, but gives a
sense of a full-bodied, tactile presence, especially evident in the robust
figure of the Christ Child. There is a more advanced coherence in the
perspective of the throne, while the simplified folds of drapery clothe
solid and believable anatomies; a dignified yet intense emotion is
expressed by the figures, which recede into a calibrated pictorial space.

The Florentine painters of the fourteenth century such as Taddeo
Gaddi and Daddi continued painting in the manner of Giotto,
although various new elements and trends appear in the second half of
the century. A singularly keen tension is felt in Orcagna's *St Matthew*
(1367), while in Giottino's *Pietà* (c1360) tragedy gives way to an
elegiac mood, and the luminous colours are suffused with a new
warmth. A hint of worldliness is introduced by the nun and the lady,
admitted under the protection of two saints to participate in the scene.
The Lombard influence is most clearly visible in Giovanni da Milano's
contemporary polyptych where the array of sumptuous costumed
figures in heavy shadow looks forward to International Gothic art.

Pisan school
End of the 12th century
The Crucified Christ with scenes of the
Passion
Tempera on panel, 377 × 231 cm
Inv.no.432
This complex, large-scale Crucifix
combines an image of the Crucified
Christ, the devotional focus, with
narrative scenes of the *Passion* and also
of the Redemption of souls in the
Descent into Limbo, seen to the bottom
right.

2

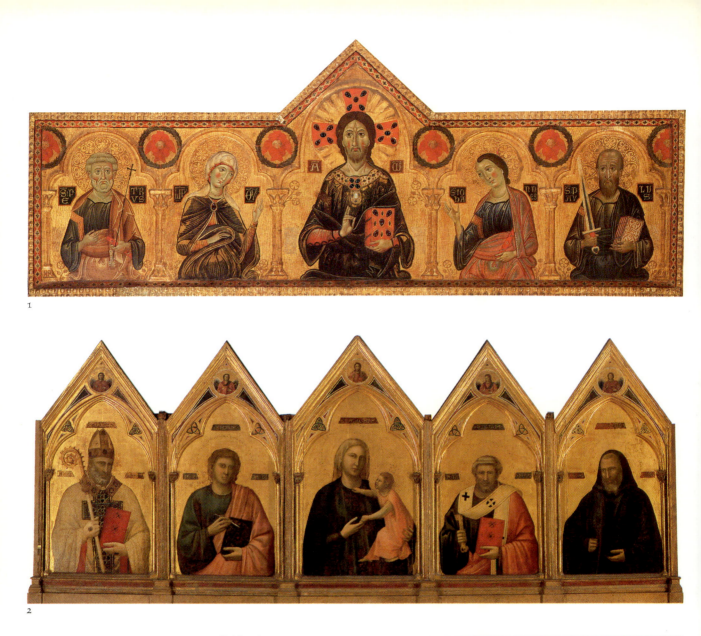

1

2

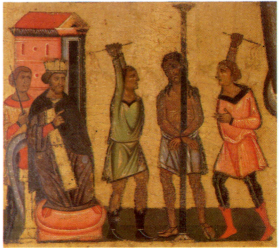

1

Meliore di Jacopo
Active 1260 in Florence
*The Redeemer with the Virgin and Sts
John, Peter and Paul and four others,*
signed and dated 1271
Tempera on panel, 85 × 210 cm
Inv.no.9153
This panel is one of the best surviving
examples of a type of low altar retable
with a raised central section, which
enjoyed brief popularity in late
13th-century Florence.

2

Giotto
Vespignano, Vicchio di Mugello
1267 – 1337 Florence
The Badia polyptych
Tempera on panel, 91 × 334 cm
Inv.no. Depositi S. Croce 7
In contrast to Meliore's retable, the
half-length figures of the Virgin and

Child and saints in Giotto's painting
are painted on separate panels to form
a polyptych. Giotto's painting was
made around 1300 to adorn the high
altar of the Badia in Florence.

3

Master of San Francesco Bardi
Active between 1240 and 1270
*The Crucified Christ with eight scenes
from the Passion*
Tempera on panel, 250 × 200 cm
Inv.no.434
This Crucifix is an early example of
the type illustrated on page 11,
though the panels that would have
formed the terminals to the arms of
the Cross are now missing.

3a
The Crucified Christ (detail): *The
Flagellation*

3A

12

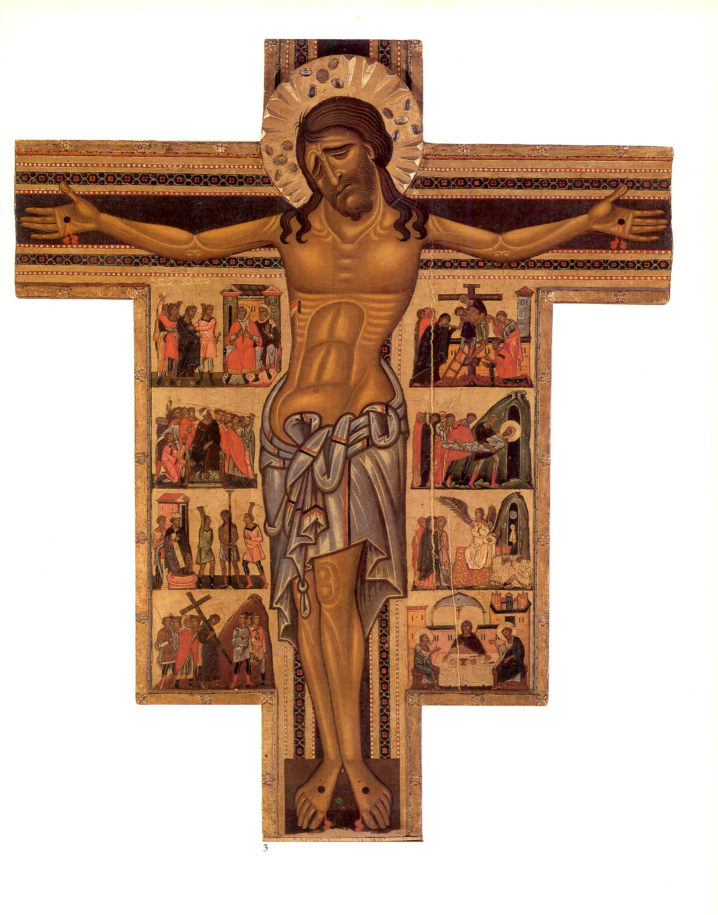

3

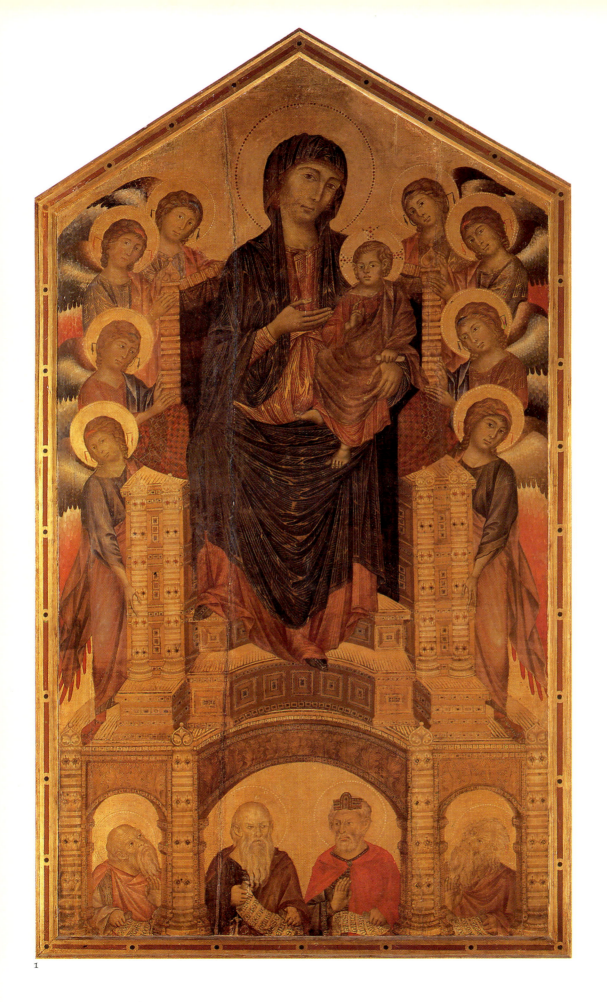

1

Cimabue
Documented in Florence 1272;
died 1302 Florence
The Santa Trinità *Madonna*, *c*1260/80
Tempera on panel, 385 × 223 cm
Inv.no.8343
This magnificent panel once formed
the high altarpiece of the church of
Santa Trinita in Florence. The throne
is flanked by angels who seem to
present the Virgin and Child to the
viewer while there appear beneath it
Prophets who look out as if from a
loggia.

2

Giotto
Vespignano, Vicchio di Mugello
1267 – 1337 Florence
The Ognissanti *Madonna*
Tempera on panel, 325 × 204 cm
Inv.no.8344
Deliberately conforming to the same
formal type as Cimabue's celebrated

panel, Giotto's altarpiece was placed
above the high altar of the church of
the Ognissanti or All Saints in
Florence. Hence the several unidenti-
fied saints who, together with the
angels, help to define a convincing
three-dimensional space around the
Virgin's throne.

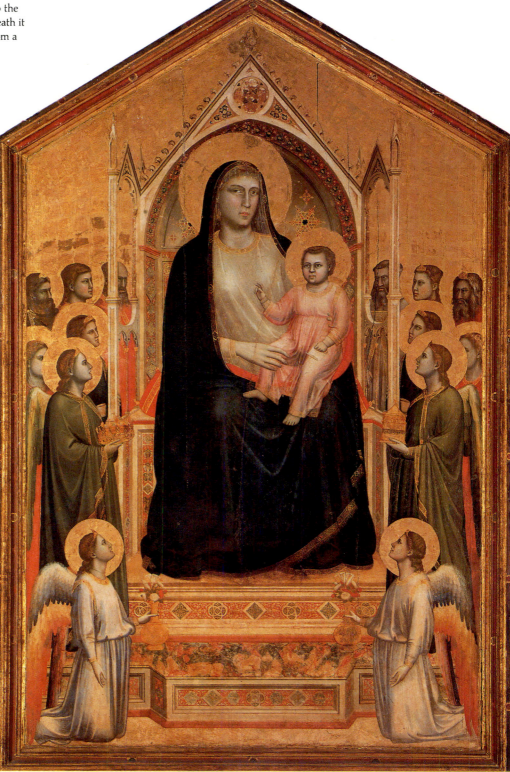

2

15

1

Master of Santa Cecilia
Active in Florence *c*1300–20
The Santa Cecilia altarpiece
Tempera on panel, 85 × 181 cm
Inv.no.449

Made as a low retable that was placed
above an altar, this panel depicts the
titular saint of the church for which it
was painted in Florence. St Cecily is
surrounded by scenes from her life
which take place in a series of
imaginative and complex architectural
spaces.

1A

Detail of the Santa Cecilia altarpiece:
*The wedding feast of Sts Cecily and
Valerius*

1B

Detail of the Santa Cecilia altarpiece:
The martyrdom of St Cecily

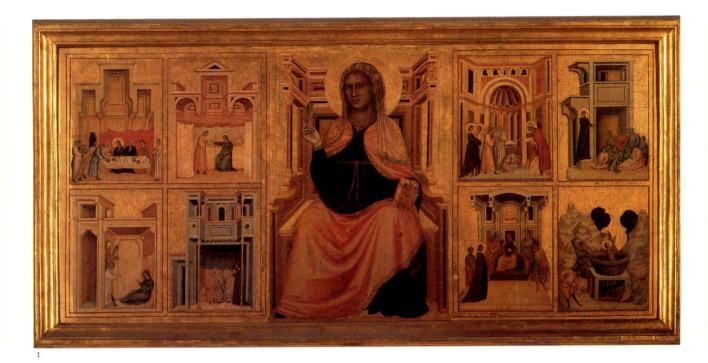

1

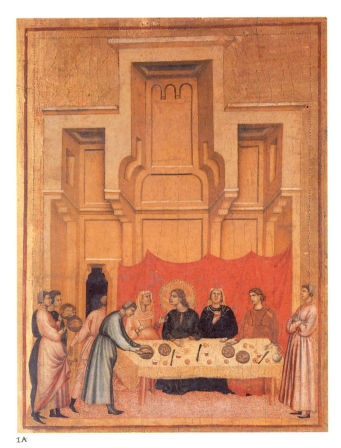

1A

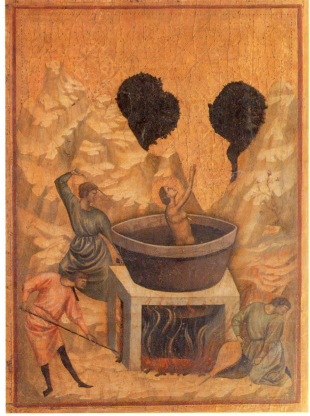

1B

Andrea di Cione, known as Orcagna, and Jacopo di Cione
Florence *c*1320 – 1368 Florence;
Florence *c*1330 – 1398 Florence
St Matthew with scenes from his life
Tempera on panel, 291 × 265 cm
Inv.no.3163

St Matthew, as patron saint of the Florentine bankers' guild (Arte del Cambio), was chosen as the subject of their altarpiece commissioned in 1367. It originally hung in the guild church of Orsanmichele. The painting is an interesting example of collaboration within a family workshop. Orcagna,

also a famous sculptor, died shortly after it was commissioned and the work was completed by his brother Jacopo.

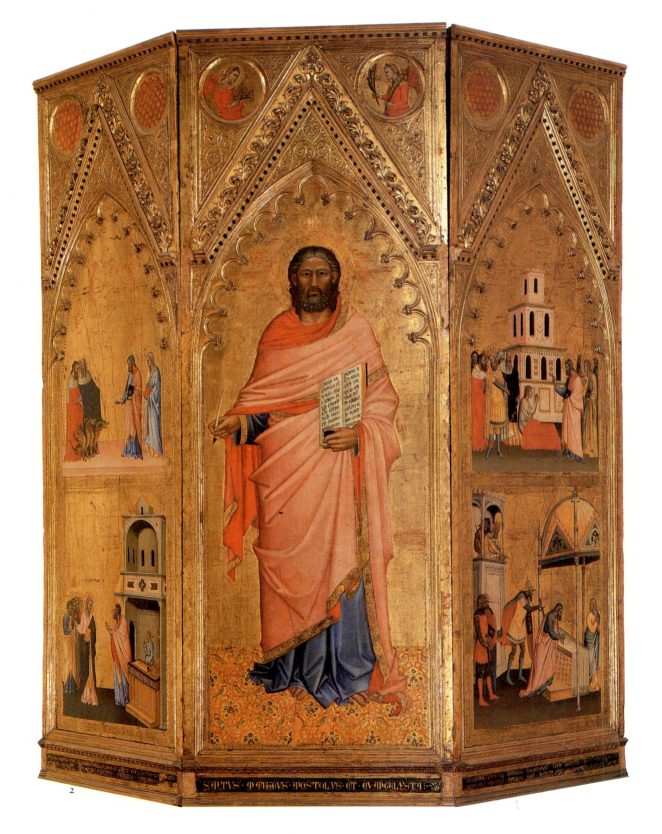

Giovanni da Milano
Como *c*1325 – **after 1369**
The Ognissanti polyptych
Tempera on panel, panels 132 × 39 cm
and 49 × 39 cm
Inv.no.459

Probably painted in the 1360s, these
panels formed part of the polyptych
which replaced Giotto's *Madonna*
(p.15) on the high altar of the church
of the Ognissanti. The paired saints,
the unusual roundels showing *Creation*
scenes and the figures of the heavenly

host were originally grouped around a
larger panel showing the Coronation
of the Virgin.

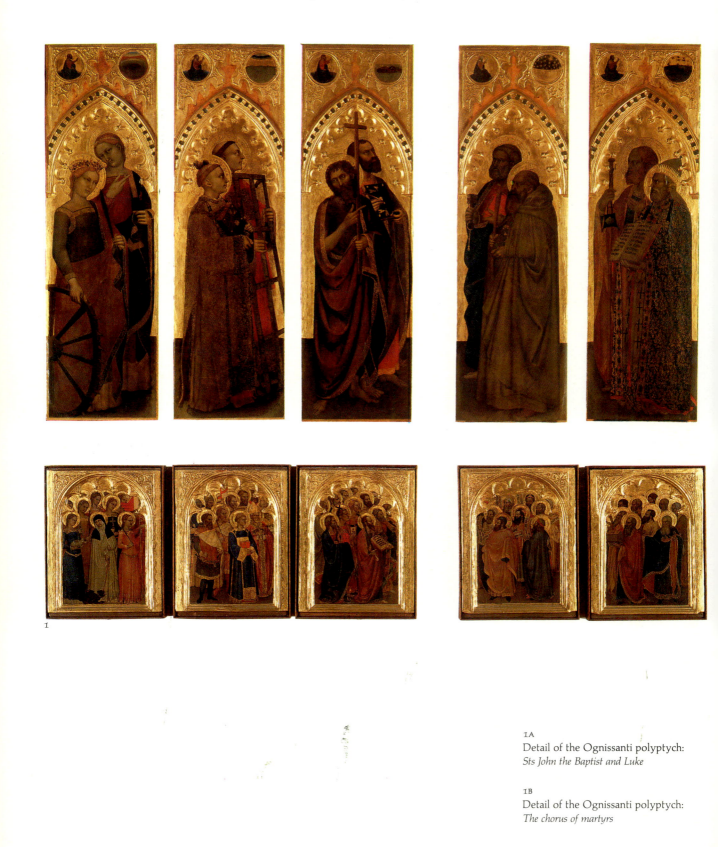

1

1A
Detail of the Ognissanti polyptych:
Sts John the Baptist and Luke

1B
Detail of the Ognissanti polyptych:
The chorus of martyrs

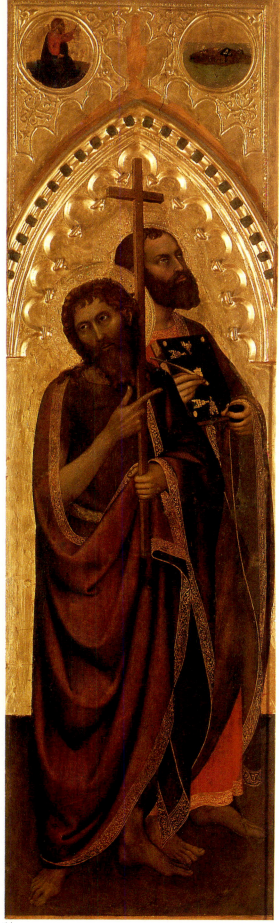

1A

1B

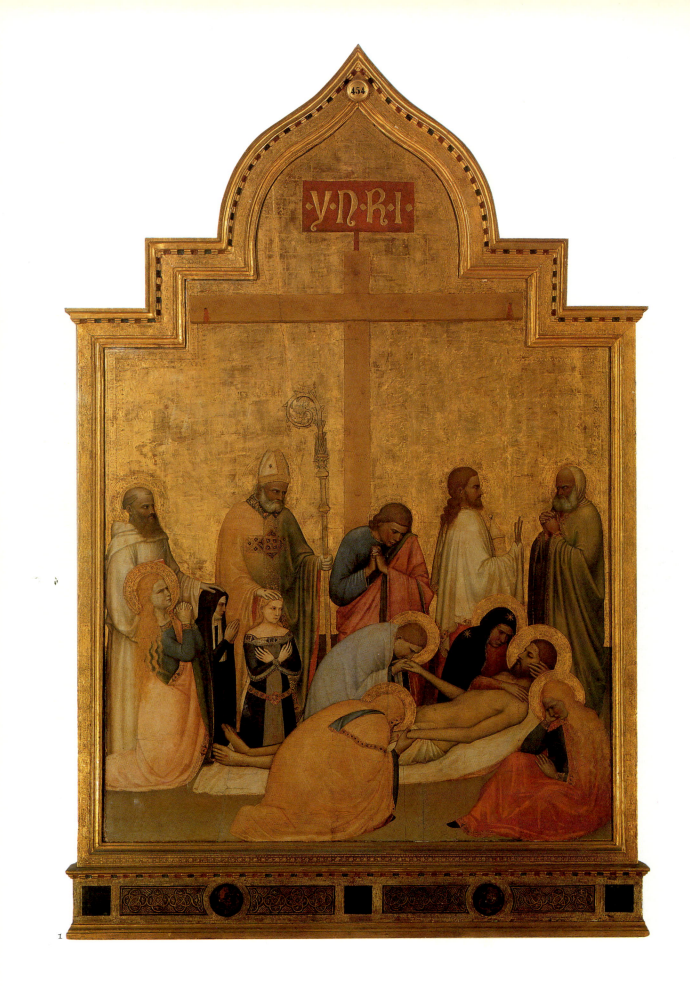

1

Giottino
Florence *c*1320/30 –
after 1369 Florence
Pietà (Lamentation over the dead
Christ)
Tempera on panel, 195 × 134 cm
Inv.no.454
In this painting from the church of San
Remigio in Florence the *Lamentation* is
witnessed by its donors, a Benedictine
nun and a young woman in contem-
porary dress who, kneeling in devo-
tion, are presented by their patron
saints Benedict and Remigius.

2

Giovanni del Biondo
Documented in Florence 1356–99
St John the Baptist and eleven episodes
from his life
Tempera on panel, 275 × 180 cm
Inv.no. Contini Bonacossi 27
Still within its original frame, the
painting shows St John the Baptist,
patron saint of Florence, surrounded
by scenes from his life. The icon-
ography of the central panel, which
shows the Baptist triumphant over a
prostrate Herod, is unusual. The
saint's scroll identifies him with the
prophesied Voice crying in the
Wilderness who would bear witness
to the coming of Christ.

3

Domenico di Michelino
Florence 1417 – 1491 Florence
Three painters of the Gaddi family
Tempera on panel, 47 × 89 cm
Inv.no.3281
This painted tribute to the Gaddi
family of painters forms part of the
15th-century pictorial genre which
celebrated specifically Florentine
uomini famosi or famous men. It is also
a very early example of portraiture.

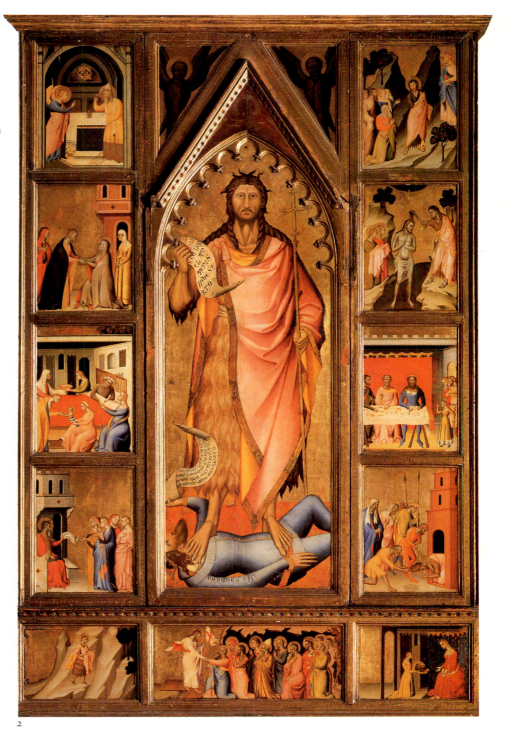

2

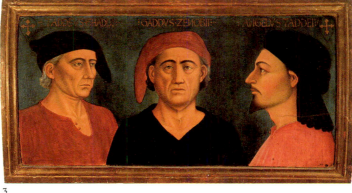

3

1A

1, 1A

Duccio di Boninsegna
Siena 1255 – c1319 Siena
The Rucellai *Madonna* (*Maestà*)
Tempera on panel, 450 × 290 cm
Unnumbered
Duccio's reputation outside his native
Siena seems to have won him the
prestigious commission of 1285 for
the chapel of the Compagnia dei
Laudesi in Santa Maria Novella. His
altarpiece was subsequently trans-
ferred to the Rucellai chapel in the
same church, hence its name. Recently
restored, the *Maestà* is characterized
by tremendous linear and colouristic
subtlety, an outstanding quality of the
Sienese school.

Even Ghiberti, a fifteenth-century artist and a Florentine, fully
acknowledged the superlative achievements of the major Sienese
painters of the Gothic era, some of whom indeed were active in
Florence. The case of Duccio has already been mentioned. The works
of Simone Martini, however, provide a perfect illustration of the
famous comparison between Giotto and Dante on the one hand, and
Simone and Petrarch on the other, a comparison that is reinforced by
the bonds of friendship that existed between them in reality. The
exquisitely cadenced image of Simone's *Annunciation* (painted in 1333
for Siena Cathedral) echoes the best of Petrarch's poetry. A
paradisaical aura surrounds the hyper-sensitive figures of the Virgin
and the angel which, in their melodious intensity of curving lines,
seem to 'melt' into the golden expanse of the panel; the 'still-life' vase
of lilies placed in the very centre of the painting creates a marvellous
lull and suggests the perfume of flowers. The work dates from the
period shortly before Simone's move to Avignon, which was to be a
determining factor in the development of the 'international' Gothic
style.

Of the two Lorenzetti brothers, Pietro has generally the more
psychological and dramatic approach, while the more sensuous yet at
the same time contemplative works of Ambrogio have prompted
some critics to make comparisons with oriental Buddhist art. The
narratives recounted in the side panels of Pietro's *Beata Umiltà*
altarpiece have a powerful charm, and there is a striking clarity in the
architectural settings. His *Madonna with angels* offers an equally forceful
vision of heavenly figures. The works of Ambrogio in the Uffizi are of
a more complex nature. In the St Proculus triptych (1332), the figures
are sumptuously and warmly painted and the overall approach is
intensely psychological, especially in the portrayal of the relationship
between Mother and Child. The four stories of St Nicholas, which are
now no longer believed to belong to this triptych, are quite
extraordinarily advanced both in the treatment of perspective and in
the realistic rendering of naturalistic details (with a rich variety of
episodes), achievements more commonly associated with works of the
early fifteenth century. The seascape, with its stretch of rocky coast,
boats approaching from over the horizon and landing operations
being carried out on the choppy waters of the port, would not look
out of place in a painting by Gentile of 1422. In his *Presentation in the
Temple*, the temple appears as a richly decorated, fabulously
complicated structure, receding far back into space; the foreground
figures, on the other hand, are solid, weighty, each subtly observed
and differentiated according to type, right down to the wrinkled old
female saint. The work is also characterized by its chromatic intensity,
almost a furnace of colouristic warmth. The Uffizi's magnificent
collection of fourteenth-century Sienese works has recently benefited
from a programme of restoration, which has restored their original
clarity.

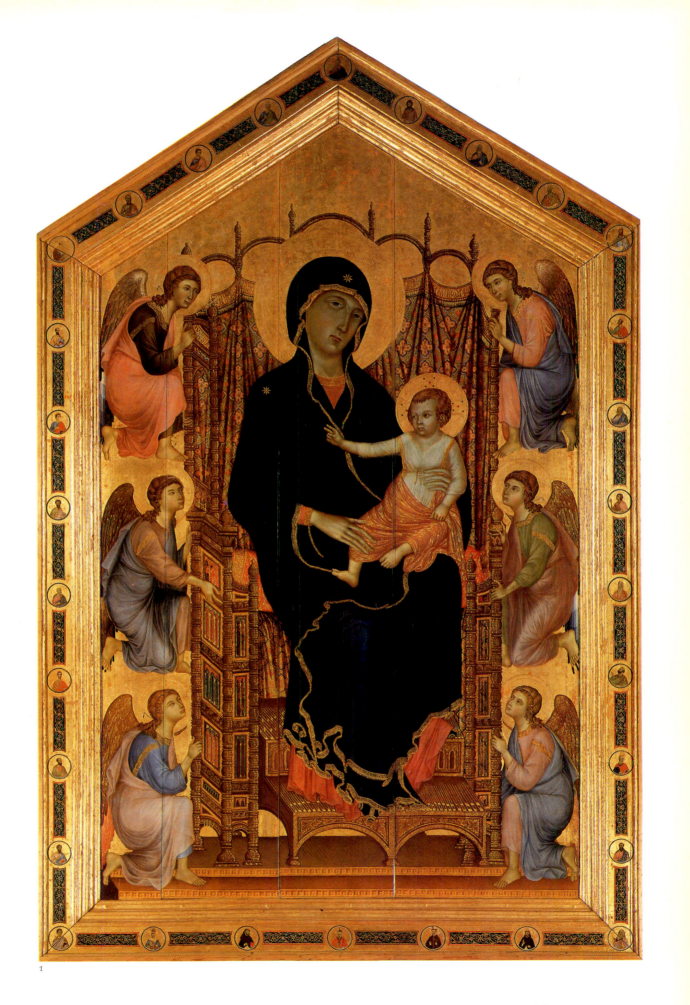

1

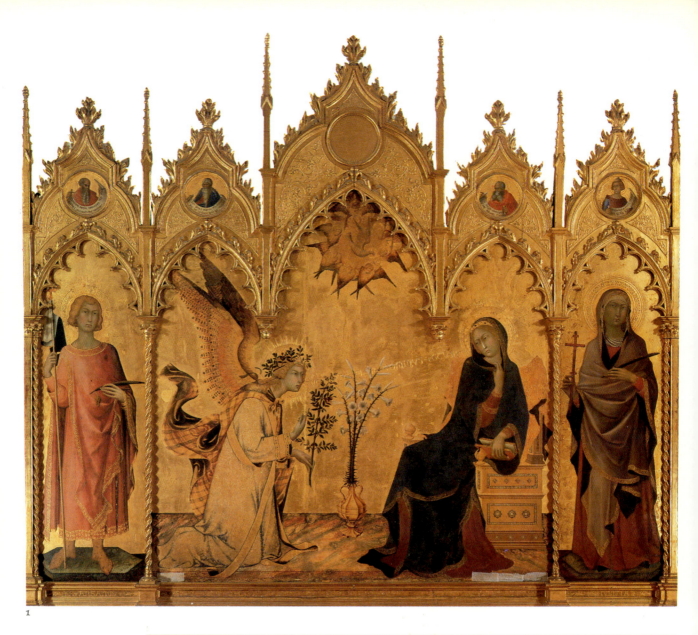

1

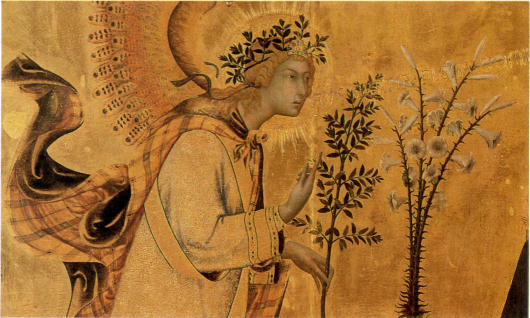

1A

1

Simone Martini and Lippo Memmi
Siena *c*1284 – 1344 Avignon;
? *c*1290 – *c*1347 ?
The Annunciation and two saints, signed
and dated 1333
Tempera on panel, 184 × 210 cm
Inv.nos. 451-53
This celebrated *Annunciation* was made
for one of the principal altars in Siena
cathedral, its patron saint Ansanus
appearing to the left. The Virgin takes
fright at the appearance of the arch-
angel whose wings and drapery
suggest he has just alighted. The two
lateral saints are attributed to Lippo
Memmi.

1A
Detail of the *Annunciation*

2

Ambrogio Lorenzetti
Siena *c*1285 – 1348 ?
The San Procolo triptych
Tempera on panel, central panel
171 × 57 cm, side panels 141 × 43 cm
Inv.nos.8731, 9411, 8732
An inscription, now lost, recorded
that Ambrogio Lorenzetti of Siena
made this triptych in 1332 and we
know that it remained in the church of
San Procolo for which it was commis-
sioned until the 17th century. Sts
Proculus and Nicholas appear in the
side panels.

3

Ambrogio Lorenzetti
Siena *c*1285 – 1348 ?
Four stories of St Nicholas
Tempera on panel, each 96 × 35 cm
Inv.nos.8348, 8349
Possibly intended as side panels for a
tabernacle, these four scenes represent
St Nicholas providing a dowry for
three poor girls; his consecration as
bishop of Myra; the resuscitation of a
boy possessed by the Devil; and the
saint saving Myra from famine.

2

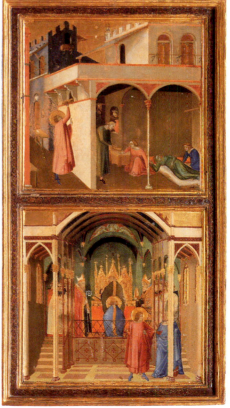

3

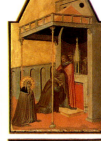
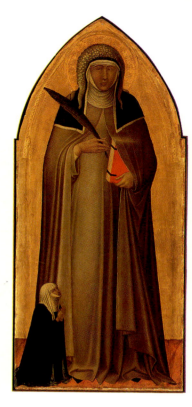

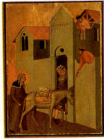

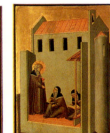

1

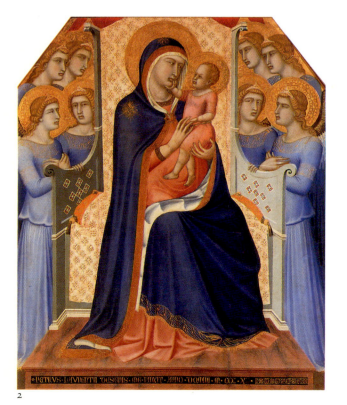

2

3

26

1

Pietro Lorenzetti
Siena *c*1280 – 1348 ?
The Beata Umiltà altarpiece
Tempera on panel, central panel
128 × 57 cm, others 45 × 32 cm,
pinnacles 51 × 21 cm
Inv.nos.8347, 6129-31, 6120-26
This ambitious polyptych was pro-
duced for the Florentine convent of
Vallombrosan nuns called San Gio-
vanni Evangelista delle Donne di
Faenza. The central panel depicts
the convent's Blessed founder,
Sister Humility, venerated by a nun,
probably the donor, while the
subsidiary scenes illustrate episodes
from Humility's life.

2

Pietro Lorenzetti
Siena *c*1280 – 1348 ?
Madonna and Child enthroned with
angels
Tempera on panel, 145 × 122 cm
Inv.no.445
This painting is inscribed on the
throne with Pietro Lorenzetti's name
and the date of its completion, 1315
or 1340 (?) (now partially illegible).

3

Niccolò di Ser Sozzo
Active in Siena 1334–63
Madonna and Child
Tempera on panel, 85 × 55 cm
Inv.no.8439

4

Ambrogio Lorenzetti
Siena *c*1285 – 1348 ?
The Presentation in the Temple, signed
and dated 1342
Part of a triptych, tempera on panel,
257 × 168 cm
Inv.no.8346
Like the Simone Martini/ Lippo
Memmi *Annunciation* (p.24) this panel
was one of the major 14th-century
commissions for altars in Siena cathe-
dral and the deep columnar perspec-
tive of the temple recalls Siena
cathedral itself. The painting is signed
and dated by Ambrogio Lorenzetti,
younger brother of Pietro. Unfortu-
nately the flanking panels, which
showed Sts Crescentius and Michael,
are now missing.

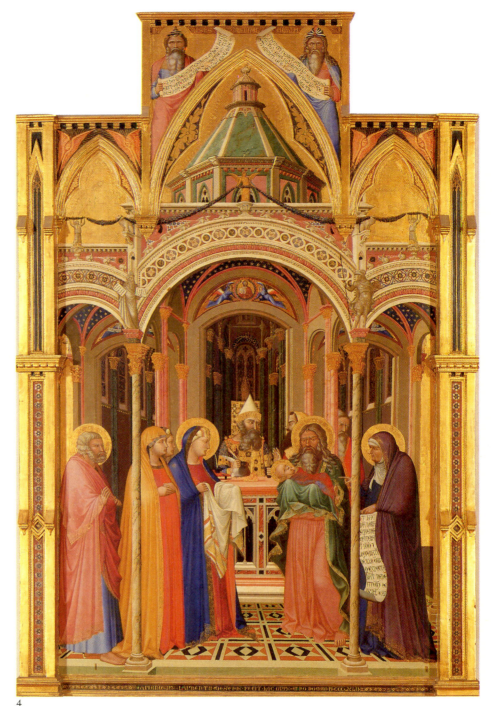

4

Late Gothic in Florence

1A

Following a period of repetitiveness and aridity in the late fourteenth century, the first quarter of the fifteenth century saw a renewal of artistic activity in Florence. A guiding light in these developments was Ghiberti and his creation of a soft, flowing elegance in the bronze reliefs cast for the first of the Florentine Baptistery doors. Indeed, Ghiberti's workshop was a breeding ground for younger artists, including painters such as Masolino and Paolo Uccello, who were destined to play important roles in the future.

In the meantime (1403-13) Starnina returned from Spain, bringing with him some intimation of international developments in painting, and this seems to have inspired a more lively spirit of observation, together with a psychological approach in the rendering of emotions and attitudes. Very little, however, is definitely known about Starnina. The *Thebaïd* in the Uffizi is a problematic work as far as attribution is concerned (Fra Angelico and Paolo Uccello have also been suggested as possible authors), but its charm is apparent in a delightful episodic variety and in the early hints of naturalism, although the artist's sweeping, diagrammatic vision lacks a systematic perspective: despite their foreground position, the boats and castles are tiny and toy-like. Lorenzo Monaco, on the other hand, takes his anti-naturalism to visionary levels, in a spiritual polemic that resisted the fading of the medieval era to the last. In his *Coronation of the Virgin*, painted for the Convento degli Angeli, where he was a monk, a grandiose and sonorous effect like that of a choir is achieved; devotional intensity is expressed by the curving, polychromatic figures, arranged to create a sort of rainbow of participating mystics. His *Adoration of the Magi* (1422), which is exactly contemporaneous with Gentile's richly detailed Florentine version of the same theme (see p.123), is, in contrast, deliberately ascetic, with its arid rocky landscape, its scattering of wholly abstract buildings, and its insubstantial, schematic human figures.

The *Madonna of Humility*, however, an early work by Masolino, is beginning to be touched by a gentle sensuality, and is bathed in a delicate dawn light. The colours have a milky quality, the flesh tones are tender, the Christ Child feeds voraciously on the life-giving milk. It has a carnal and sentimental sweetness, a subtle yet significant foreshadowing of a new pictorial birth. Masolino here sets out instinctively in the direction of his future encounter and collaboration with Masaccio.

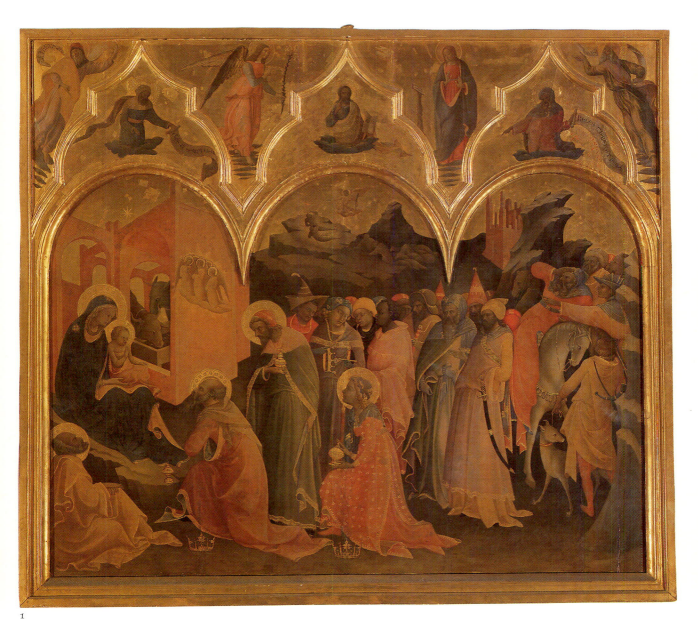

1

1
**Lorenzo Monaco and Cosimo
Rosselli**
**Siena? c1370 – c1425 Florence;
Florence 1439 – 1507 Florence**
The Adoration of the Magi
Tempera on panel, 115 × 170 cm
Inv.no.466
This *Adoration* is thought to be the
altarpiece for the church of Sant'Egi-
dio in Florence for which Lorenzo was

paid in the early 1420s. Originally
designed with a more elaborate
Gothic frame, the altarpiece was
regularised into a simpler rectangle in
the later 15th century when Cosimo
Rosselli's angels and Annunciation
figures were added in the new
spandrels.

1A
Detail of *The Adoration of the Magi*

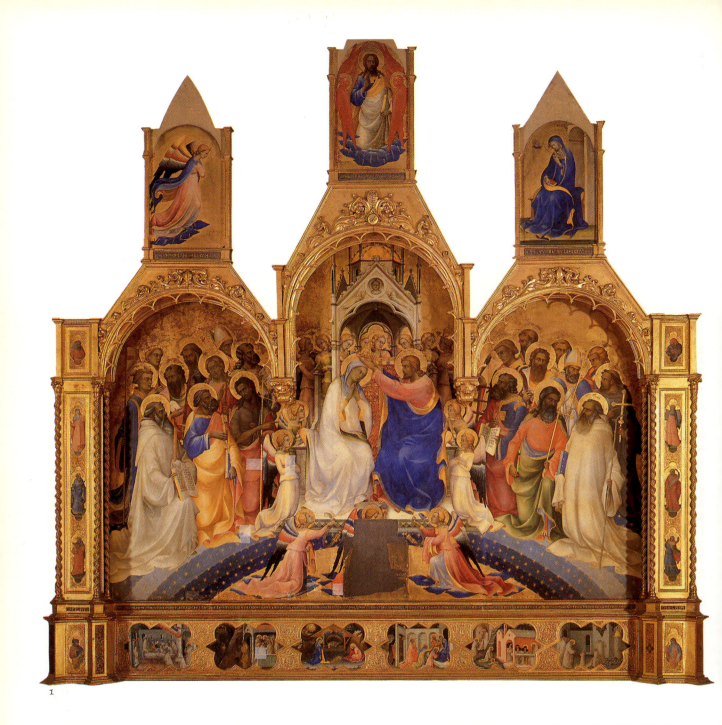

1

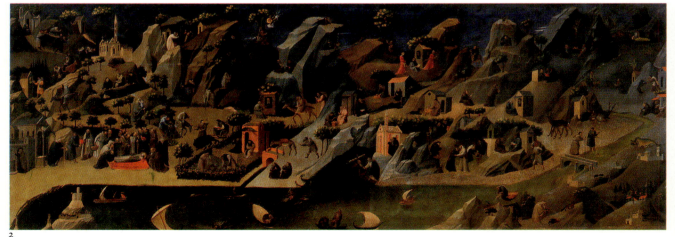

2

1

Lorenzo Monaco
Siena? *c*1370 – *c*1425 **Florence**
The Coronation of the Virgin, signed and
dated 1414
Tempera on panel, 450 × 350 cm
Inv.no.885
This magnificent celebratory altarpiece
with its hierarchical frame structure
was painted by Lorenzo Monaco for
his own monastery of Santa Maria
degli Angeli in Florence. According to
the lengthy inscription, he made the
work as an act of piety and to replace
a pre-existing altarpiece.

2

Gherardo Starnina
Active in Florence late 14th, early
15th century
Thebaïd
Tempera on panel, 75 × 208 cm
Inv.no.477
The panel depicts scenes from the
lives of the monks who lived near
Thebes in Egypt. This unusual subject
provided the opportunity for the artist
to represent human activity taking
place within a semi-naturalistic land-
scape, filled with recognisable plants
and animals.

3

Masolino
San Giovanni Valdarno 1383? –
? 1447
The Madonna of Humility
Tempera on panel, 110.5 × 62 cm
Inv.no.9922

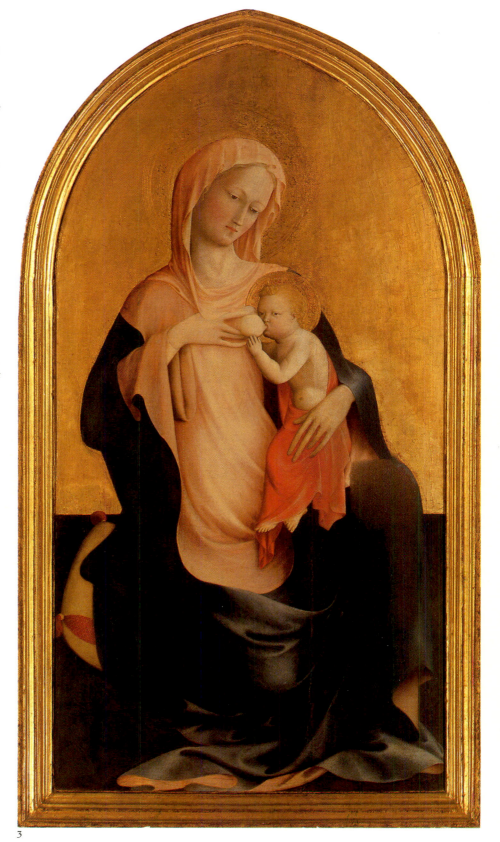

3

Early Renaissance

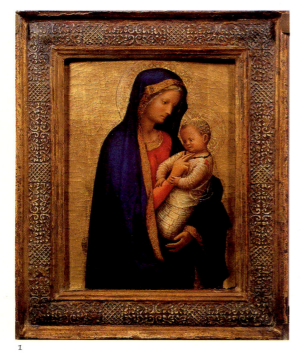

1

1
Masaccio
San Giovanni Valdarno 1401 –
1428 Rome
The Cassini *Madonna*
Tempera on panel, 24.5 × 18 cm
Inv.no.9929

2
Masaccio and Masolino
San Giovanni Valdarno 1401 –
1428 Rome
San Giovanni Valdarno 1383? –
? 1447
The Virgin and Child with St Anne and
five angels
Tempera on panel, 175 × 103 cm
Inv.no.8386
This painting showing the Virgin with
the Christ Child seated in the lap of
her mother St Anne was described by
Vasari in the 16th century when it was
in the church of Sant'Ambrogio,
Florence. The work illustrates the
collaboration on a smaller scale of
Masaccio and Masolino, who had also
worked alongside one another on the

The transition from a late Gothic to a Renaissance style may be seen
with the clarity of a theorem and within the confines of a single
painting: the *Madonna and Child with St Anne and angels* (c1425) by
Masolino and Masaccio. Masolino is responsible for the doll-like
angels (except for the more vigorously painted one in green robes)
and the inward-looking St Anne. But the powerful figure of the
Madonna, compact and solid, belongs instead to Masaccio, as does the
lively and robust Christ Child whose total nakedness suggests
inspiration from some antique example. The forms are thrown into
relief by a single light source coming from the left and the use of
foreshortening sometimes also produces abrupt and ungraceful effects,
as for example in the left leg and arm of the Christ Child. Masaccio's
contribution is of a revolutionary character, expressing a new,
coherent order (aligning it with the work of Brunelleschi and
Donatello), and an intransigent and aggressive ideology.

But the lesson of Masaccio was interpreted by his immediate
successors in their own strongly personal terms, with (fortunately)
varied results. For Fra Angelico, Masaccio's substitution for
transcendence of an immanence truly of this world signified a way
forward but not the way, yet a comparison of his *Coronation of the
Virgin* with that of Lorenzo Monaco shows the development of quite a
different sense of space in its perspectival order; its celestial radiance
shows awareness of the actual light of day. Despite its dimensions, the
huge spiritual assembly is sedately ordered, the figures solidly
constructed.

In his *Battle of San Romano*, Paolo Uccello experiments with a
fanatical exaggeration of perspective to produce a metaphysical, magic
effect. The painting has an almost playful quality that divests the
warlike encounter of its drama, transforming it into a fabulous jousting
tournament with horses portrayed in the most varied foreshortening,
lances slicing the air and robotic knights in armour.

Domenico Veneziano's altarpiece instead has an air of complex
refinement, the triptych partitions of an earlier age having given way
to a single, unified scene. Space is defined by a continuous series of
receding planes, and an equally scrupulous perfection of
draughtsmanship is apparent in the calm figures, painted with
meticulous attention to detail, right down to the last gem-stone and
scrap of embroidery, in a manner derived from contemporary Flemish
works. Domenico aims also at the creation of exquisite light effects,
choosing a delicate, spring-like, morning light that sets off his palette
of soft colours.

By contrast, Castagno is of a proud temperament, his *Famous men*
series the expression of an heroic ideal. These statuesque figures set on
a marbled ground have a vigorous linearity that suggests great
strength and a sculptural quality like that of burnished metal. The
influence of all of these painters was also felt beyond the confines of
Florentine art, and it was by such means that the Renaissance
established itself all over Italy, branching out into a wonderful
multiplicity. Siena, too, was undergoing a renewal of its own local
fourteenth-century tradition, notably in the exquisitely sensitive
creations of Sassetta.

famous frescos in the Brancacci chapel
in Santa Maria del Carmine. Masaccio,
as the leading light, seems to have
been responsible for the figures of the
Virgin and Christ, while Masolino's
delicate, less sculptural style is appar-
ent in the painting of St Anne and
most of the angels.

2

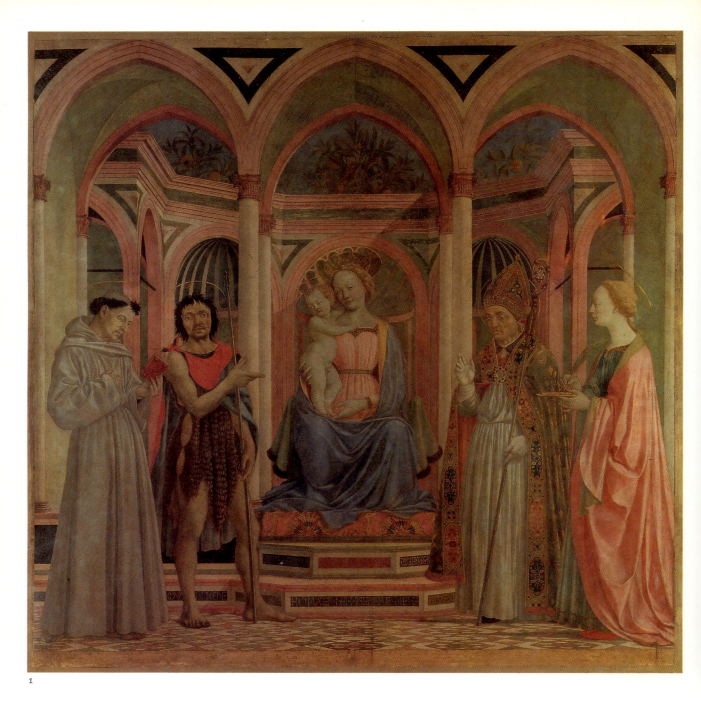

1

1

Domenico Veneziano
Venice c1400 – 1461 Florence
The Santa Lucia altarpiece
Tempera on panel, 209 × 216 cm
Inv.no.884
This altarpiece was first recorded in a
side chapel of the church of Santa
Lucia dei Magnoli in Florence. It is
signed by the artist along the base in
an inscription that asks for the divine
mercy of the Virgin, Mother of God.
Probably painted around the
mid-1440s, it represents an early
example of the less elaborate rectan-
gular panel format that became
popular from the mid-15th century in

Florence, though the arches of the
loggia deliberately recall the earlier
type of frame. Domenico's manipula-
tion of space, scale and light to create
a convincing pictorial unity is highly
sophisticated.

2

Paolo Uccello
Florence 1397 – 1475 Florence
The battle of San Romano
Tempera on panel, 182 × 220 cm
Inv.no.479
The battle of San Romano, which took
place between Florence and Siena in
1432, formed the subject of three
panels which decorated a ground floor

room of the new Medici palace in
Florence, finished in 1451. This panel,
showing the unseating of the Sienese
commander, hung at the centre of the
series, while those in the National
Gallery, London, and the Louvre hung
to left and right.

2A
Detail of *The battle of San Romano*

34

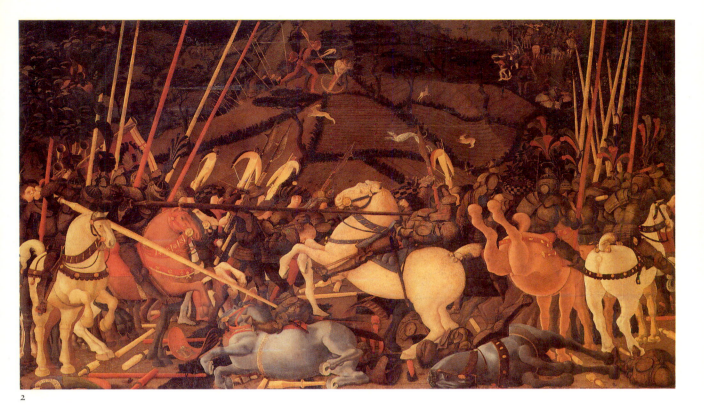

2

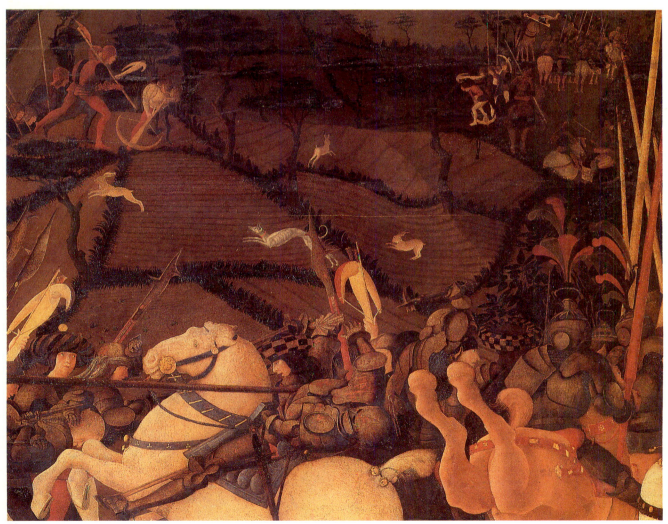

2A

1

Lorenzo di Pietro, called Vecchietta
Castiglione d'Orcia 1410 –
1480 Siena
Madonna and saints, signed and dated
1457
Tempera on panel, 156 × 230 cm
Inv.no.474
The tripartite division of the picture
field, virtually abandoned in
Domenico Veneziano's Santa Lucia
altarpiece (p.34), is retained in this
later but more conservative Sienese
altarpiece, which is richly decorative.

2

Stefano di Giovanni, called Sassetta
Cortona *c*1400 – 1450 Siena
The Madonna of the Snow
Tempera on panel, 240 × 256 cm
Inv.no. Contini Bonacossi 1
The most important Sienese painter of
the generation preceding that of
Vecchietta, Sassetta was commis-
sioned to make this elaborate work for

1

2

3

the chapel of St Boniface in Siena
cathedral. Like earlier altarpieces for
the cathedral (see pp.24–27) it orig-
inally had side panels. The square
predella scenes illustrate the founda-
tion of the basilica of Santa Maria
Maggiore in Rome on an area miracu-
lously covered with snow in summer.

3

Alesso Baldovinetti
Florence 1425 – 1499 Florence
The Annunciation, 1457
Tempera on panel, 167 × 137 cm
Inv.no.483

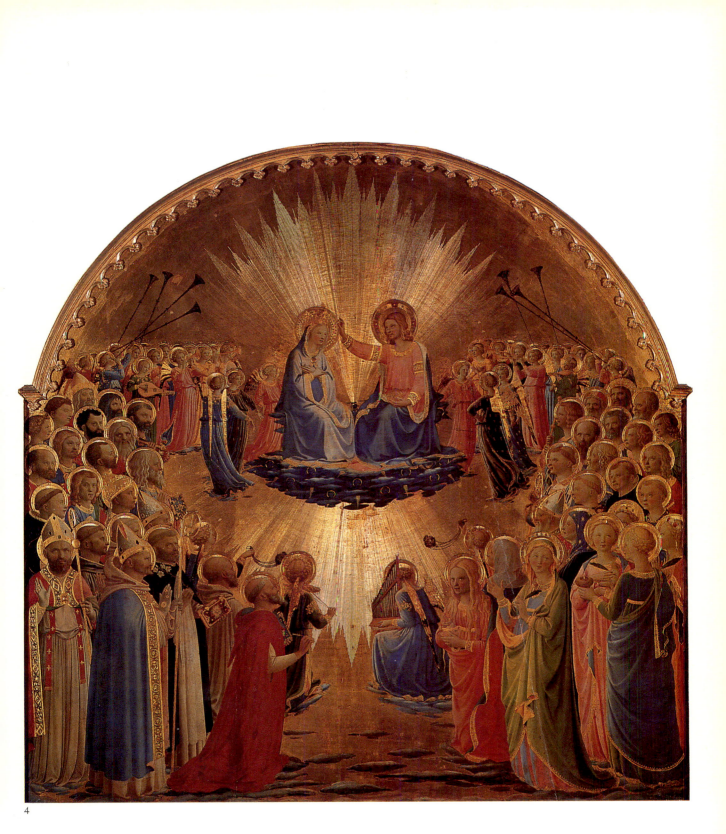

4

4
Fra Angelico
Vicchio di Mugello *c*1400 –
1455 Rome
The Coronation of the Virgin
Tempera on panel, 112 × 114 cm
Inv.no.1612
This panel by Fra Angelico was seen
by Vasari on the *tramezzo* wall of the

Dominican church of Sant'Egidio in
Florence in the 16th century. The
presence of St Egidius next to St
Dominic in the host of male saints
would seem to confirm that it was
always intended for this site. The
spectacular tooled gold ground makes
use of light reflected off the surface of
the picture to reinforce the glory
surrounding Christ and the Virgin.

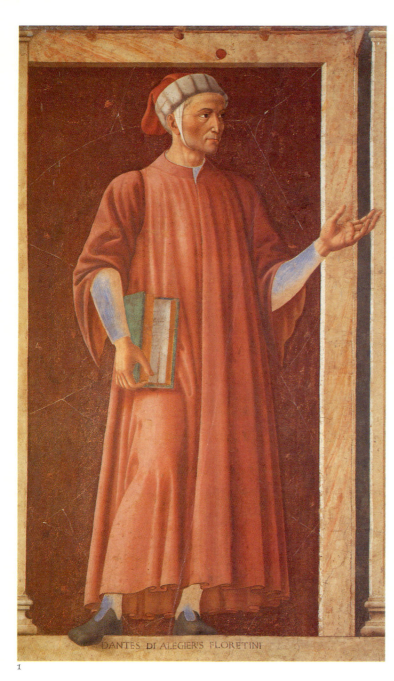

1

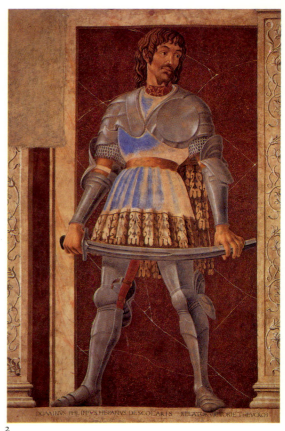

2

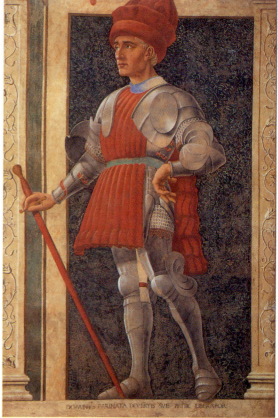

3

**1
Andrea del Castagno
Castagno c1421 – 1457 Florence**
*Famous men and women: Dante Alighieri,
Pippo Spano, Farinata degli Uberti, Queen
Tomiris, Petrarch, the Cumaean Sibyl*
Frescos transferred to canvas, each
247 × 153/155 cm
Inv.nos. San Marco e Cenacoli 167,
173, 172, 168, 166, 170
These six figures were removed in
1847 from the long wall of the hall/
loggia in the Villa Carducci at Legnaia
near Florence along with further

'portraits' of Nicolò Acciaioli, Gio-
vanni Boccaccio and Esther. They
formed part of a larger scheme of
fresco decoration that included images
of the Virgin and Child and Adam and
Eve on the end wall. They are related
to earlier cycles representing the nine
Famous Men or Worthies of antiquity
and the Old and New Testaments. In
this cycle, however, the patron has
chosen not only three famous women
of antiquity but also specifically
Florentine heroes, both military and
literary.

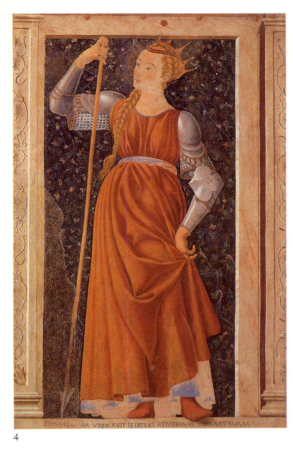

4

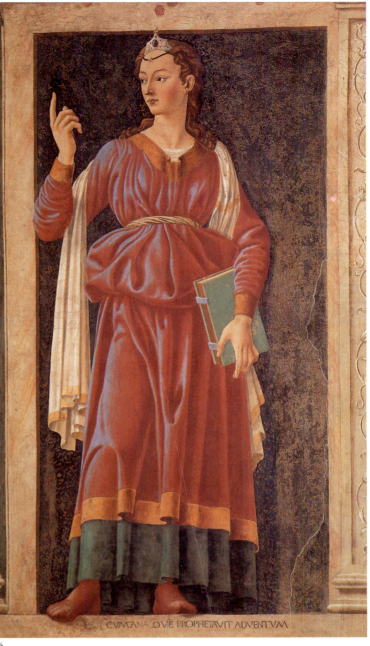

6

5

1
Dante Alighieri

2
Pippo Spano

3
Farinata degli Uberti

4
Queen Tomiris

5
Petrarch

6
The Cumaean Sibyl

Filippo Lippi

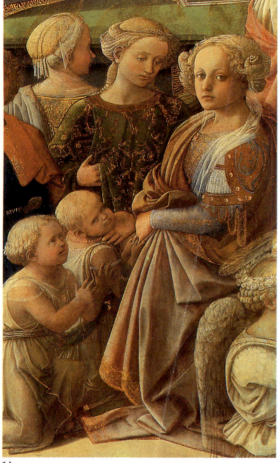

1A

1
Filippo Lippi
Florence _c_1406 – 1469 Spoleto
The Coronation of the Virgin, 1441–47
Tempera on panel, 200 × 287 cm
Inv.no.8352

1A
Detail of _The Coronation of the Virgin_

Filippo Lippi was one of the first followers of Masaccio and as a very young friar watched the older artist at work in the Brancacci chapel in Santa Maria del Carmine. Yet he differed from Masaccio in having an instinctive and sensual temperament (later in life he would seduce and elope with a nun, Lucrezia Buti). Lippi was empirical rather than systematic, his perceptions, experiences and inventions seemingly in a constant state of flux. Perhaps this was inevitable given that the single most important influence on his art – far more than Brunelleschi's perspectival system or the solidity of Masaccio – was the linear dynamism of Donatello's low-relief sculptures.

In his _Coronation of the Virgin_ of the 1440s, the monk and the angel in the foreground act as links between the fictitious world of the painting and the reality of the spectator; one is depicted in the act of entering the scene, the other leaving it, and both figures are truncated by the edge of the frame. There is thus no clear-cut separation between the representation of the scene and our experience of it, but rather the establishment of a communication between the two. As spectators we feel we have been allowed to enter in on the action and to take part in it along with the other participants, as part of a mixed gathering of sacred and profane that includes saints and angels as well as men, women and children: it is like the stage of a theatre upon which all the actors are crowded for the final curtain.

Here, too, Lippi eschews Masaccio's clear-cut plasticity in favour of lightly compressed forms which have a soft, malleable quality; the scene is lit by several light sources rather than a single, unifying one. A sense of fluidity rather than of stability is conveyed, of continual variation and variability similar to that experienced psychologically and through the senses in ordinary life, and here portrayed affectionately and perceptively by a Lippi inspired more by a general _eros_ than by _ethos_ or by _logos_.

Nowhere is the exquisite grace of Filippo Lippi's art more apparent than in his much loved _Virgin and Child with angels_ where an open window behind the sitters permits both a view of a landscape and the entry of a gentle breeze which lifts the folds of the young Virgin's veil. The disarmingly mischievous gaze of one of the three young boys is turned towards the spectator.

Lippi's uninhibited sensitivity allowed him to explore a great variety of motifs. The predella of the Barbadori altarpiece comprises three scenes of great intensity, in both the chromatic and emotional sense. In another example, Lippi shows a heightened awareness of direct impressions in the _Adoration of the Child_ from the monastery at Camaldoli, which is bathed in an 'underwater' light, clearly inspired by the forest-clad and mountainous landscape surrounding the hermitage there.

Lippi's *Coronation of the Virgin* was painted for the high altar of the church of Sant'Ambrogio in Florence. Commissioned by the procurator Francesco Maringhi in 1441, the year of his death, the work was secured by the chaplain Domenico Maringhi who appears as a donor to the right next to St John the Baptist. The cast of saints, angels and donors are welded into spatially defined groups so that the spectator appears to look down upon the figures in the foreground, many of whom look directly out of the picture. The second on the left is the painter's self-portrait.

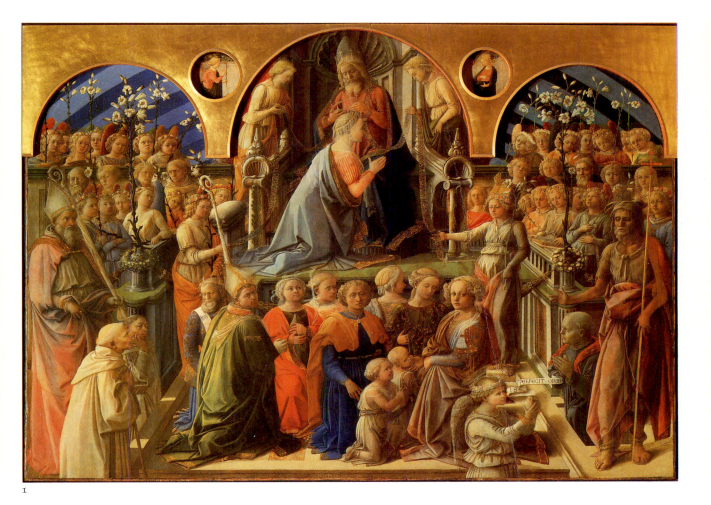

1

2

3

2
Filippo Lippi
Florence *c*1406 – 1469 Spoleto
Predella of the Barbadori altarpiece:
The Annunciation
Tempera on wood, 40 × 235 cm
Inv.no.8351

3
Filippo Lippi
Florence *c*1406 – 1469 Spoleto
Predella of the Barbadori altarpiece:
St Augustine in his cell
Tempera on wood, 40 × 235 cm
Inv.no.8351

These two scenes, together with a third Uffizi panel representing a *Miracle of San Frediano*, formed part of the predella of Lippi's Barbadori altarpiece now in the Louvre.

Filippo Lippi
Florence *c1406 – 1469* Spoleto
The Adoration of the Christ Child
Tempera on wood, 140 × 130 cm
Inv.no.8353
In 1463 Piero di Cosimo de' Medici financed the building of the hermitage of the Camaldoli in Florence. It was probably soon after this that Piero's wife, Lucrezia Tornabuoni, commissioned this intimate devotional work for the Camaldolese monks. It relates closely in type not only to another painting by Lippi in the Uffizi (inv.no.8350) but in particular to the altarpiece, now in Berlin, that he had made earlier for the Medici Palace chapel. The Holy Spirit is seen descending on the Christ Child while the young St John the Baptist and St Bernard act as intermediaries who direct the spectator's meditation to the mystery.

Filippo Lippi
Florence *c1406 – 1469* Spoleto
Madonna and Child with angels
Tempera on panel, 95 × 62 cm
Inv.no.1598
The Virgin is shown seated in front of a window opening high above the landscape while the Christ Child is lifted up to her by angels. This is a very important prototype of a compositional formula that both Botticelli and Leonardo would develop.

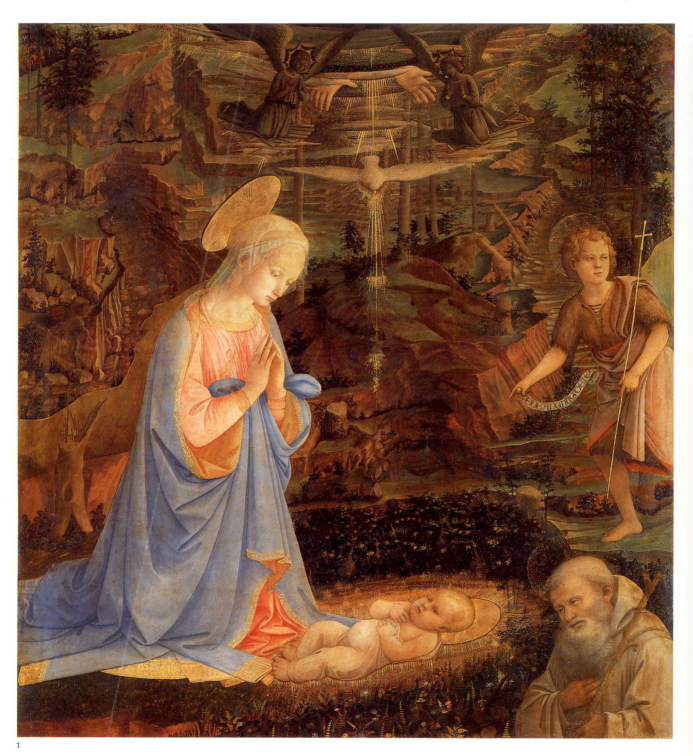

1

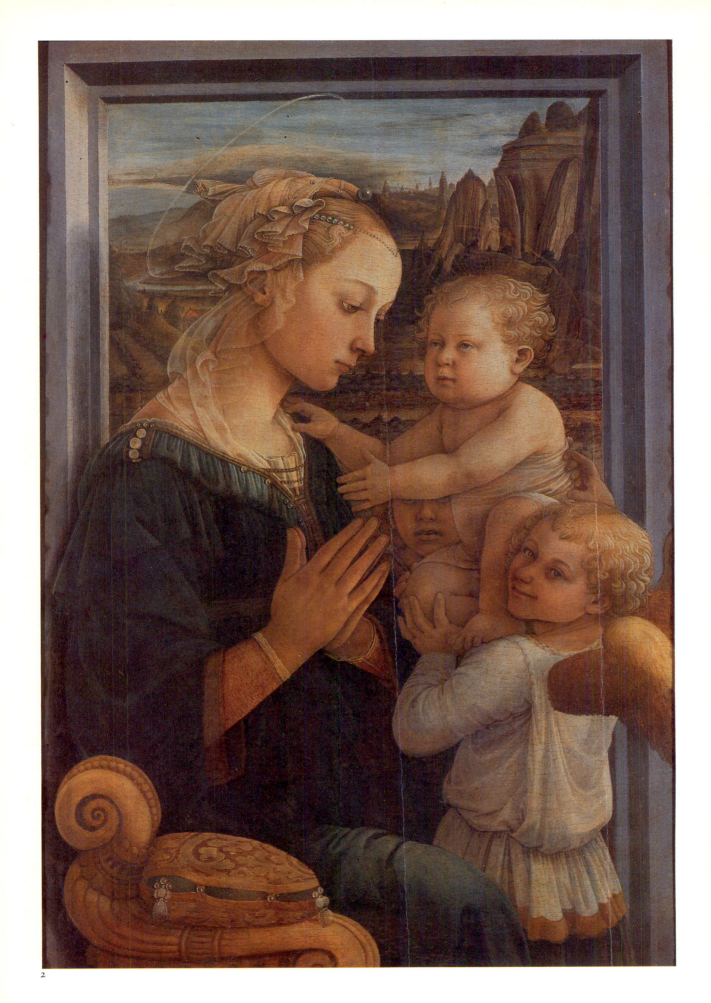

Piero della Francesca

Since the frescos he executed in collaboration with his master Domenico Veneziano in the church of Sant'Egidio in 1439 are now lost, the Uffizi's diptych portrait of the Duke and Duchess of Urbino is all that is left in Florence to represent the art of Piero della Francesca. Nonetheless his time in Florence, working beside a 'modern' artist like Domenico, was of fundamental importance for the painter from Borgo San Sepolcro: here he came into contact with the major works of the leaders of Early Renaissance art, by Masaccio and Masolino, Donatello, Ghiberti, Brunelleschi, Paolo Uccello, Luca Della Robbia After this immersion in the most progressive cultural circles of the period, Piero evolved his own extraordinarily lucid vision, combining a perspective clarity with a close attention to the fall of light, enriching a new, Renaissance spatial and compositional logic with vibrancy of colour. At the same time the essential earthiness of his figures lends his art a timeless, classic quality.

The Uffizi diptych was produced at a period of Piero's career in which his links to the court of Urbino, established in the 1460s thanks to the patronage of Federico da Montefeltro, had exposed him to further stimulating artistic currents, for instance the work at Urbino of Francesco Laurana and Francesco di Giorgio, and many paintings by Netherlandish artists. Piero's portrayal of the Duke in profile against a landscape background seen from a high viewpoint is one of his finest achievements: it succeeds in raising description of the particular to a universal level by a combination of geometrical abstraction in the figures and an atmospheric, luminous rendering of the landscape. Thereby it provides a sense of the standing of Federico and his wife Battista Sforza in the natural and social order, to which the two *Triumphs* painted on the rear also refer. Here, on floats of superb design, the virtues of the Duke and Duchess are celebrated in an eternal march-past. The text, in an extremely elegant Roman script, again suggests the pair's clear self-consciousness of their role.

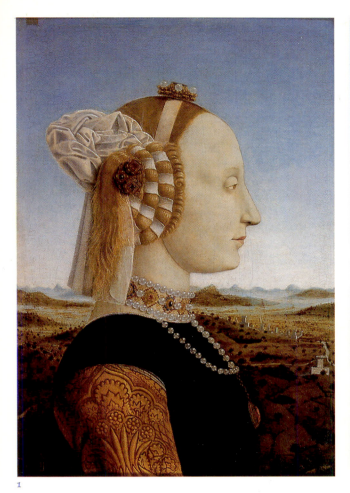

1

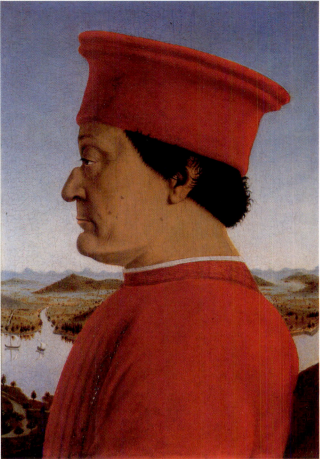

2

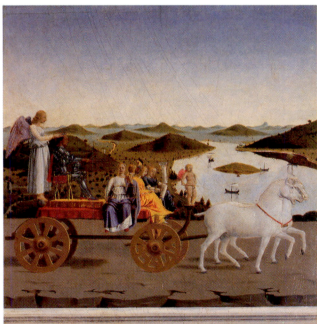

CLARVS INSIGNI VEHITVR TRIVMPHO ·
QVEM · PAREM · SVMMIS · DVCIBVS PERHENNIS ·
FAMA VIRTVTVM · CELEBRAT DECENTER ·
SCEPTRA TENENTEM ⟶

3

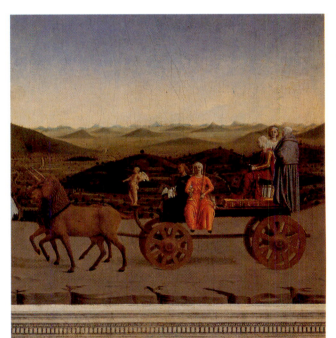

QVE MODVM · REBVS · TENVIT · SECVNDIS ·
CONIVGIS · MAGNI · DECORATA · RERVM ·
LAVDE GESTARVM VOLITAT · PER · ORA ·
CVNCTA · VIRORVM ·

4

Pollaiolo

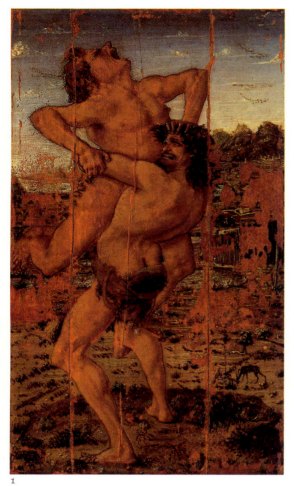

1

Antonio Pollaiolo
Florence *c*1431 – 1498 Rome
Hercules and Antaeus
Tempera and oil on panel, 16 × 9 cm
Inv.no.1478

In the second half of the fifteenth century, Renaissance painting in Florence developed beyond its initial phase of establishing a spatial-perspectival system capable of containing the newly concrete reality of the human figure. In place of Masaccesque purism came a more virtuoso sophistication, while unequivocal humanistic certainties gave way instead to more pronounced and conscious debate. This debate involved the problem of man's relationship with nature and, in stylistic terms, of endowing the draughtsman's line with the capacity to reflect in all their variety both physical and psychological states. Many artists trained initially as goldsmiths, a craft which taught them minute precision of an analytical, meticulous nature. It also formed them as sculptors, masters that is of plasticity of form, with a depth of expression not confined to a flat, painterly execution.

Such was the background of Antonio Pollaiolo, described in 1489 by Lorenzo the Magnificent as 'the foremost master of this city, this being the opinion shared by all connoisseurs...'.

Despite their small size, *Hercules and Antaeus* and *Hercules and the hydra* (1460), now lost, painted for the Palazzo Medici, still manage to preserve and convey the high drama of the hero's mortal struggles, caught in the moment of greatest and most anguished tension. The muscles are so taut with effort as to be almost locked in spasm; the faces express savagery. And if the human figure, dominating the foreground as it does, is here the protagonist, the wide sweep of landscape in the background is also brought to life with all the restless vitality of the natural world. The artist has created no pleasant, soothing background but one which competes with the fury of the main action, signalling its fated outcome.

The altarpiece from the Cardinal of Portugal's chapel in San Miniato is another work of sumptuous richness: here, the geometrical perfection of the round marble plinths is in contrast to the figures of the three saints who are immersed, not in the serene calm of a Domenico Veneziano, but in a much fresher *plein air*. They are not contemplative but seem instead to have struck a pose only momentarily, before returning to action. Pollaiolo was also active as a portrait painter. In his *Galeazzo Maria Sforza* (in which his more heavy-handed brother Piero also had a part), the sitter is portrayed as proud, ambiguous, tyrannical and greedy. But in the *Head of a young girl*, by contrast, his brush captures with mastery all the seductive grace of the sitter's radiant looks, etched in profile upon a ground of lapis lazuli. The textural beauty of her dress, her jewels and the softness of her hair even anticipate the work of Bronzino in the following century.

2

Antonio Pollaiolo
Florence _c_1431 – 1498 Rome
Hercules and the hydra
Tempera and oil on panel, 17 × 12 cm
Inv.no.8268

These two tiny panels were apparently made as near replicas of two of the three large-scale canvases showing the _Labours of Hercules_ painted by Antonio in 1460 for the principal first floor room of the Medici palace in Florence (now lost). The sense of energy and the monumentality of the canvases are retained in the panels, despite their extremely minute technique. They illustrate Pollaiolo's dedicated study of movement in space.

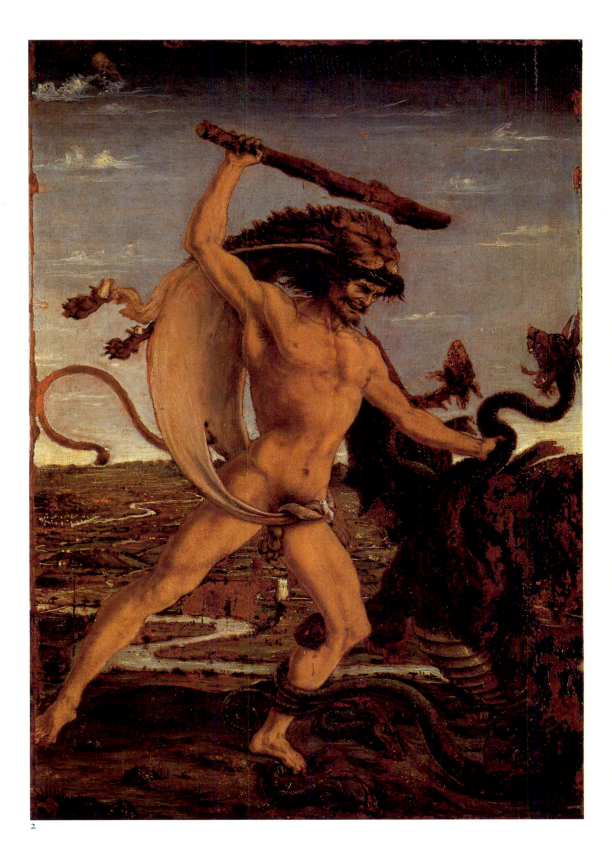

2

1

Piero Pollaiolo
Florence *c*1433 – 1496 Rome
Charity
Tempera and oil on panel,
167 × 88 cm
Inv no.499
This large-scale panel formed part of
the series of Virtues commissioned by
the Florentine merchants' Tribunal or
Mercanzia in 1469, to adorn their
council hall.

2

Antonio and Piero Pollaiolo
Florence *c*1431 – 1498 Rome;
Florence *c*1433 – 1496 Rome
Altarpiece of the Cardinal of
Portugal's chapel
Tempera and oil on panel,
172 × 179 cm
Inv.no.1617
Commissioned from both Antonio
and Piero Pollaiolo in 1466, this
altarpiece, which is still in its original
all'antica frame, formed the devotional
focus of the magnificent burial chapel
built for Cardinal James of Portugal in
the church of San Miniato al Monte
above Florence. In the centre is the
cardinal's name saint with Sts Vincent
and Eustace.

3

Piero Pollaiolo
Florence *c*1433 – 1496 Rome
Portrait of Galeazzo Maria Sforza,
Duke of Milan
Tempera on panel, 65 × 42 cm
Inv.no.1492
This portrait was recorded in the
Medici Palace inventory of 1492,
hanging in the same room as Uccello's
Battle of San Romano panels (see p.35).
It was almost certainly painted on the
occasion of the Duke of Milan's visit
to Florence in 1471.

4

Attributed to Antonio Pollaiolo
Florence *c*1431 – 1498 Rome
Portrait of a woman
Tempera on wood, 55 × 34 cm
Inv.no.1491

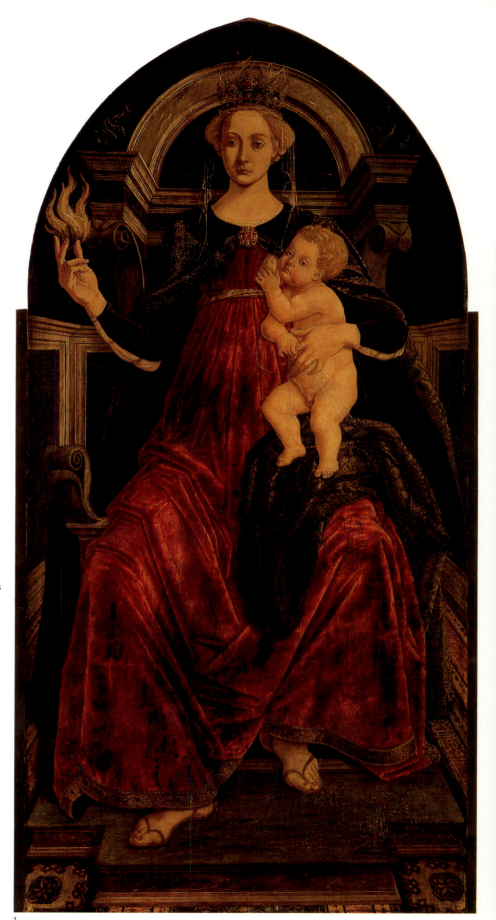

1

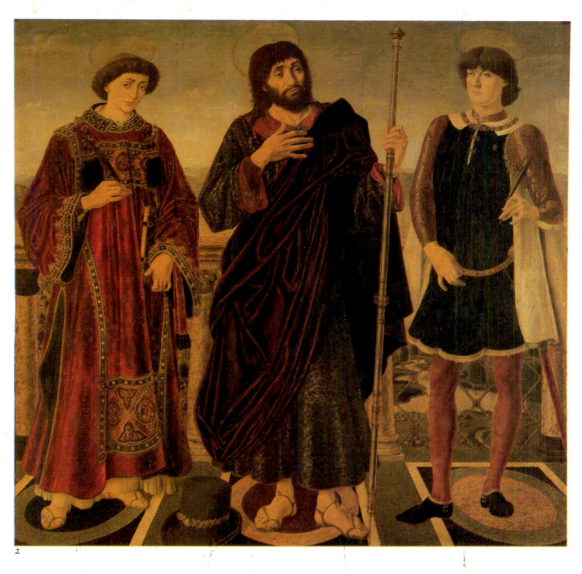

2

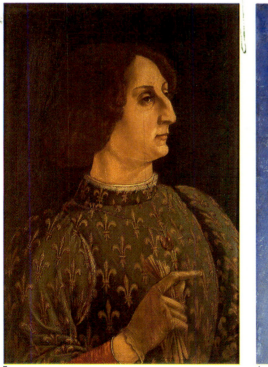

3

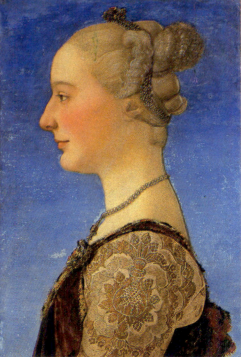

4

Botticelli

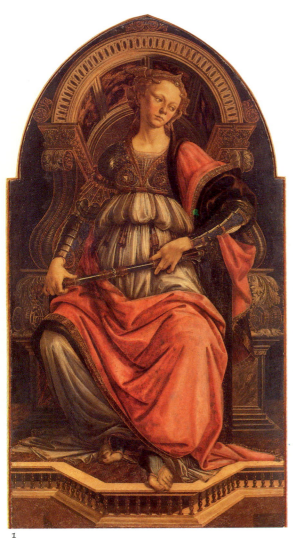

1

Around 1485, a knowledgeable observer described Botticelli to
Ludovico il Moro, Duke of Milan, as a 'very excellent' painter, adding,
however, that 'his works have a virile air', and, even more significantly,
that 'they are possessed of excellent regularity of form and sound
proportion'. By contrast, we tend now to regard Botticelli as
expressing a delicate sweetness, as a subjective and lyrical painter
rather than a rational one, whose talents are more musical than
mathematical. Yet consideration must be given to the complexity of
the 'Neoplatonic' culture that revolved around the figure of Lorenzo
the Magnificent, a culture which sought the secrets of harmony in
allegory and hermeticism.

Leonardo was one of the first critics of Botticelli, observing that he
was little interested in a naturalistic and scientific approach to
landscape painting and, for this reason, was not 'universal';
incomprehension grew and was to last several centuries until at last
Botticelli's œuvre was reappraised by the late Romantics, only to be
interpreted then as 'neurotic and sensual' and labelled as decadent.
Others thought of him as a 'neo-Gothic', without considering that his
architectural creations, for example in the *Calumny of Apelles*, are
among the most refined and ornate demonstrations of the principles of
the Renaissance perspectival system.

This is not to negate the unique, dream-like quality that
distinguishes his work, apparent even in an early picture (and despite
the subject matter) such as *Fortitude*, which makes the other works in
the series of the *Virtues*, painted by Piero Pollaiolo, look sluggish in
comparison. These same qualities give both vivacity and dignity to
the protagonist of *The return of Judith*, portrayed wending her way
home after a night of tragedy in the purifying first light of dawn. And
it offsets the obsequious atmosphere of the *Adoration of the Magi* with
all its Medici portraits. In *The birth of Venus*, a composition for the
Baptism of Christ is metamorphosed into ancient myth, yet the sense
of the water's purifying quality is retained, and the nude goddess has a
spiritual chastity. In the *Primavera*, a succession of allusions to the
months of the year and to the kingdom of Venus-Humanitas unfold in
sequence from right to left, as in the development of a musical tempo.
The scene is set in the half-light of a fabulous wood that is as
metaphysical as a painting by Paolo Uccello. Is *Pallas and the centaur* –
the latter a symbol of bestiality and sensuality – a political or moral
allegory? Whichever it is intended to be, the work suggests that
cultural values will dominate and bring about peace. A sumptuous
richness of ornament characterizes the San Barnaba altarpiece; but
austerity the *Annunciation* from Cestello, painted after Botticelli had
become a follower of Savonarola. Savonarola's influence is also
apparent in the mystic fervour of the altarpiece painted for San Marco.
If there is a metaphor with which to describe Botticelli's style, it might
be in the protean yet piercingly sharp quality of the violin.

2

Sandro Botticelli
Florence 1445 – 1510 Florence
The Adoration of the Magi
Tempera on panel, 111 × 134 cm
Inv.no.882
The panel was commissioned by
Guaspare del Lama as an altarpiece for
his burial chapel in Santa Maria

Novella in Florence. Del Lama, a
supporter of the Medici, may have
asked for the introduction of portraits
of Medici family members, some of
whom are clearly recognizable. The
figure looking out at the spectator to
the far right is generally believed to
be the artist.

2A
Detail of *The Adoration of the Magi*

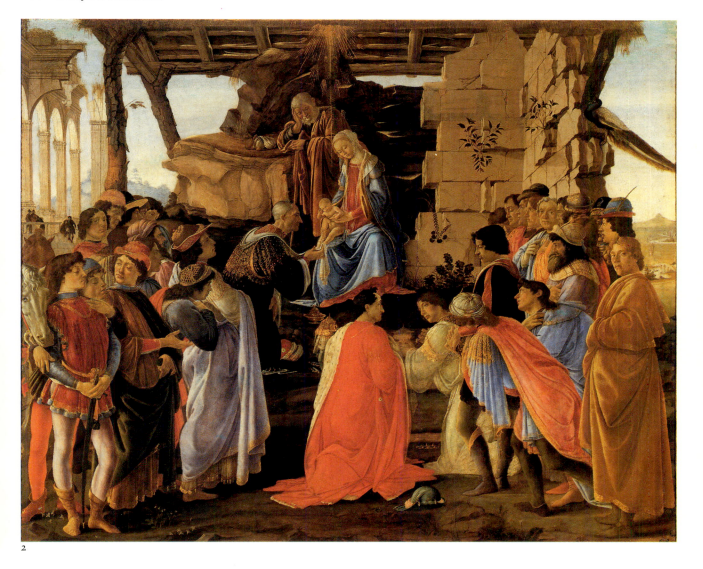

2

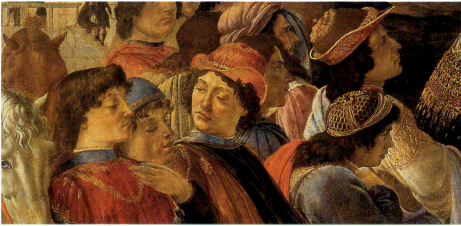

2A

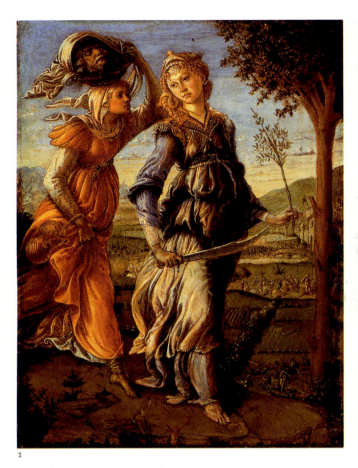

1

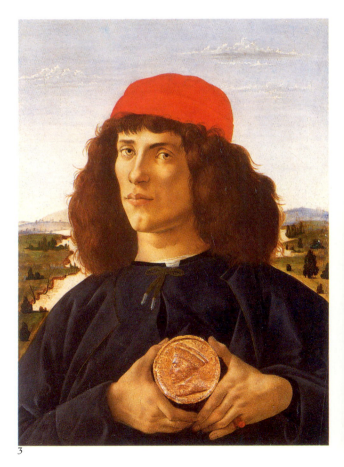

2

1
Sandro Botticelli
Florence 1445 – 1510 Florence
The return of Judith from the enemy camp
Tempera on panel, 31 × 24 cm
Inv.no.1484

2
Sandro Botticelli
Florence 1445 – 1510 Florence
The discovery of the corpse of Holofernes
Tempera on panel, 31 × 25 cm
Inv.no.1487
These small-scale scenes of Old
Testament history were perhaps
commissioned from the young Bot-
ticelli as panels to decorate furniture.
The biblical heroine Judith, who
severed the head of the enemy leader
Holofernes to save her people, was an
exemplary figure of liberty and
resistance to tyranny.

3
Sandro Botticelli
Florence 1445 – 1510 Florence
Portrait of a young man with a medal
of Cosimo il Vecchio de' Medici
Tempera and gesso on panel,
57 × 44 cm
Inv.no.1488
Never convincingly identified, the
youthful sitter holds a plaster copy of

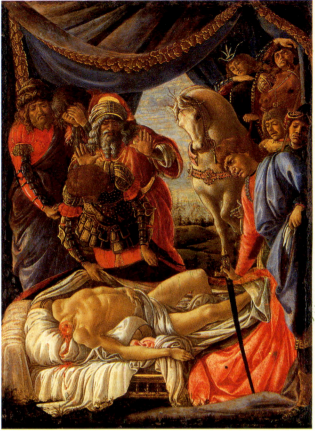

3

4

a famous medal of Cosimo il Vecchio de' Medici by which he seems to be declaring himself as a supporter of the leading Florentine family. Both the unusual angle of the head and the landscape background show Botticelli to have been in the vanguard of developments in Florentine panel portraiture, under the influence of Netherlandish examples.

5

4
Sandro Botticelli
Florence 1445 – 1510 Florence
The San Barnaba altarpiece
Tempera on panel, 268 × 280 cm
Inv.no.8361
The altarpiece was commissioned for the high altar of the Augustinian church of San Barnaba in Florence. St Barnabus, whose feast marked a famous Florentine military victory, is distinguished among the saints at the foot of the throne. Carrying an olive branch, he is shown pointing to the Christ Child who appears to be blessing him. The upper step to the throne is inscribed with a line from Dante reading 'O Virgin Mother, daughter of your Son'.

5
Sandro Botticelli
Florence 1445 – 1510 Florence
Panel from the predella of the San Barnaba altarpiece: *The vision of St Augustine meditating on the Trinity*
Tempera on panel, 20 × 38 cm
Inv.no.8392

Sandro Botticelli
Florence 1445 – 1510 Florence
Primavera (Spring)
Tempera on panel, 203 × 314 cm
Inv.no.8360
This painting has been identified as one recorded in 1499 in the palace of Giovanni and Lorenzo di Pierfrance-sco de' Medici, wards of Lorenzo il Magnifico. From the 16th to the 18th century it was in the Medici Villa di Castello, the country seat of Lorenzo di Pierfrancesco. Probably employing mythological figures to embody concepts of contemporary Neopla-tonic philosophy, with echoes of Politian's poetry, the painting has been variously interpreted: its figures (from the right, Zephyrus, Chloris, Flora, Venus and Cupid, the Three Graces, Mercury) probably represent a kind of celebration of the power of Venus, who elevates the material instincts of men and directs them towards civilization and the refine-ment of their intellectual and spiritual

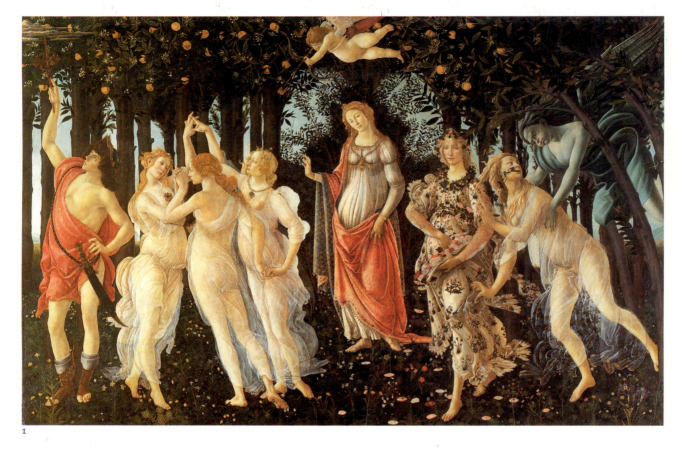

1

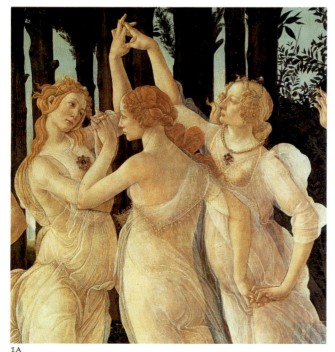

1A

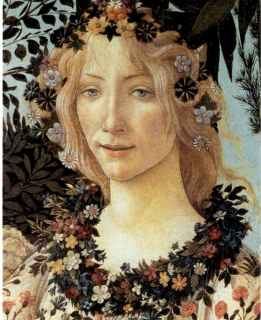

1B

qualities. The figures stand or move against a background of orange trees gracefully and fluently, superb examples of Botticelli's draughtsmanship.

2, 2A, 2B
Sandro Botticelli
Florence 1445 – 1510 Florence
The birth of Venus

Tempera on canvas, 175.5 × 278.5 cm
Inv.no.878
This canvas is also recorded in the 16th century in Lorenzo di Pierfrancesco's villa at Castello, and probably here again, as in the *Primavera*, Botticelli's marvellous figures embody a Neoplatonic idea – the coming into being of beauty through the union of

the spirit (Zephyr and Aura) with material nature (the Hour who proffers a floral mantle to the goddess as she reaches land). Like the *Primavera*, the picture is rich in echoes both literary and visual (the Venus recalls the pose of the antique statue-type known as the *Venus pudica*).

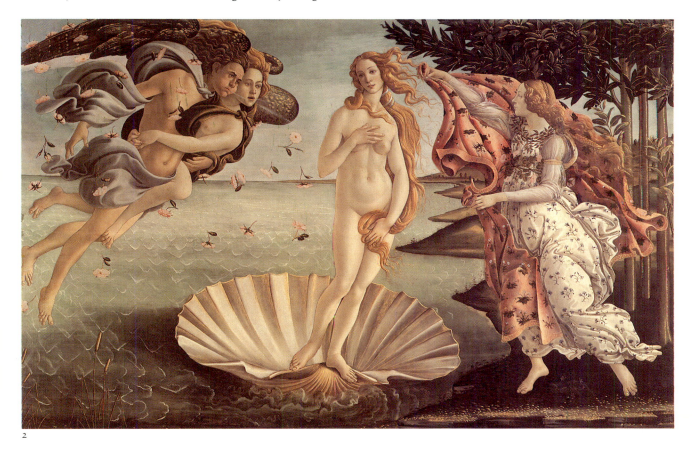

2

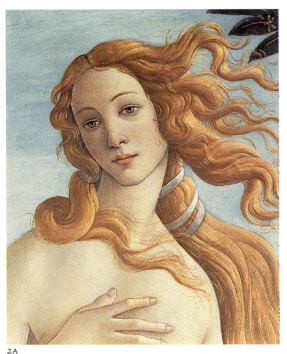

2A

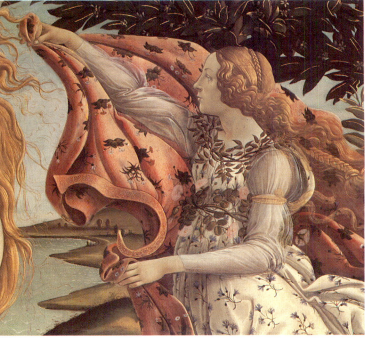

2B

1
Sandro Botticelli
Florence 1445 – 1510 Florence
The San Martino *Annunciation*
Fresco transferred on to panel,
243 × 550 cm
Inv.no. Depositi 201

2
Sandro Botticelli
Florence 1445 – 1510 Florence
The Madonna of the Pomegranate
Tempera on panel, diameter 143.5 cm
Inv.no.1607
This circular painting or *tondo* has
been identified with a picture by

Botticelli for the Magistracy of the
Massai di Camera in the Palazzo della
Signoria, Florence. The connection
seems to be confirmed by the fleur-de-
lys on a blue ground appearing on the
frame, an emblem used by the Floren-
tine government.

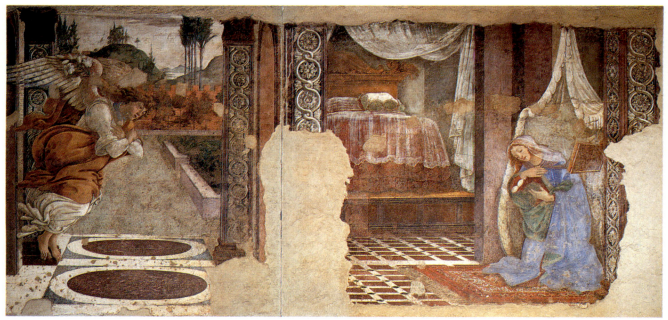

1

3
Sandro Botticelli
Florence 1445 – 1510 Florence
The Cestello *Annunciation*
Tempera on panel, 150 × 156 cm
Inv.no.1608
This dynamic composition is a com-
paratively late work by Botticelli. Still
in its original frame, the altarpiece
adorned a side chapel dedicated to the
Annunciation in the church of the
Cestello (Santa Maria Maddalena dei
Pazzi) in Florence. It was commis-
sioned in about 1489 by one
Benedetto Guardi whose coat of arms
appears on the frame.

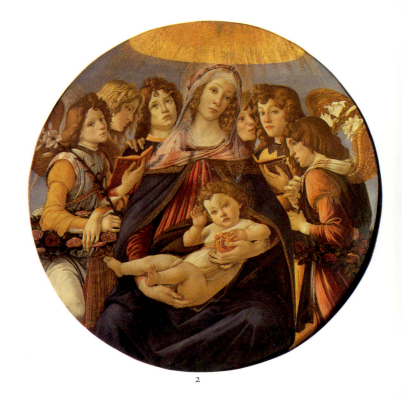

2

3

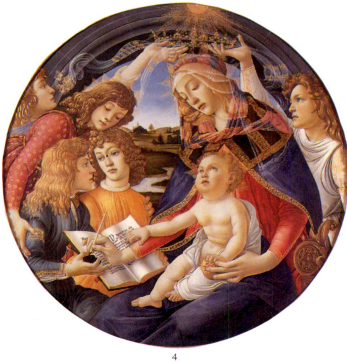

4

4

Sandro Botticelli
Florence 1445 – 1510 Florence
The Madonna of the Magnificat
Tempera on panel, diameter 118 cm
Inv.no.1609
The painting is named after the initial
words of the hymn that the Virgin,
crowned with the twelve stars of the
Apocalypse, is depicted in the act of
writing, while the Christ Child
appears to guide her hand. This
painting is some years earlier than the
Madonna of the Pomegranate

Sandro Botticelli
Florence 1445 – 1510 Florence
Pallas and the centaur
Tempera on canvas, 207 × 148 cm
Inv.no. Depositi 29

Pallas and the centaur appeared in the same room as Botticelli's *Primavera* in the 1499 inventory of the palace of Lorenzo and Giovanni di Pierfrancesco de' Medici. The female figure, carrying a halberd and shield and arrayed in Medici devices, is almost unanimously identified as Pallas (Minerva). Whatever her precise identity, it is clear that she had an allegorical significance as a figure of virtue restraining vice, or the brutal instincts of men, represented by the centaur, half-man and half-beast.

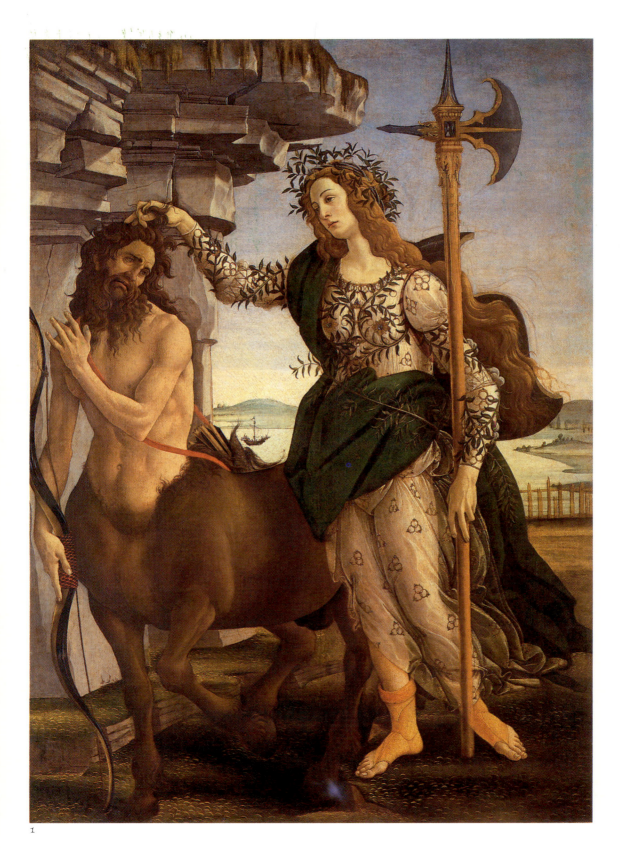

1

2, 2A, 2B
Sandro Botticelli
Florence 1445 – 1510 Florence
The Calumny of Apelles
Tempera on panel, 62 × 91 cm
Inv.no.1496

The unusual subject of this work derives from a classical source, Lucian's description of a famous painting by Apelles depicting an allegory of Calumny or Slander. This prototype, which showed personifications of Ignorance, Deceit and Suspicion dragging their slandered victim before the throne of king Midas, before the intervention of Penitence and Truth, was developed by Botticelli with extraordinary inventiveness; the background of the painting, with its statues and low reliefs adorning the throne room, nostalgically evokes the grandeur of antiquity.

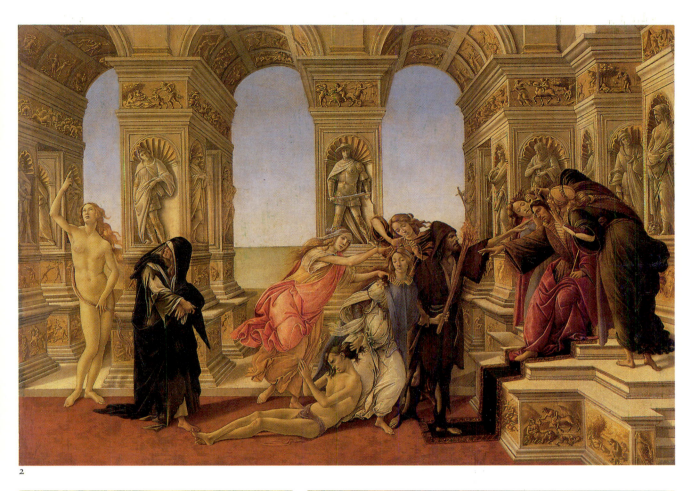

2

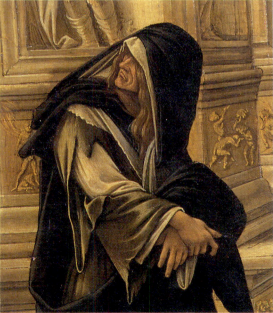

2A

2B

1

1

Sandro Botticelli
Florence 1445 – 1510 Florence
The Coronation of the Virgin (the San
Marco altarpiece)
Tempera on panel, 378 × 258 cm
Inv.no.8362
Roughly contemporary with the
Cestello *Annunciation* (p.57), this large,
arch-topped altarpiece was commis-
sioned by the goldsmiths of the Silk
Guild (Arte di Por Santa Maria or
della Seta) for their chapel in the
Florentine church of San Marco. The
saints, who appear to be standing in
an earthly realm below the angels, are
John the Evangelist, Augustine,
Jerome and Giles, the patron saint of
goldsmiths. In the upper scene of
Paradise the artist employs a gold
background of 14th-century type in
order to show reversion to a tradi-
tional piety.

2

Sandro Botticelli
Florence 1445 – 1510 Florence
The Adoration of the Magi
Tempera on panel, unfinished by the
artist and mostly coloured in the 18th
century, 107.5 × 173 cm
Inv.no.4346

3

Sandro Botticelli
Florence 1445 – 1510 Florence
St Augustine in his cell
Tempera on panel, 41 × 27 cm
Inv.no.1473

4

Sandro Botticelli
Florence 1445 – 1510 Florence
Predella of the San Marco altarpiece:
St John on Patmos
Tempera on panel, 21 × 268 cm
Inv.no.8389

5

Sandro Botticelli
Florence 1445 – 1510 Florence
Predella of the San Marco altarpiece:
The penitent St Jerome
Tempera on panel, 21 × 268 cm
Inv.no.8389

6

Sandro Botticelli
Florence 1445 – 1510 Florence
Predella of the San Marco altarpiece:
A miracle of St Giles
Tempera on panel, 21 × 268 cm
Inv.no.8389

2

3

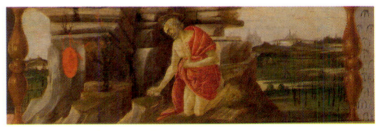

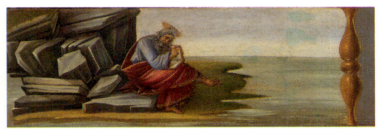

4 5 6

Ghirlandaio

1

Domenico Ghirlandaio
Florence 1449 – 1494 Florence
Madonna and Child with angels and saints
Tempera on wood, 190 × 200 cm
Inv.no.881
Made as the high altarpiece of San Giusto alle Mure in Florence, the picture was moved in the earlier 16th century to the church of San Giovannino or 'della Calza'. St Just is shown kneeling with the Florentine St Zenobius in the foreground while the archangels Michael and Raphael flank the Virgin's throne.

2

Domenico Ghirlandaio
Florence 1449 – 1494 Florence
The Adoration of the Magi, dated 1487
Tempera on panel, diameter 172 cm
Inv.no.1619
Depictions of the Adoration of the Magi were common in private commissions of the later 15th century in Florence (see p.51) and it is possible that the patron of this work, like the Medici themselves, belonged to the prestigious confraternity of the Magi that met at San Marco.

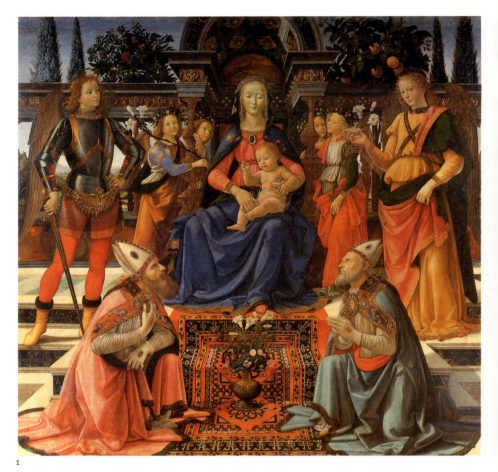

1

Until the crisis of the end of the century, fifteenth-century Florence was the home of a self-satisfied culture. Such a culture did not only require inspired poets, but able and willing illustrators, too. In this sense, Ghirlandaio's works were the continuation of a tradition, the principal exponent of which, as his frescos in the chapel of the Palazzo Medici show, had been Benozzo Gozzoli, a painter-narrator who evolved a style somewhere between the fairy-tale and the documentary. Ghirlandaio, however, at the same time kept pace with the most recent artistic developments: the interest in antiquity, the work of Verrocchio, Netherlandish painting, etc. There is no tormented questioning in his work, just serene and industrious mastery.

In his *Virgin with saints* (1484) all the component parts are symmetrically balanced: the carpet takes prominence in the foreground, while behind the ornamental balustrade – a device that has the effect of increasing space and light – the scene opens out on to cypresses and small trees bearing ripe fruits. The figures, however, are not possessed of any depth of feeling. In the 1487 *Adoration of the Magi* each plane within the picture is clearly distinguished: the whole scene is disposed so that the eye may read it easily, right down to

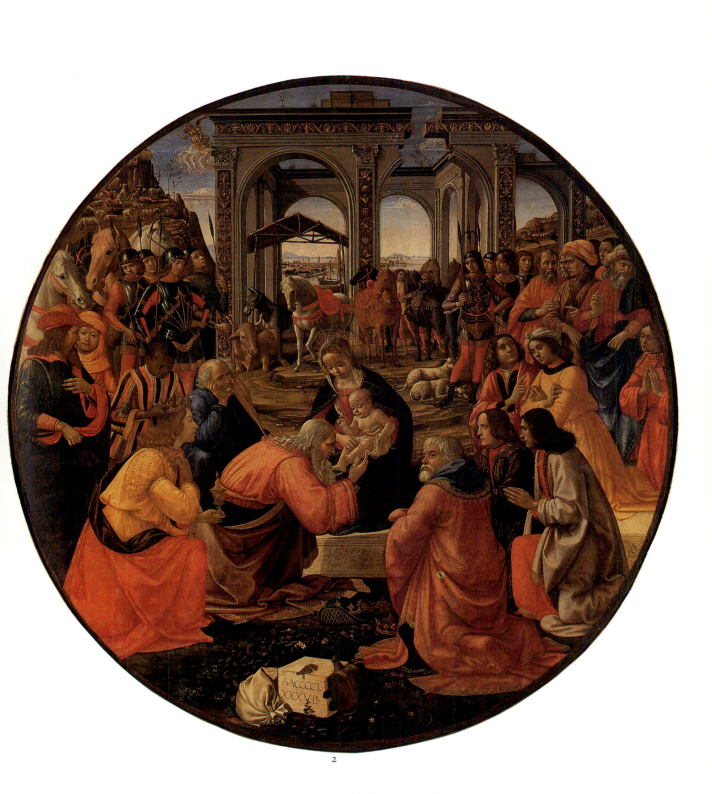

2

small details such as the little negro boy in brightly striped robes or the shining armour worn by some of the figures. Ghirlandaio was a bourgeois painter, and the merchandise he had to offer was of a high quality. In the hardly enthusiastic, but still very positive opinion of one contemporary, 'his works have a pleasant air and he is an expeditious sort, producing a considerable quantity of work'.

Filippino

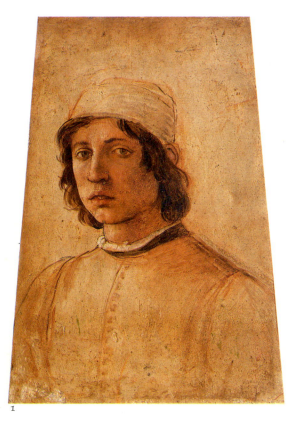

1

Filippino Lippi ?
Prato 1457 – 1504 Florence
Self-portrait
Fresco on ceramic, 50 × 31 cm
Inv.no.1711
It is difficult to judge the original
function of this portrait, which,
though painted in fresco on plaster,
does not appear to have been
removed from a larger composition
(see also Filippino's portrait of an old
man, p.66, for this technique). The
nervous directness of the gaze and the
similarity to a portrait head in Filippi-
no's Santa Maria del Carmine frescos
has led to the suggestion that this
work is a self-portrait, though more
solid evidence for this is lacking.

The son of Filippo Lippi, during the first ten years of his activity
(c1472-82) Filippino was heavily influenced by Botticelli, but if
anything his works are characterized by a more light-hearted
sweetness. With his completion of the fresco cycle begun by Masaccio
in the Brancacci chapel, he showed himself to be singularly capable of
imitating the style of other artists, a fact that has long intrigued
scholars. The so-called 'self-portrait' in the Uffizi, acquired in 1771, was
in fact formerly believed to be a self-portrait by Masaccio and was
copied as such by Manet. More recently, it has been suggested that it
may actually be by a very able eighteenth-century imitator.

The arrival in Florence in 1483 of the extraordinary triptych by
Hugo van der Goes (see pp.202–203) triggered Filippino's search for a
style of his own: from that date, deeper colours, greater solidity in the
figures, and a vigorous approach to landscape began to appear in his
work. The *Madonna degli Otto* (1486) is also inspired, however, by the
novelty and subtlety of Leonardo's early works, especially in the upper
part of the apse, with its flying angels in half-shade.

Filippino later spent a period in Rome (1488-93), absorbing antique
influences that were further to complicate his œuvre, aspects of which
have been interpreted as 'proto-Mannerist' and even 'proto-Baroque'.
Certainly, his works testify to a bizarre and exuberant theatrical taste,
but one nonetheless of high quality.

The Adoration of the Magi (1496) was painted as a replacement for
Leonardo's uncompleted work of the same title (1481, see p.71) for the
church of San Donato agli Scopeti, and Leonardesque influences are
apparent in the vortex of agitated figures rotating around the sacred
group. In the background, behind the tattered, rustic canopy, animated
groups of horsemen converge from all corners of an equally animated
landscape. Also included are portraits of those Medici who had given
their support to Savonarola's Republic. Filippino's palette describes a
brooding, stormy air, shot through by a new pathos, and the whole
gathered into a symphonic vibrato.

The small *Allegory*, with its distant view of a city half obscured by
an insalubrious fog, is another allusion to the turbulent political climate
of Florence at the end of the century, a city poisoned by ideological
and civil battles.

2

Filippino Lippi
Prato 1457 – 1504 Florence
The Madonna degli Otto, dated 1486
Tempera on panel, 355 × 255 cm
Inv.no. 568

This large, arch-topped composition was painted for the great hall of the Two Hundred on the first floor of the Palazzo della Signoria in Florence. It was later removed to the Sala degli Otto di Pratica from which its present name derives. The specifically Florentine civic context of the commission is reinforced by the choice of the especially 'Florentine' saints John the Baptist, Zenobius, Victor and Bernard, while the arms of the Commune appear on the shield above the Virgin's head.

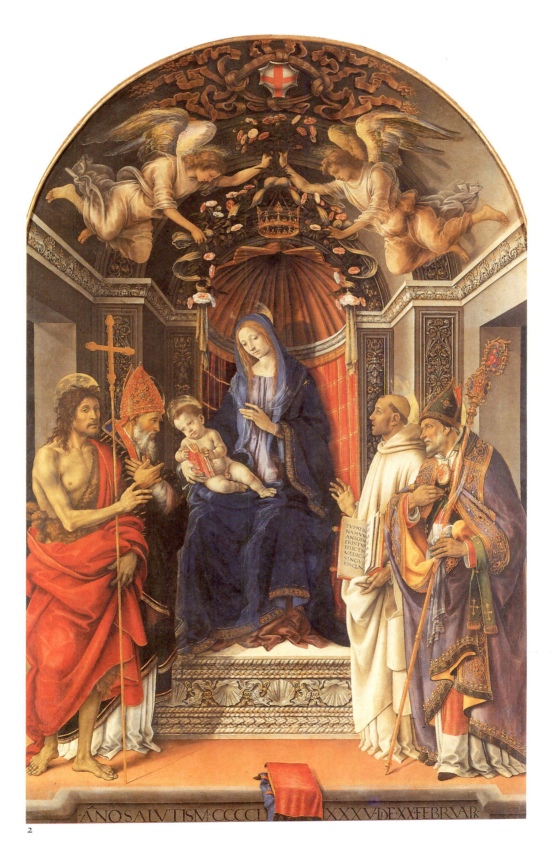

2

1
Filippino Lippi
Prato 1457 – 1504 Florence
The Adoration of the Christ Child
Oil on panel, 96 × 71 cm
Inv.no.3246

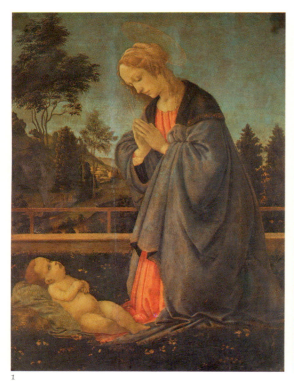

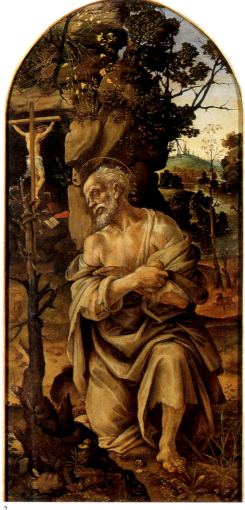

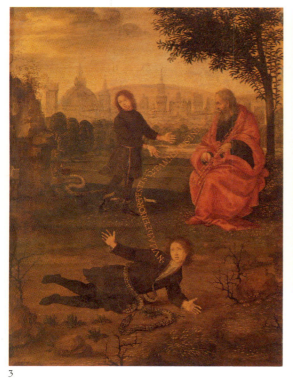

1

2

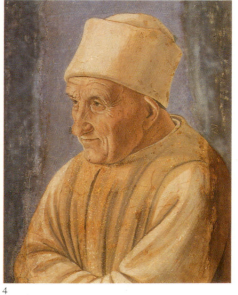

3

4

4
Filippino Lippi
Prato 1457 – 1504 Florence
Portrait of an old man
Fresco on tile, 47 × 38 cm
Inv.no.1485

2

Filippino Lippi
Prato 1457 – 1504 Florence
St Jerome in penitence
Oil on panel, 136 × 71 cm
Inv.no.8652

3

Filippino Lippi
Prato 1457 – 1504 Florence
Allegory
Oil on panel, 29 × 22 cm
Inv.no.8378
Once attributed to Leonardo, this
curious panel has been variously

described as depicting Laocöon and
his sons killed by serpents during the
siege of Troy, or, perhaps more
plausibly given the Florentine land-
scape, as an allegorical treatment of
poisonous factional rivalry between
citizens.

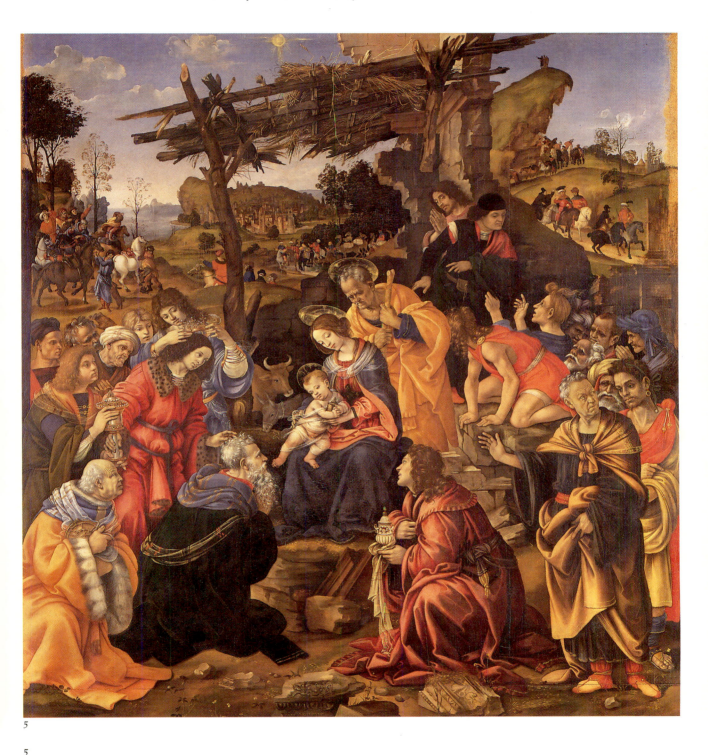

5

5

Filippino Lippi
Prato 1457 – 1504 Florence
The Adoration of the Magi, signed and
dated 1496
Oil on panel, 258 × 143 cm

Inv.no.1566
Commissioned by the monks of San
Donato a Scopeto to replace the
unfinished picture by Leonardo of the
same subject (see p.71), Filippino's
Adoration registers the impact of

Leonardo's ideas. The pyramidal
composition, complex figure group-
ings and elaborate background
interest clearly recall Leonardo.

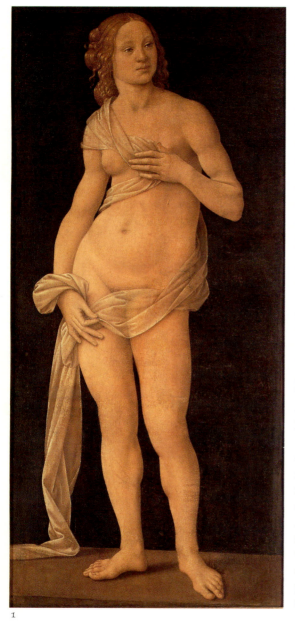

1

1
Lorenzo di Credi
Florence 1459 – 1537 Florence
Venus
Oil on canvas, 151 × 69 cm
Inv.no.3094

Like Pollaiolo, Verrocchio was a goldsmith turned sculptor, but whereas Pollaiolo's style was aggressive, his depictions full of tension, and his forms always defined in terms of energy, Verrocchio experimented instead with the fusion of figures with their surroundings noting with great sensitivity the slightest nuance of light and the most fleeting physical and psychological changes registered by it. His marble bust of a lady with a posy of flowers in the Bargello is a masterpiece that is perfectly representative of his art. The question of Verrocchio's output as a painter, however, continues to be problematic, given the presence in his workshop of a number of outstandingly talented youths who were allowed great freedom of initiative: these included not just the young Leonardo but also Lorenzo di Credi, his most faithful pupil, as well as Perugino and Botticini. It seems likely that Botticelli and Ghirlandaio also worked there at one time or another. Around 1475, therefore, Florence was home to a Verrocchio-inspired 'mode', a painting style expressing a refined aristocratic sensibility that was perfectly attuned to the tastes of Lorenzo the Magnificent's court.

Verrocchio, unlike the imperious and jealous Pollaiolo, was unconcerned about guarding his own signature. Despite its attribution to him, even the *Baptism of Christ* shows signs of having been a collaborative effort: the figures of the Baptist and Christ seem certainly to owe their conception to Verrocchio, yet the former has a fleshless appearance owing to its unfinished state, while the latter must have been repainted by Leonardo. Leonardo's hand is further apparent not only in the sweet-faced angel on the left, but in the flooded, misty landscape as well.

Verrocchio's influence can be seen in other works in the same room of the Uffizi, but in a more indirect way. Botticini's *Three archangels* move through their painted space in a way that recalls Verrocchiesque models, while his St Michael in armour shares the same lithe, page-like elegance of his master's bronze statue of *David*. Leonardo's *Annunciation* is also indebted to Verrocchio, although certain characteristics unique to the younger painter's art are here already visible: the scientific 'truth' of the angels' wings, the botanical realism of the lush grass and the trees in the background, the distant view of a port and a mountain peak, and the way this succession of planes is echoed in the multiple layers of the Virgin's drapery.

In his cartoon for the uncompleted *Adoration of the Magi* (1482), however, Leonardo has abandoned any attempt to merge his figures with their surroundings, allowing any fifteenth-century sense of order and containment to be swept aside by a new and overwhelming visionary *furore*, violating the usual iconography.

Leonardo's *Adoration* brings us to the grandiose classicism and commanding ideals of sixteenth-century art. The bizarre and whimsical imaginings of Piero di Cosimo in the same room, on the other hand, are still firmly anchored to the fifteenth century.

**Andrea del Verrocchio and
Leonardo da Vinci**
Florence 1435 – 1488 Venice;
Vinci 1452 – 1519 Amboise
The Baptism of Christ
Oil on panel, 180 × 152 cm
Inv.no.8358

This panel, which comes from the
Florentine church of San Salvi, is one
of the few paintings that can be
securely attached to the name of
Verrocchio. However, the hands of his
pupils are also apparent in the *Baptism*.

Clear evidence of a distinct hand,
noted by Vasari, is in the painting of
the angel, for example, to the far left
whose otherworldly grace, elegant
torsion and *sfumato* reveal the work of
the young Leonardo.

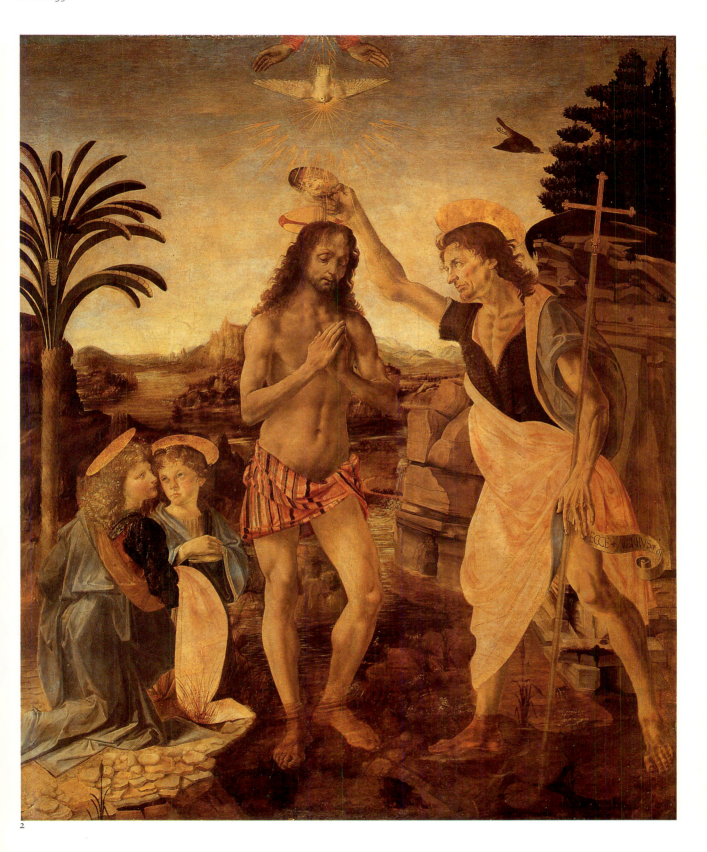

2

1, 1A

Leonardo da Vinci
Vinci 1452 – 1519 Amboise
The Annunciation
Oil on wood, 98 × 217 cm
Inv.no.1618
In this early painting Leonardo can be seen making some changes to the traditional ways in which this very common subject was presented, while the *all'antica* decoration of the Virgin's reading desk recalls the sculptural work of his teacher Verrocchio. The Virgin's mantle was apparently the product of an elaborate drapery study designed to record in great detail effects of light falling on material. It is similar in this respect to Leonardo's angel in the San Salvi *Baptism* (p.69). The background landscape, seen through an atmospheric haze or film, is already wholly 'Leonardesque'.

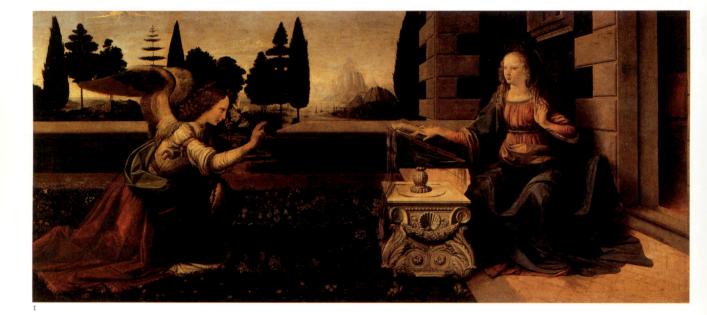

1

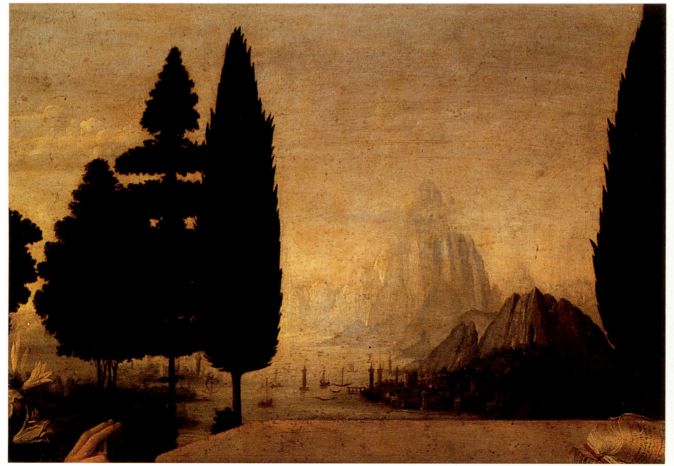

1A

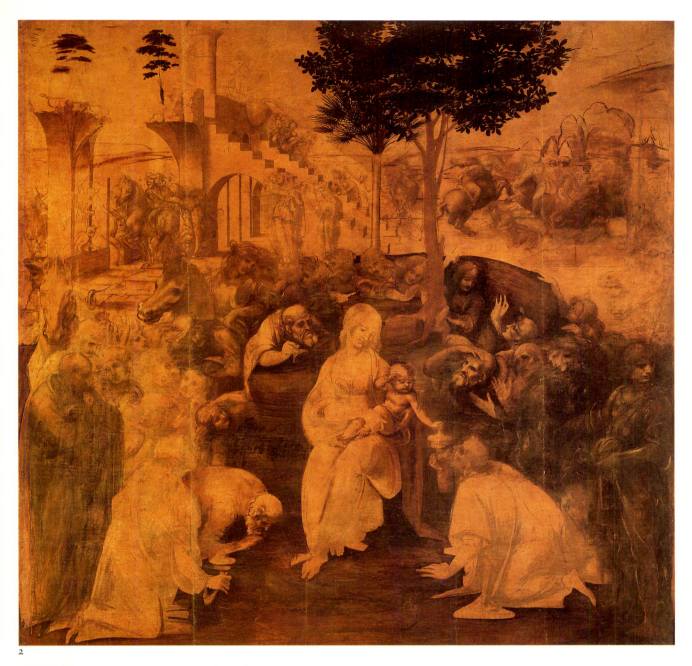

2

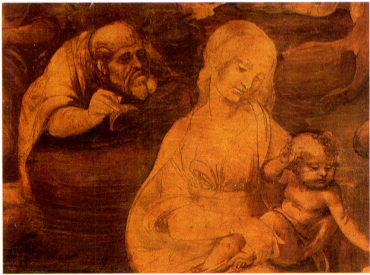

2A

2, 2A
Leonardo da Vinci
Vinci 1452 – 1519 Amboise
The Adoration of the Magi
Tempera and oil on panel,
243 × 246 cm
Inv.no.1594
This unfinished painting, seen by
Vasari in the house of Amerigo Benci,
was commissioned by the monks of
San Donato a Scopeto in March 1481.
For a work which is little more than an
elaborate underpainting without
colouring, it is extraordinarily innova-
tive in terms of compositional soph-
istication, richness of detail and
psychological acuteness. It marks a
significant creative leap even in a
period of rapid artistic development.

1

2

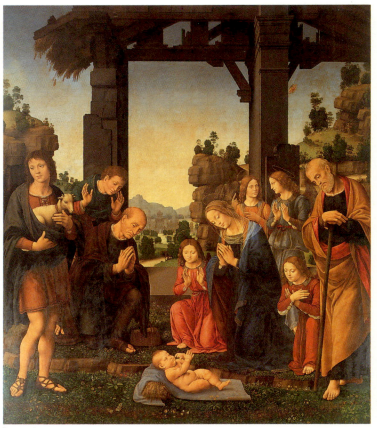

3

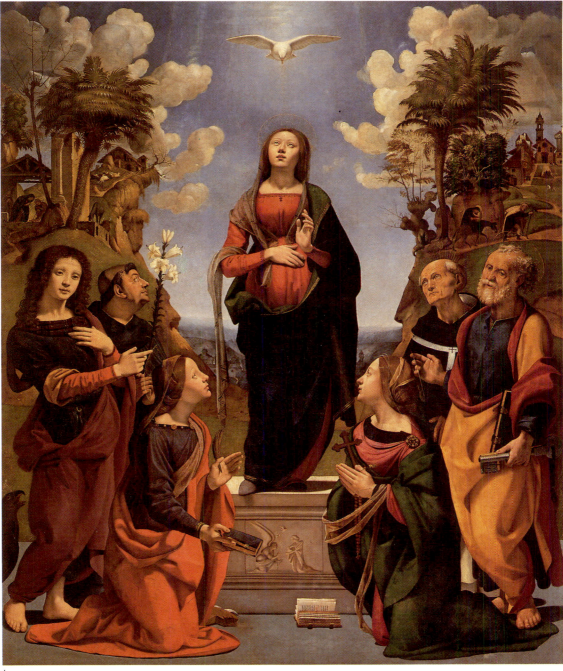

4

1

Piero di Cosimo
Florence? 1461/2 – 1521 Florence
Andromeda saved by Perseus
Oil on panel, 66 × 152 cm
Inv.no.510
The panel formed part of a series of
paintings illustrating the myth of
Perseus and Andromeda made by
Piero di Cosimo to decorate a room in
the Strozzi palace in Florence. They
were commissioned by Filippo Strozzi
probably around 1515.

2

Lorenzo di Credi
Florence 1459? – 1537 Florence
The Annunciation
Oil on panel, 88 × 71 cm
Inv.no.1597

3

Lorenzo di Credi
Florence 1459? – 1537 Florence
The Adoration of the Shepherds
Oil on panel, 224 × 196 cm
Inv.no.8399
The considerable technical finesse of
this painting is made possible partly
through the use of oil, which had
already overtaken egg tempera as the
principal paint medium.

4

Piero di Cosimo
Florence? 1461/2 – 1521 Florence
The Incarnation with saints
Oil on panel, 206 × 172 cm
Inv.no.506
This altarpiece was made for the
Tebaldi chapel in Santissima Annun-
ziata in Florence. The main light
source within the picture emanates
from the Holy Spirit above the head
of the Virgin. Her pedestal contains an
image of the Annunciation, referring
to Christ's Incarnation.

Signorelli

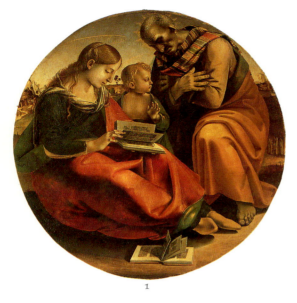

1

Luca Signorelli
Cortona *c*1445 – 1523 Cortona
The Holy Family
Oil on panel, diameter 124 cm
Inv.no.1605
This *tondo* once hung in the audience
hall of the Captains of the Guelph
Party in Florence where it was men-
tioned by Vasari. The composition of
the painting with its close-knit, monu-
mental figures of the seated Virgin,
Joseph and the Christ Child seems to
prefigure Michelangelo's Doni *tondo*
(see p.83).

A pupil of Piero della Francesca, Signorelli nevertheless evolved a
strongly expressive, vigorous personal style which was forceful in
tone and sometimes even emphatically so. The vulgarization of his
style carried out by assistants employed to help fulfil his many
commissions was not something that troubled him (his later works
show increasing signs of sloppy workshop intervention). The *tondo*
now in the Uffizi, painted for a Medici villa (around 1490), has close
ties with Florentine humanist culture yet does not have the dream-like
detachment so often associated with that milieu. The Virgin sits on the
ground playing with the Child, as in a traditional Virgin of Humility,
but the two figures are twisted round in *contrapposto*, their vital energy
finding an immediate echo in the background in the wiry nakedness of
the shepherds, who clearly allude to antique models, in the classical
ruins, as well as in the remarkable arch of rock that forms a matching
'ruin', this time of natural origin. The whole is painted in austere,
almost steely colour harmonies that blend with the monochrome
frame in which more figures are depicted.

In the later *tondo* of the *Holy Family*, almost all of the available space
is occupied by solid, bulky figures crammed inside the picture frame,
while the two open books function as perspectival parameters. In their
overpowering grandeur and in the stern thoughtfulness of the sacred
group, as well as in the nostalgic counterpoint of pagan sensuality in
the background, these two *tondi* seem to look forward to
Michelangelo's Doni *Holy Family* (see p.83).

The *Crucifixion with St Mary Magdalen* provides a good indication of
the range of effects of which Signorelli was capable. One particular
mark of this is the macabre skull, with its echoes of Northern
prototypes, between whose jaws a lizard is poised, and the
contrastingly pretty wreath of little flowers around the base of the
crucifix. The Santa Trinita altarpiece is a late work, painted for
Cortona, Signorelli's birthplace and the city to which he returned in
old age to live out the last years of his career in an active but declining
provincialism. It has a somewhat oppressive, yet still powerful
monumentality.

Luca Signorelli and Pietro Perugino
Cortona *c*1445 –
1523 Cortona; Citta della Pieve
*c*1448 – 1523 **Fontignano**
Crucifixion with saints
Oil on panel, 203 × 180 cm
Inv.no.3254

Vasari says this altarpiece was made by Perugino for the church of San Giusto in the convent of the Gesuati just outside Florence. When the church was demolished during the siege of Florence in 1529 it was moved, like Ghirlandaio's *Madonna and child with saints and angels* (p.62),

to San Giovannino. The hand of Signorelli, who was working with Perugino at the time of the commission, is clearly distinguishable in the figure of St Jerome to the left and in the kneeling Magdalen.

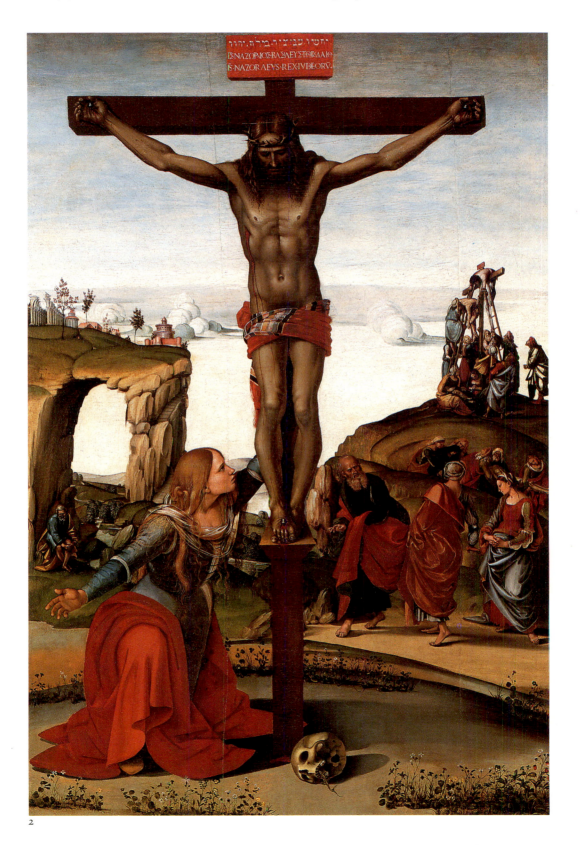

2

1

Luca Signorelli
Cortona *c*1445 – 1523 Cortona
The Virgin and Child with Prophets and
St John the Baptist
Oil on panel, 170 × 117.5 cm
Inv.no.502

According to Vasari this highly
original work was painted for Pier-
francesco di Lorenzo de' Medici who
hung it in his villa at Castello. The
painting combines a large *tondo* of the
seated Virgin and Child with fictive
roundels containing monochrome

figures of Prophets and a small bust of
St John the Baptist. This combination
of the illusionistic and the deliberately
fictive is reminiscent of Signorelli's
famous frescos in Orvieto cathedral.

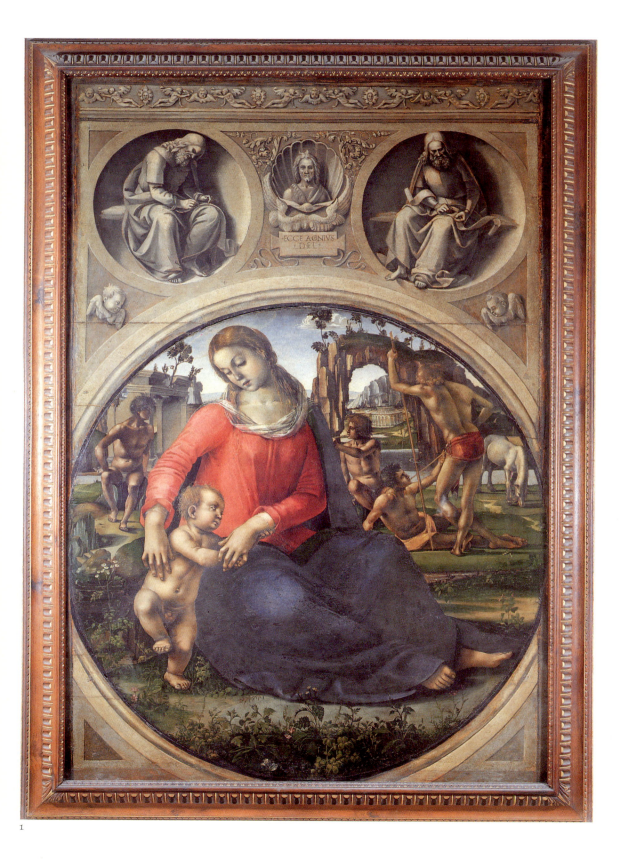

1

Luca Signorelli
Cortona c1445 – 1523 Cortona
The Trinity, the Virgin and two saints
Oil on panel, 272 × 180 cm
Inv.no.8369

Commissioned for the Confraternity of the Trinity of the Pilgrims in Signorelli's native town of Cortona, the work was removed from the church of Santa Trinità in 1810. The Trinity of God the Father, the Son and the Holy Spirit appear above the Virgin and Child, flanked by arch-angels, while the massive forms of seated bishop saints, with their open books in foreshortening, occupy the foreground.

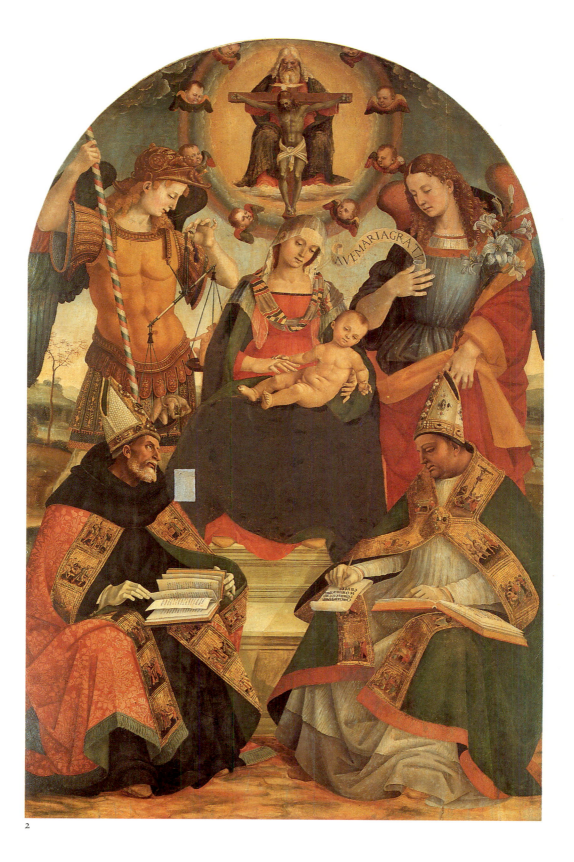

2

Perugino

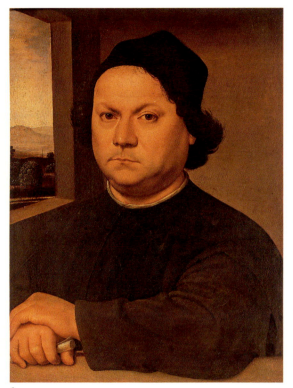

1

1

Lorenzo di Credi
Florence 1459? – 1537 Florence
Portrait of Pietro Perugino
Oil on panel, 51 × 37 cm
Inv.no.1482
At various times this painting has
been thought to be a portrait of
Verrocchio and even a portrait of
Luther by Holbein. The idea that the
sitter was the painter Perugino dates
from the beginning of this century.
The mistaken attribution to Holbein is
explained by the strong Northern
influence evident in this portrait.
Elements like the hands resting on a
parapet with an angled view through
a window to a landscape seem to
derive from a familiarity with the
work of artists such as Dieric Bouts
and Hans Memling.

There are a number of close parallels between the lives of Perugino
and Signorelli. Both were born in the area around Lake Trasimeno,
between Tuscany and Umbria, in the mid-fifteenth century and both
died in 1523. Both were pupils of Piero della Francesca, but completed
their training within the sphere of the Florentine school. Both were
called upon to work on the frescos for the Sistine Chapel (1482),
alongside Botticelli and Ghirlandaio. They were both highly esteemed
and in great demand in Florence during the last twenty years of the
fifteenth century. After reaching the height of their powers around
1500, both entered a long period of repetitiveness and decline.

But there the comparisons end, for in temperament the two were at
opposite poles. Perugino's works communicate a contemplative and
'angelic' message, while those of Signorelli are inspired by something
like the energetic force of Dante's *Hell*. Perugino was a very successful
artist; in 1500 a sophisticated plutocrat and patron, Agostino Chigi,
declared him to be 'the best master in Italy'. Vasari speaks of a
Peruginesque fashion which, before the growth in popularity of the
Michelangelesque style, attracted even foreign adherents and enjoyed
a good market internationally. Raphael's art grew out of that of
Perugino.

Perugino's approach is based on symmetry, analogy, mediation, the
achievement of a generic ideal and perfect equilibrium. The synthesis
he provides seems eternal and not the result of a conciliation of thesis
and anti-thesis. A demonstration of this is in the Uffizi *Virgin and Child
with saints*, where the two standing figures are aligned with that of the
Virgin, who sits above them on a pedestal, and where the sensuality of
St Sebastian is toned down. In another example, the *Pietà*, the form of
the vault with lunettes is inferred in the figures in the foreground, and
echoed yet again in the figures under the portico, while the two saints
standing slightly further back introduce the perspectival vista of
receding pilasters. In the background, the barest hint of a boundless
sky veiled by a late-evening light confers the impression of space and
communicates a mystical sense of infinity.

Quite different qualities are evident in the portrait of Francesco delle
Opere (1494), where the intensely vivid appearance suggests it was
painted from life. The sitter's eyes and mouth have a troubled
expression and his hair forms a ruffled halo around the face, while his
hands – the hands of a skilled craftsman – are held before his chest in
masterly foreshortening. Behind him is a lakeland landscape with light
blue tones fusing with those of the sky. It is a work that carries on
where Verrocchio had left off and looks forward to the portraiture of
Raphael. Although he tends to be less favoured by present-day
criticism, Perugino is nonetheless an important link in Florentine as
well as Umbrian painting, his œuvre forming a bridge from the
fifteenth century to the sixteenth-century work of Fra Bartolomeo and
Albertinelli.

Pietro Perugino
Città della Pieve *c*1448 –
1523 Fontignano
Pietà
Oil on panel, 168 × 176 cm
Inv.no.8365

This panel, like the *Crucifixion* (see
p.75), was painted for the convent of
San Giusto where Perugino was
working in the mid-1490s. The body
of the dead Christ is supported by St
John the Evangelist, the Virgin and
Mary Magdalen.

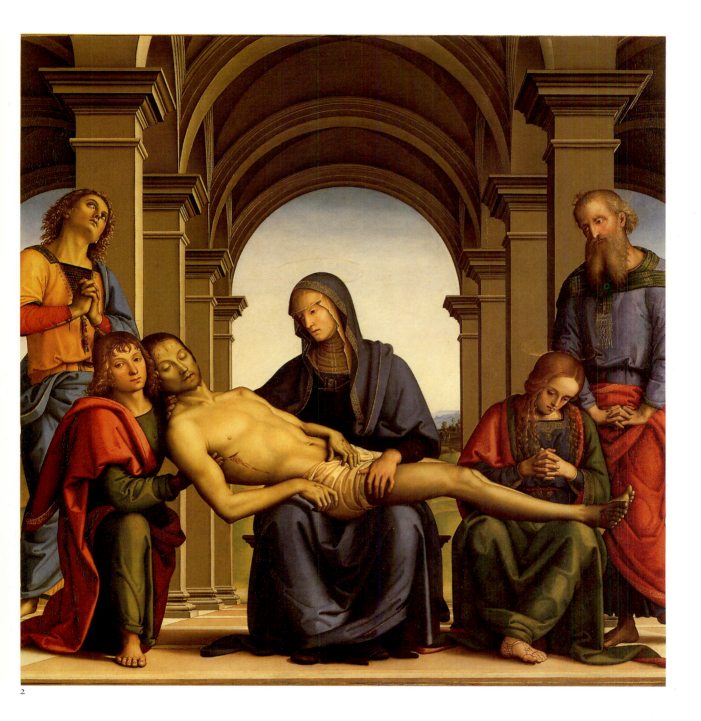

2

1

Pietro Perugino
Città della Pieve *c*1448 –
1523 Fontignano
Madonna and Child with saints, 1493
Tempera on panel, 178 × 164 cm
Inv.no.1435

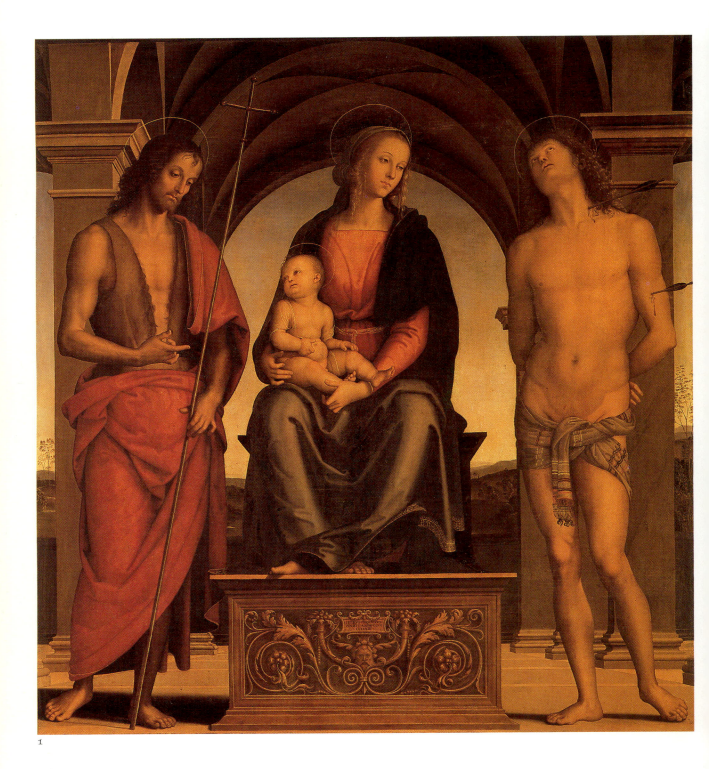

1

2

Pietro Perugino
Città della Pieve *c*1448 –
1523 Fontignano
Portrait of Francesco delle Opere,
signed and dated on the reverse 1494
Oil on panel, 52 × 44 cm
Inv.no.1700

The sitter has been identified through
an inscription on the back of the
panel. The presentation of the sitter,
slightly out of full face, with his hands
resting on the frame and in front of a
landscape, is Netherlandish in inspira-
tion, reflecting particularly the work
of Hans Memling. The moralising

inscription on the note held by the
sitter reminds the spectator to 'fear
God'.

2

1A

1, 1A
Michelangelo Buonarroti
Caprese 1475 – 1564 Rome
The Holy Family with the infant St John
the Baptist (the Doni *tondo*)
Tempera on panel, diameter 120 cm
Inv.no.1456

The beginning of the sixteenth century in Florence might be compared to the dawning of a new day after the passage of a great storm. Political domination by the Medici ended, temporarily at least, when they were driven out of Florence and exiled from 1494 to 1512. The interlude of religious fanaticism led by Savonarola had ended with the preacher being burnt at the stake in 1498. Artists, too, had participated in the public burning of 'vanities', discarding those paintings which relied too heavily on sophisticated and precious stylistic formulas, and had begun searching instead for a simplified and convincing classicism that was capable at the same time of absorbing the innovations of Leonardo and Michelangelo. Both these artists had returned to Florence in the early years of the century, rivalling each other as leaders of alternative artistic currents.

Michelangelo's Doni *tondo* (1504-06) has little need of comment: it has the crystalline quality of an idea well expressed, its shrill, sharp colours emitting a brilliant magnificence. The *contrapposto* articulation and plastic tension of the group of the Holy Family suggests an enduring moral and conceptual loftiness. Further elaboration of such a powerful message had to wait for a later generation of painters: that of the first Mannerists.

To the intervening years belongs Fra Bartolomeo's *Apparition of the Virgin to St Bernard*, in which two groups of figures stand in awe and trepidation before a boundless landscape of dewy freshness that has parallels with contemporary Venetian painting. In the same way, Albertinelli's *Visitation* surpasses Perugino with its greater monumentality and chromatic warmth, the latter now achieved tonally.

Recent years have seen a greater appreciation of early sixteenth-century Florentine painting, as the Andrea del Sarto exhibition in 1977 demonstrated. His is a style that owes something to Raphael, too, reflecting the harmonious pictorial values of Florentine works executed during his stay there between 1504 and 1508. To his contemporaries, Andrea del Sarto seemed like another Raphael, but one who had deliberately retreated into a minor, more domestic key. Yet with what subtlety and refinement did he pursue his ideal of propriety 'without error'! In his *Madonna of the Harpies*, the architectural setting is kept simple, essential, yet evokes an atmosphere of solemnity. The Virgin is raised on a pedestal like a statue but conserves her modest human sweetness, while on the step below her stand the two saints, their lofty yet gentle dignity intact despite the narrowness of the space they occupy. A hint of disquiet is introduced to the 'romantic classicism' of this painting by the two small angels in the shadows, and by the Harpies carved into the pedestal which seem in the act of coming to life. Andrea's two pupils, Pontormo and Rosso, were to exaggerate this sense of unease in the explosive contortions of their early Mannerist style.

One of very few panel paintings surviving by Michelangelo, this recently cleaned work is in almost perfect condition. It belonged to the Doni family at an early date and the presence of Strozzi arms on the frame has led to the suggestion that it was commissioned in 1503/4 for the wedding of Agnolo Doni to Maddalena Strozzi, though it may have been made for the birth of a first child.

1

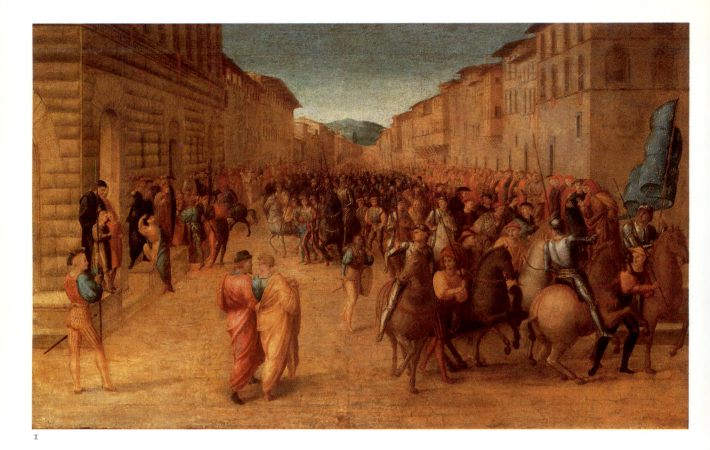

1

1

Francesco Granacci
Florence 1477 – 1543 Florence
Charles VIII entering Florence
Oil on panel, 76 × 122 cm
Inv.no.3908
Charles VIII of France entered
Florence in 1494. This painting,
however, was executed later, perhaps
on the occasion of the marriage of
Lorenzo de' Medici, Duke of Urbino,
in 1518. The 15th-century Medici
Palace in the former via Larga appears
to the left of the picture.

2

Fra Bartolomeo
Savignano 1472 – 1517 Florence
The Annunciation
Monochrome on panel, left-hand
panel 19.5 × 9 cm; right-hand panel
18 × 9 cm
Inv.no.1477
The unusual form of these small
monochrome panels derives from the
fact that they were intended to flank a
piece of sculpture. Vasari says that
they were commissioned by Piero del
Pugliese to frame a relief of the Virgin
and Child by Donatello. On the other
side of the panels, which must have
been able to fold inwards, are pictures
of the *Nativity* and *Circumcision.*

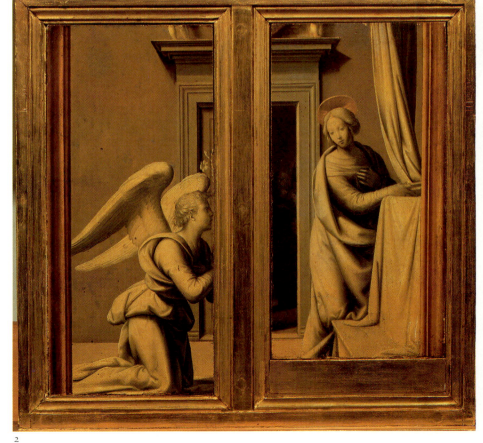

2

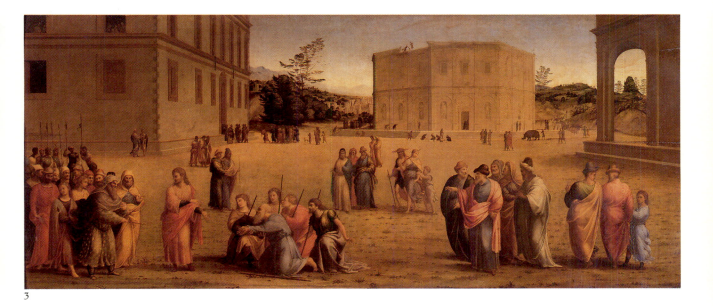

3

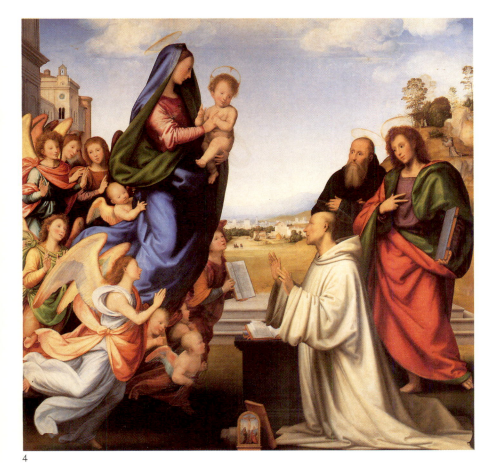

4

3
Francesco Granacci
Florence 1477 – 1543 Florence
Joseph presenting his father and brothers to Pharaoh
Oil on panel, 95 × 224 cm
Inv.no.2152
Granacci's panel was one of a series illustrating the life of the Old Testament figure Joseph that also included paintings by Andrea del Sarto, Pontormo and Bachiacca. This ambitious programme of small paintings, made in about 1515, was commissioned by Pier Francesco Borgherini for the decoration of his wedding chamber. This panel shows Joseph interceding with Pharaoh on behalf of his father and brothers who, having persecuted Joseph, threw themselves on his mercy when threatened by famine.

4
Fra Bartolomeo
Savignano 1472 – 1517 Florence
The vision of St Bernard, 1504–07
Oil on panel, 215 × 231 cm
Inv.no.8455

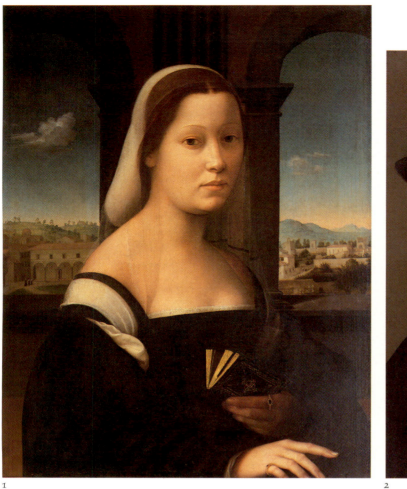

1

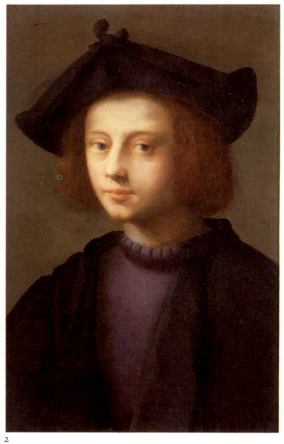

2

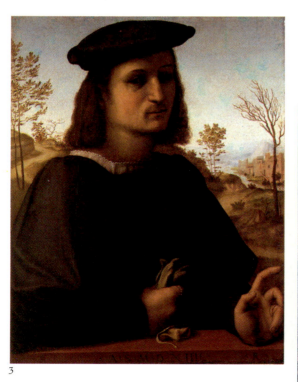

3

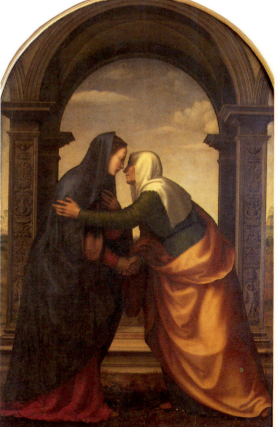

4

1
Giuliano Bugiardini
Florence 1476 – 1555 Florence
Portrait of an unknown woman
Oil on panel, 65 × 48 cm
Inv.no.8380

2
Domenico Puligo
Florence 1492 –1527 Florence
Portrait of Piero Carnesecchi
Oil on panel, 59.5 × 39.5 cm
Inv.no.1489

3
Francesco Franciabigio
Florence 1484 – 1525 Florence
Portrait of a young man, signed and
dated 1514
Oil on panel, 60 × 47 cm
Inv.no.8381; Galleria Palatina 43

4
Mariotto Albertinelli
Florence 1474 – 1515 Florence
The Visitation, dated 1503
Oil on panel, 232 × 146 cm
Inv.no.1587
This monumental and moving
depiction of the meeting of the Virgin
and St Elizabeth was painted for a
church dedicated to St Elizabeth in
Florence. The altarpiece was appar-
ently designed by Fra Bartolomeo,
whose preparatory drawings survive,
but executed by Albertinelli, with
whom he shared a workshop.

5
Andrea del Sarto
Florence 1486 – 1530 Florence
Portrait of girl with a volume of
Petrarch
Oil on panel, 87 × 69 cm
Inv.no.783
Andrea's unidentified subject is shown
presenting her text to the spectator
with unprecedented directness. The
legible script reveals the book to
contain love sonnets by Petrarch and
thus helps to suggest the context for
the sitter's intimate glance.

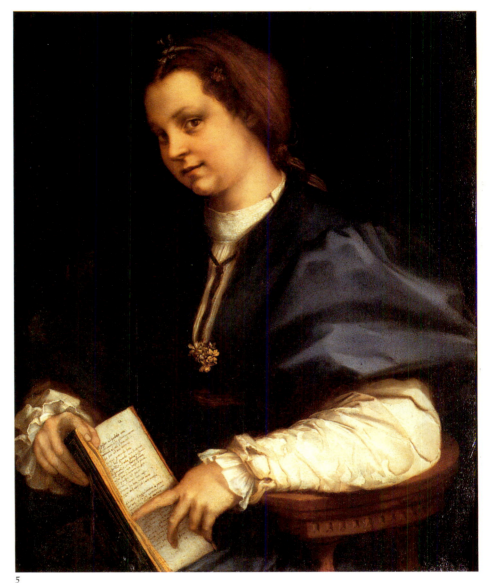
5

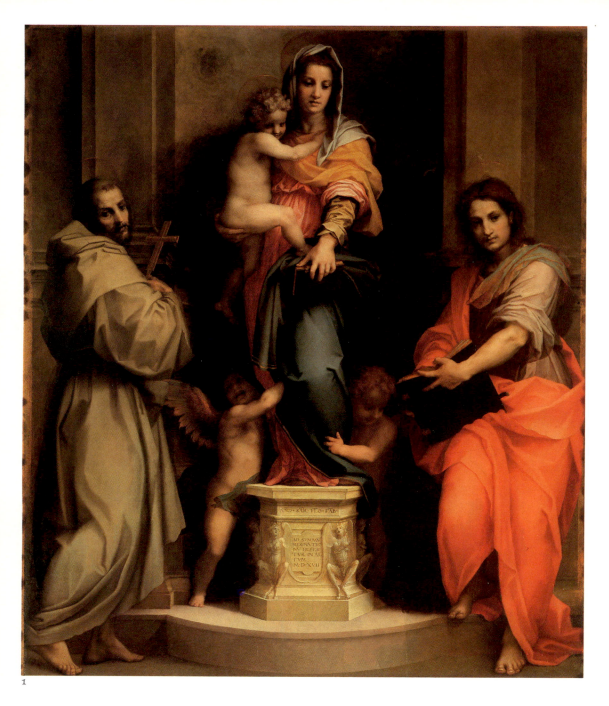

1

1
Andrea del Sarto
Florence 1486 – 1530 Florence
'The Madonna of the Harpies', signed
and dated 1517
Oil on panel, 207 × 178 cm
Inv.no.1577
Painted in 1515–17, this celebrated
work is named after the winged
creatures that adorn the Virgin's
pedestal.

2
Andrea del Sarto
Florence 1486 – 1530 Florence
*Sts Michael, Giovanni Gualberto, John
the Baptist and Bernardo degli Uberti*,
dated 1528
Oil on panel, 184 × 172 cm
Inv.no.8395

3
Andrea del Sarto
Florence 1486 – 1530 Florence
St James
Oil on canvas, 159 × 86 cm
Inv.no.1583

4
Andrea del Sarto
Florence 1486 – 1530 Florence
Self-portrait
Fresco on tile, 51.5 × 37.5 cm
Inv.no.1694

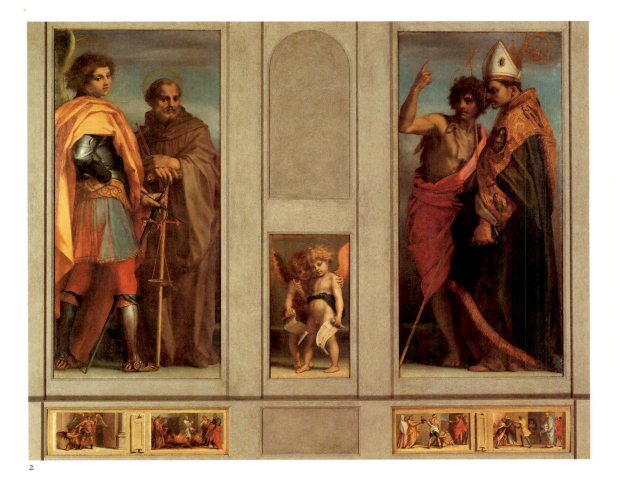

2

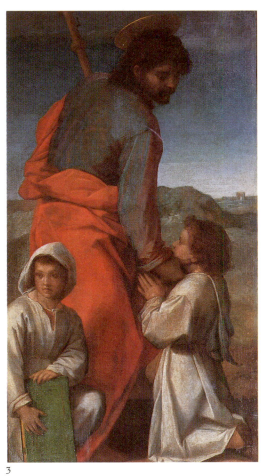

3

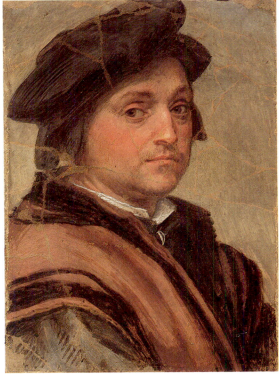

4

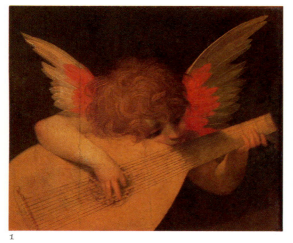

1

1
Rosso Fiorentino
Florence 1495 – 1540 Fontainebleau
Cherub making music
Oil on panel, 47 × 39 cm
Inv.no.1505

2
Rosso Fiorentino
Florence 1495 – 1540 Fontainebleau
Moses defending the daughters of Jethro
Oil on canvas, 160 × 117 cm
Inv.no.2151
This extraordinary canvas was made
for Giovanni Bandini, probably in
1523. Rosso has used the subject as a
self-conscious exercise in heroic
composition and the depiction of the
nude male, at least partly inspired by
Michelangelo's famous cartoon for
The battle of Cascina. Moses, at the
centre of the composition, is shown
striking down the Midianite shep-
herds who had driven Jethro's daugh-
ters from the well.

Between 1510 and 1520, a younger generation of artists began to
challenge the austerity of Fra Bartolomeo and the sensitive yet
restrained style of Andrea del Sarto with an approach that was instead
unorthodox, questioning, aggressive and highly intellectual. This
nouvelle vague took its inspiration from the enigmatic style of Leonardo,
from Michelangelo — especially his *Cascina* cartoon (1505) with its
formidably complex structure of foreshortened bodies — and also from
the inimitable peaks of achievement represented by the Roman works
of Michelangelo and Raphael. At the same time, however, these
younger painters had no intention of becoming passive pupils, and
continued instead to search for ways in which to develop their art
further.

From the prints of Lucas van Leyden and Dürer they absorbed
elements extraneous to Italian art, showing awareness also of the
cultural and spiritual nature of the North's polemic with Rome, for
instance in the contrast between the irrationalism of Erasmus and
Ciceronian rhetoric, or Luther's revolt against the Pope.

In his altarpiece for Santa Maria Nuova (1518) Rosso demonstrated
his usual keen painterly sensitivity but now introduced 'cruel and
desperate airs', creating an atmosphere between the satanic and the
ironic, and aiming for a quintessence that would overcome the dualism
that persisted in the Florentine style between design and colour.
Rosso's basic inclination is nevertheless extroverted, cerebral yet
instinctive, with a taste for strong contradictions. His *Moses defending
the daughters of Jethro* shows the unique distillation of classicism that
allowed him to achieve extraordinary effects of abstraction, to invent a
new spatial synthesis (*Schichten-Komposition* — in which perspectival
depth is suggested by the vertical arrangement of parallel planes)
which still looks modern today. Friedländer (1925) defined this brilliant
and sophisticated painting as the most extraordinary phenomenon of
the whole of the Renaissance.

The melancholy of Pontormo is of an equally tormented and
introverted nature. The 'portrait' of Cosimo the Elder, with its waxy,
livid flesh tones, the clasped hands and angular sharpness of outline, is
a truly funerary evocation.

The *Supper at Emmaus* (1525) painted for the refectory of the
Certosa of Galluzzo, where Pontormo retired for four years to paint
haunting lunettes 'in the German style' — that is in the style of Dürer —
also contains references to a print by the German master. But
Pontormo makes his own novel, innovatory additions that anticipate
the work of Caravaggio, Velázquez or Zurbarán: portraits from life of
the Certosa monks, painted in deep shadow; the evangelical simplicity
of the table, the barefoot pilgrims, and the cats and mongrel dogs
crouching underneath. As viewers, we, too, feel ourselves to be part of
the action, witnesses like those monks of 1525 to the Eucharist.

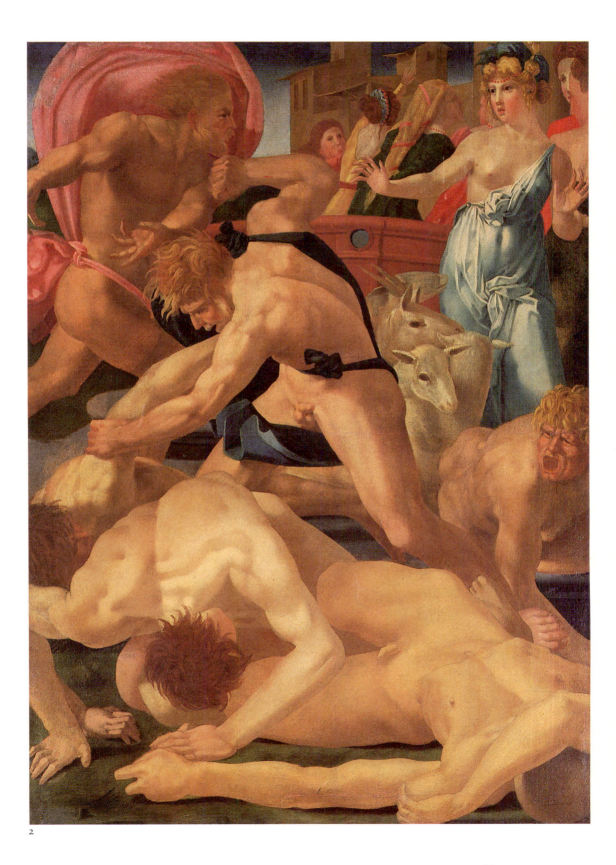

2

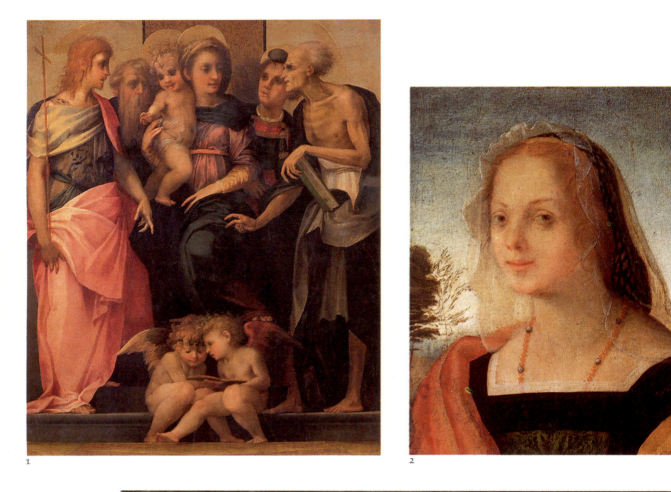

1

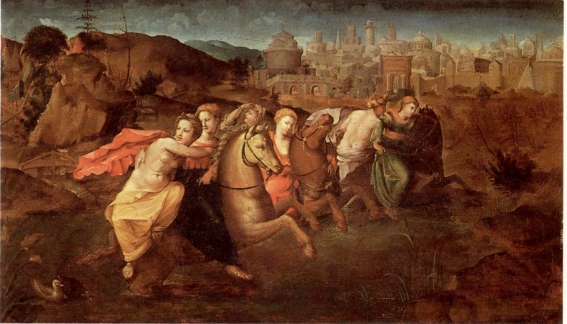

2

3

1

Rosso Fiorentino
Florence 1495 – 1540 Fontainebleau
The Virgin and Child enthroned between
Sts John the Baptist, Anthony Abbot,
Stephen and Jerome, completed in 1518
Oil on panel, 112 × 141 cm
Inv.no.3190
This altarpiece was commissioned for
the church of Ognissanti (whence it
came to the Uffizi) by Leonardo
Buonafede, the director of the hospital
of Santa Maria Nuova in Florence.
According to Vasari, the patron was
unhappy with the depiction of the
saints who he thought looked 'like
devils'. Whether or not this was the
case, we do know that there was a
documented dispute over the price of
the painting that was arbitrated by the
painters Bugiardini and Granacci.

2

Rosso Fiorentino
Florence 1495 – 1540 Fontainebleau
Portrait of a young girl
Oil on panel, 45 × 33 cm
Inv.no.3245

3

Domenico Beccafumi
Valdibiena c1486 – 1551 Siena
The flight of Clelia and the Roman virgins
Oil on panel, 74 × 122 cm
Inv.no.6057
This panel may have decorated a
cassone or wedding chest. The scene
derives from Roman history, as
recounted by Livy, and shows the
young Clelia and other female cap-
tives of king Porsenna escaping back
to Rome.

4

Francesco Bachiacca
Florence 1494 – 1557 Florence
Christ before Caiaphas
Oil on panel, 50.5 × 41 cm
Inv.no.8407
Bachiacca's painting appears to have
been partially based on a composition
of the same subject by Dürer, whose
prints were well known and admired
in Florence in the 16th century. An
inscription on the verso suggests the
picture once belonged to the Corsini
family.

5

Domenico Beccafumi
Valdibiena c1486 – 1551 Siena
The Holy Family with the young St John
the Baptist
Oil on panel, diameter 84 cm
Inv.no.780

4

5

1
Jacopo da Pontormo
Pontorme 1494 – 1556 Florence
Lady with a basket of spindles
Oil on panel, 76 × 54 cm
Inv.no.1480
In this portrait of a well-to-do woman
Pontormo uses the device of strong

directional light falling from behind
the sitter to cast the face partially into
shadow, as he does in the portrait of a
musician. Emphasis is placed on the
sitter's direct gaze and her elegant
hands which play with the contents of
her work basket.

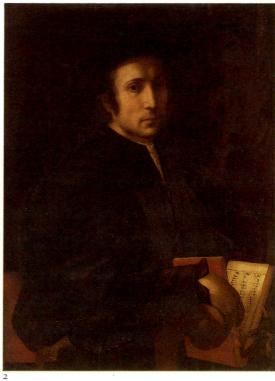

2

1

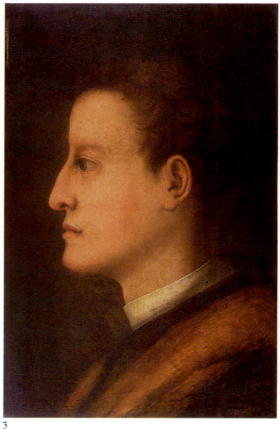

3

2
Jacopo da Pontormo
Pontorme 1494 – 1556 Florence
Portrait of a musician
Oil on panel, 88 × 67 cm
Inv.no.743

3
Jacopo da Pontormo
Pontorme 1494 – 1556 Florence
Profile of Cosimo I as a young man
Oil on panel, 47 × 31 cm
Inv.no.5052
This portrait is perhaps to be assoc-
iated with one that Vasari says Pon-
tormo had made of the young ruler
after his victory at Montemurlo in
1537. He is shown in profile, unusual
for such a late date, and without the
beard which he began to grow in the
same year. A drawing for the portrait
also survives in the Uffizi collection.

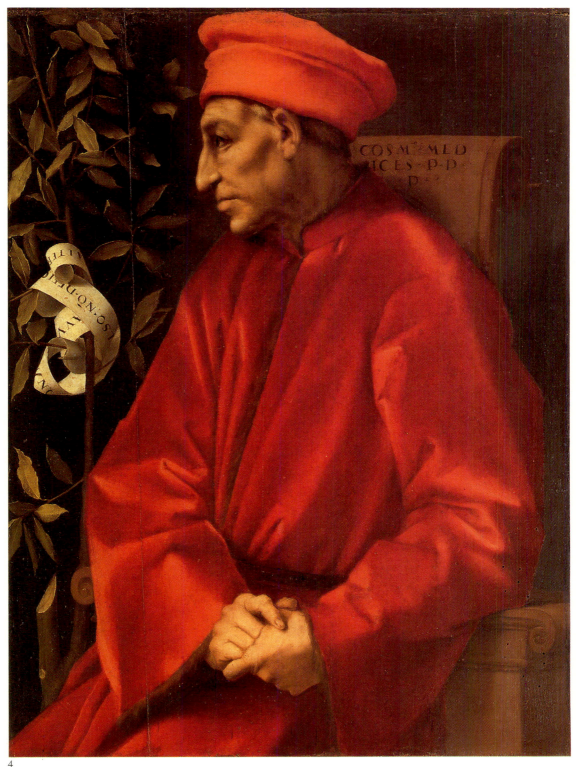

4

4
Jacopo da Pontormo
Pontorme 1494 – 1556 Florence
Portrait of Cosimo il Vecchio de'
Medici
Oil on panel, 86 × 65 cm
Inv.no.3574

This unusual posthumous portrait was
commissioned by Goro Geri, the
secretary of Lorenzo de' Medici, Duke
of Urbino, in about 1519. The portrait
combines the profile convention of the
15th-century portraits of Cosimo with
a more complex, though equally
artificial, half-length seated posture.

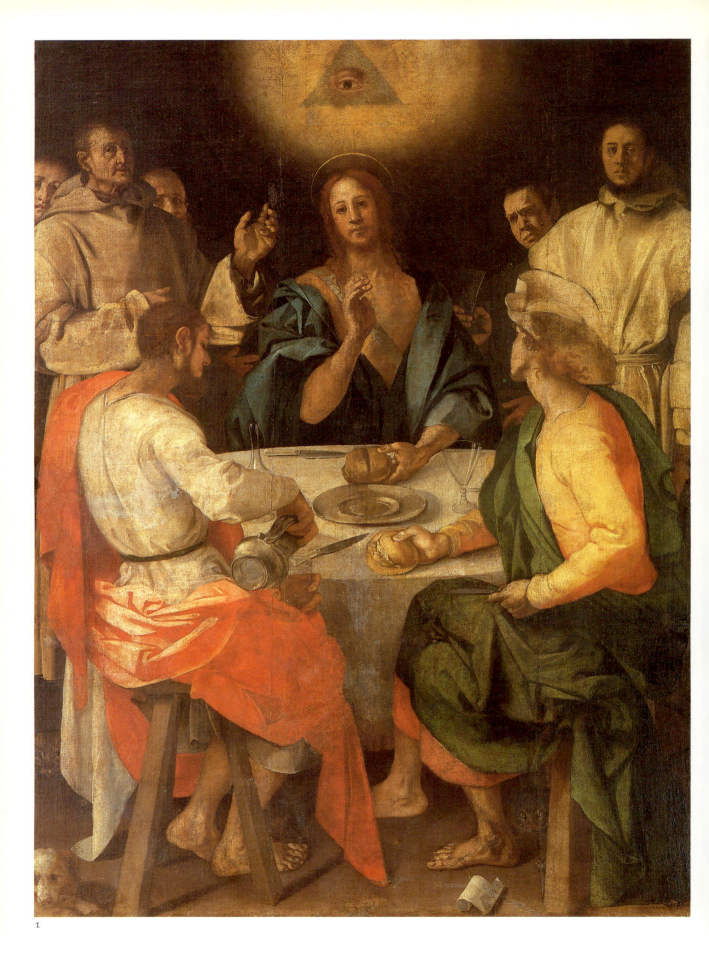

1

Jacopo da Pontormo
Pontorme 1494 – 1556 Florence
The Supper at Emmaus, dated 1525
Oil on canvas, 230 × 173 cm
Inv.no.8740
Dated 1525 on the paper in the
foreground, this painting was made
by Pontormo for the Charterhouse of
Galluzzo, where in the same period he
was painting frescos of the Passion of
Christ. The portrait quality of the
monks standing in the background
was recognised by Vasari who says
they were drawn from those at
Galluzzo. They appear as witnesses to
the revelation of the Risen Christ at
the supper at Emmaus. The symbol
above Christ's head represents the eye
of the Trinity.

2

Jacopo da Pontormo
Pontorme 1494 – 1556 Florence
The birth of John the Baptist
Oil on panel, diameter 59 cm
Inv.no.1532
This dish belongs to the long Floren-
tine tradition of the *desco da parto* or
birth tray which was given to a
mother in celebration of the birth of
her child. The subject matter of the
image confirms the occasion for the
commission. The Della Casa/
Tornaquinci arms on the back of the
dish suggests that the painting was
made to celebrate the birth of
Aldighieri Della Casa in 1526.

3

Jacopo da Pontormo
Pontorme 1494 – 1556 Florence
*Madonna and Child with two saints and
two angels*
Oil on panel, 73 × 61 cm
Inv.no.1538
The composition of this striking
altarpiece seems to owe something to
Rosso's altarpiece for Leonardo
Buonafede (p.92) with its flanking
saints who take up almost the whole
height of the panel, the lively standing
Christ Child and the complementary
poses of the seated putti at the foot of
the throne. However, the sharp
delineation of the figures, the balus-
trade and the tight handling of the
paint is in marked contrast to the
looser brushwork of Rosso's work.

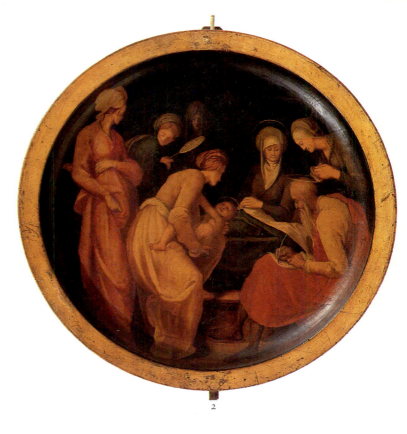

2

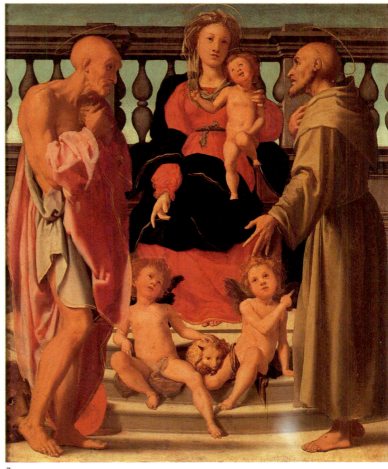

3

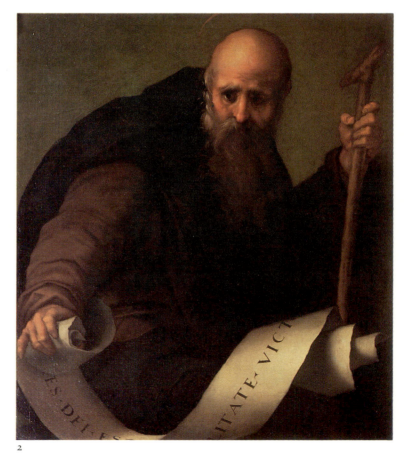

1

1
**Jacopo da Pontormo after
Michelangelo**
Pontorme 1494 – 1556 Florence
Venus and Amor
Oil on panel, 128 × 197 cm
Inv.no.1570

2
Jacopo da Pontormo
Pontorme 1494 – 1556 Florence
St Anthony Abbot
Oil on canvas, 78 × 66 cm
Inv.no.8379
St Anthony Abbot is identifiable by
the inscription on his scroll and by the
Tau cross which he holds in his left
hand. Always depicted as an old man,
the saint is charged by Pontormo with
great vitality through the powerful
foreshortened gesture of his out-
stretched arm, the long curve of the
back and the dramatic turn of the head
away from the direction of the body.

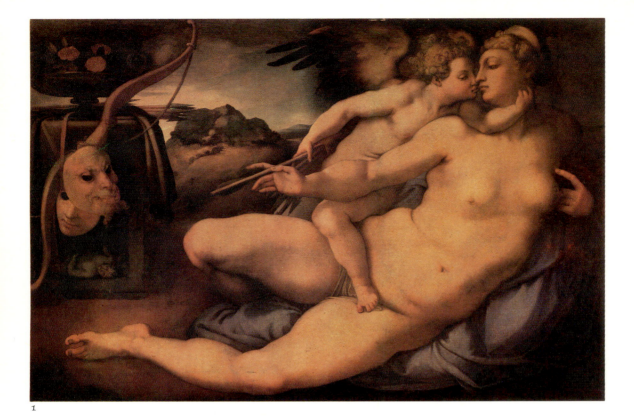

2

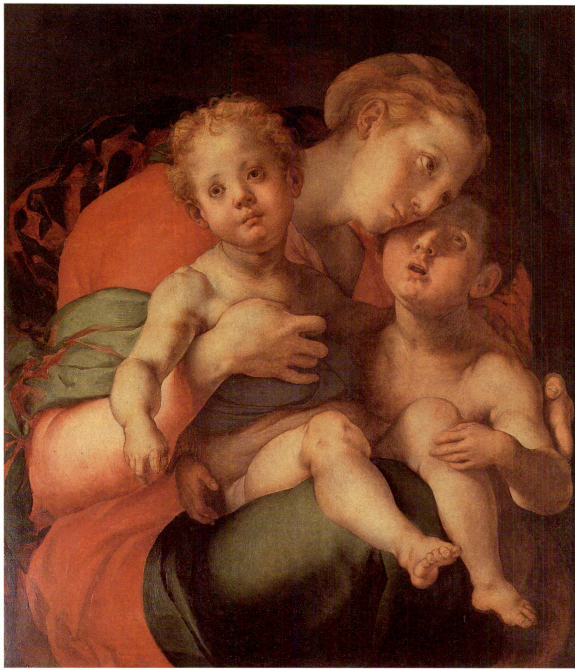

3

3
Jacopo da Pontormo
Pontorme 1494 – 1556 Florence
*The Virgin and Child with the young St
John the Baptist*
Oil on panel, 89 × 74 cm
Inv.no.4347
An unusually close relationship is
developed between the Virgin and the
young Baptist, while the Christ Child
is shown gazing wistfully beyond the
spectator in the centre. This may help
to account for the early confusion
over the subject of the picture, which
was thought to represent Charity.

High Mannerism

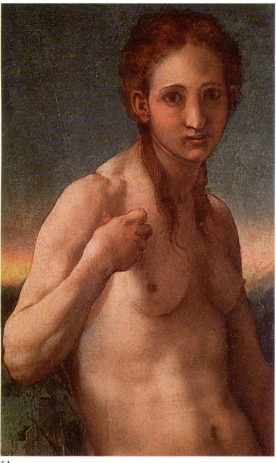

1A

1, 1A
Agnolo Bronzino
Florence 1503 – 1572 Florence
Pygmalion and Galatea
Oil on panel, 81 × 64 cm
Inv.no.9933

In 1530 Florence lost the last vestige of her republican freedom with the establishment of absolutist power by the Medici, who were formally installed as sovereigns. There thus began a period of very active, if imperious, patronage under Cosimo I and his successors, around whose power art was made to revolve as if it were a state business.

Some clue as to the nature of these changes is apparent in the magnificent portraits painted by Bronzino: the sitters have taken on an aristocratic air, their bearing is proud, impassive, their lips as if sealed. Behind them – as may be seen in the portrait of Bartolomeo Panciatichi – are architectural settings of a rigid elegance. There is a haughty, statuesque stillness in these portraits, a chromatic brilliance reminiscent of works in *pietre dure*. The Panciatichi *Holy Family* has a refined, yet detached and somewhat melancholic preciosity reflected in the evening glow of the landscape background, where the ramparts of a neo-feudal castle tower upon a steep hill. Even in his portraits of dukes and princelings, the sitters are frozen in an atmosphere of stately refinement that has great allure but stops short of any confidentiality.

For fifty years, Florentine painting continued to be dominated by the 'maniera'. The most varied and representative treasure-house of this style is the *studiolo* of Francesco I (1570) in the Palazzo Vecchio. Salviati's *Charity* is a bravura exercise in anatomical and plastic complexity held tightly *en bloc*, yet the pursuance of values expressed by Michelangelo in his Doni *tondo* (see p.83) now smack of an excess of virtuosity and of a formal hedonism of a superficial kind. Vasari, who was responsible for the fresco decoration of the interior of the Palazzo Vecchio, was a prolific extoller of history and allegory, but his pragmatic approach meant that he was not always stylistically in control. Allori continued in the tradition of his master, Bronzino, but with a heavier hand.

Thus a dignified Florentine academism was founded, its roots in the cult of Michelangelo and the supremacy of *disegno*, criteria which would finally rob the school of any painterly veracity and vitality, qualities that were developed brilliantly instead in Venice (see p.184).

This painting has been identified as the cover which Vasari says Bronzino painted for Pontormo's portrait of Francesco Guardi (now lost) in 1529/30. At this time Bronzino was still a pupil and collaborator of Pontormo and working in a style very close to his master's. The scene represents the artist Pygmalion praying that his statue of Galatea, with which he has fallen in love, should come to life. As a myth which played on the relationship between art and life it made an appropriate cover for a portrait.

1

1

Agnolo Bronzino
Florence 1503 – 1572 Florence
Portrait of Bartolomeo Panciatichi
Oil on panel, 104 × 84 cm
Inv.no.741

This portrait and its companion were admired by Vasari who identified the sitters as Giovanni (actually Bartolomeo) Panciatichi and his wife. Both portraits were still in the hands of the family in 1584 when they were seen by Borghini. Born in 1507, the sitter, who was Florentine ambassador to France, is shown seated with his dog in front of a fantastic, though clearly Florentine, architectural backdrop. His family arms appear on the wall. This portrait and its pendant were painted about 1540.

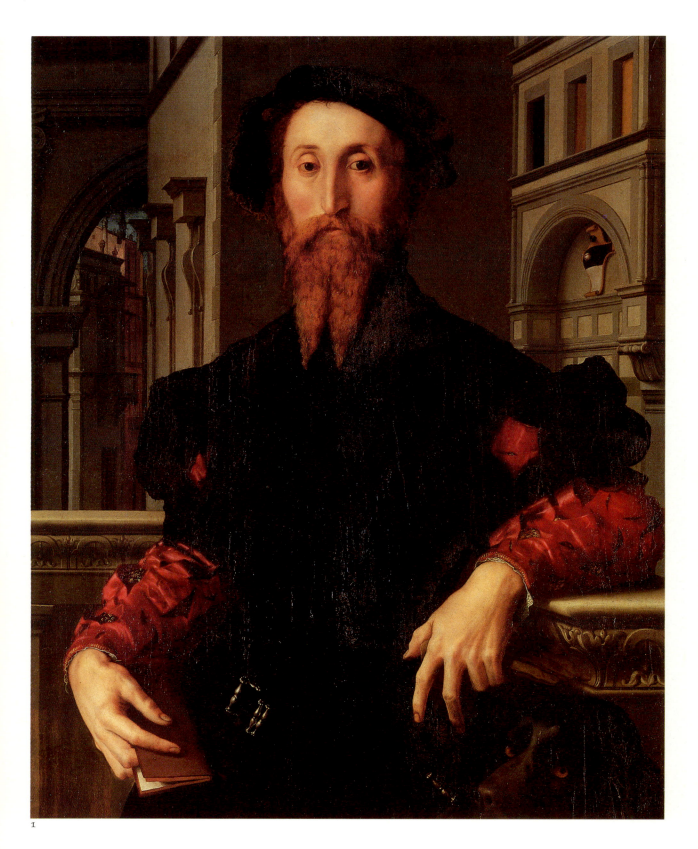

1

Agnolo Bronzino
Florence 1503 – 1572 Florence
Portrait of Lucrezia Panciatichi
Oil on panel, 102 × 85 cm
Inv.no.736

While Bartolomeo Panciatichi is shown wearing dark clothes against a lighter ground, Lucrezia Panciatichi provides the perfect complement to her husband, being dressed in a brilliantly coloured gown in front of a dark ground. Lucrezia di Gismondo Pucci married Panciatichi in 1528 and was probably also in her forties when this painting was made, at the height of her husband's prosperity. Her devotion to him is underlined by the French inscription on her rings which reads 'Sans fin amore dure' – Love survives without end.

1

2

3

1
Agnolo Bronzino
Florence 1503 – 1572 Florence
The Panciatichi *Holy Family*
Oil on panel, 117 × 93 cm
Inv.no.8377, Galleria Palatina 39
Bartolomeo Panciatichi commissioned
this Holy Family with St John the
Baptist from Bronzino. The classiciz-
ing Virgin and St Joseph look on
while the young Baptist shows his
solicitude for the Christ Child.

2
Agnolo Bronzino
Florence 1503 – 1572 Florence
Portrait of a young man with a lute
Oil on panel, 98 × 82 cm
Inv.no.1575
Like so many of Pontormo and Bron-
zino's sitters the unknown subject
belongs to the class of high-ranking,
educated Florentines who wished to
be shown with tokens of their accom-
plishments and interests, in this case a
lute and a classicizing statuette. As in
other portraits, the artist has used
light and shade to dramatic effect and
placed emphasis on the extreme
beauty of the hands.

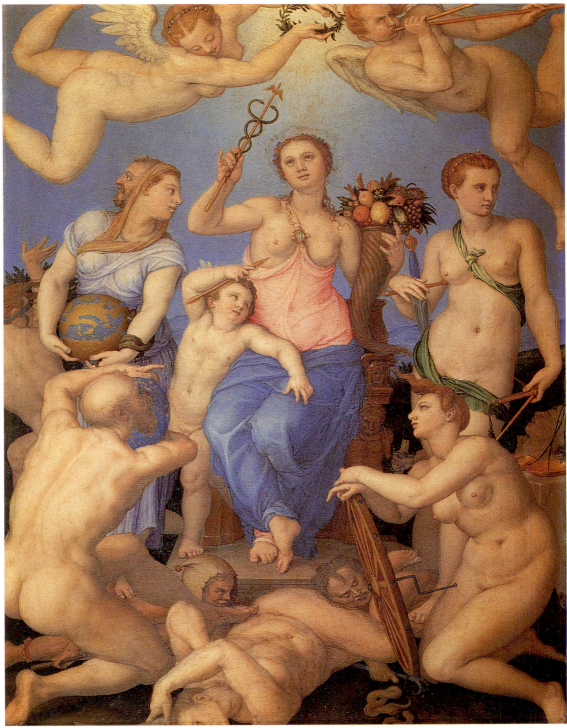

4

3
Agnolo Bronzino
Florence 1503 – 1572 Florence
Portrait of a noblewoman in a black
dress
Oil on panel, 121 × 95 cm
Inv.no.793

4
Agnolo Bronzino
Florence 1503 – 1572 Florence
Allegory of happiness
Oil on copper, 40 × 30 cm
Inv.no.1543
This is a late work by Bronzino,
sometimes associated with a painting

mentioned by Vasari of 1567. It is
supposed that the central figure
represents Happiness while the figures
to her left and right are Prudence with
two faces and Justice with a sword.
Time and Fortune kneel at her feet and
she is crowned by Fame and Glory.

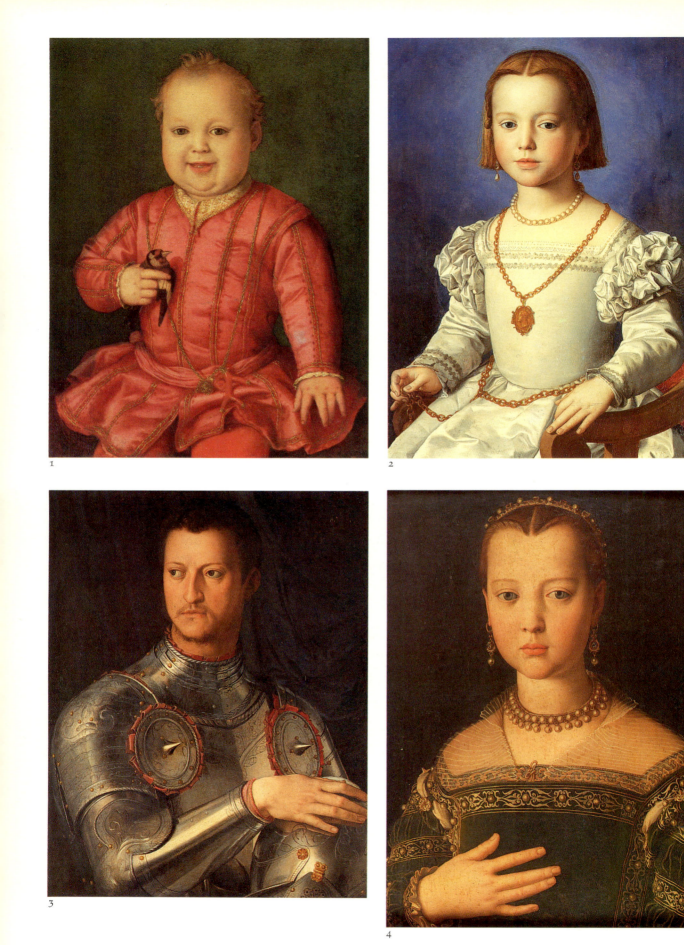

1

2

3

4

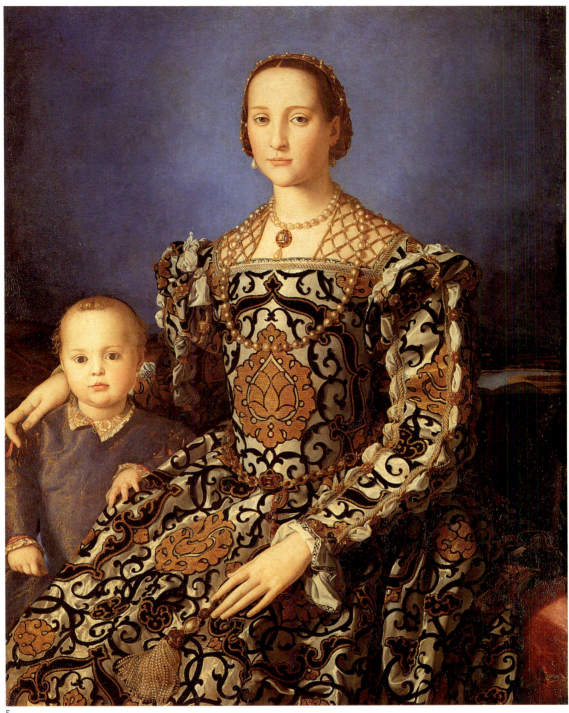

5

1
Agnolo Bronzino
Florence 1503 – 1572 Florence
Portrait of Giovanni de' Medici as a child
Oil on panel, 58 × 45.6 cm
Inv.no.1475

2
Agnolo Bronzino
Florence 1503 – 1572 Florence
Portrait of Bia, natural daughter of Cosimo I
Oil on panel, 63 × 48 cm
Inv.no. 1472

3
Agnolo Bronzino
Florence 1503 – 1572 Florence
Portrait of Cosimo I
Oil on panel, 71 × 57 cm
Inv.no.Depositi 28

4
Agnolo Bronzino
Florence 1503 – 1572 Florence
Portrait of Maria, daughter of Cosimo I
Oil on panel, 52.5 × 38 cm
Inv.no.1572

5
Agnolo Bronzino
Florence 1503 – 1572 Florence
Portrait of Eleanora da Toledo with her son Giovanni
Oil on panel, 115 × 96 cm
Inv.no.748
Giovanni, standing beneath his mother's protective arm, appears to be a little older than in his other portrait (1). When the Medici tombs were opened in 1857, Eleanora was found to have been buried in this same dress with its extremely rich embroidery.

1
Giovanni Bizzelli
Florence c1550 – 1607 Florence
The Annunciation
Oil on panel, 54 × 43.5 cm
Inv.no.1547

2
Alessandro Allori
Florence 1535 – 1607 Florence
The Sacrifice of Isaac, signed and dated
1601
Oil on panel, 94 × 131 cm
Inv.no.1553
The artist's inscription at the bottom
left of this painting is particularly
interesting. He signs himself with his
teacher's name Bronzino as well as his
own and declares that he has never
found greater pleasure than in learn-
ing. Nonetheless the style of this late
work is closer to Flemish painting,
with its emphasis on landscape and
close delineation of natural detail, than
it is to that of Bronzino.

3
Alessandro Allori
Florence 1535 – 1607 Florence
Portrait of Bianca Cappello
Oil on copper, 37 × 27 cm
Inv.no.1514
This small portrait of the wife of
Francesco I de' Medici is minutely
painted on copper. On her forehead is
a tiny relief of Venus and Cupid
between two figures. The composition
on the reverse of the portrait is based
on a famous late chalk drawing by
Michelangelo, known as the *Dream of
human life*, in which a nude man with a
globe, surrounded by the Seven
Deadly Sins, is inspired by a winged
figure blowing a trumpet.

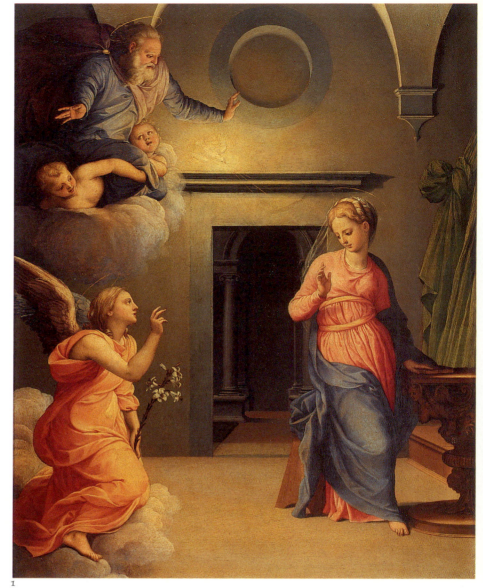

1

2

3

4

5

4
Alessandro Allori
Florence 1535 – 1607 Florence
Portrait of Ludovico Capponi (?)
Oil on panel, 45 × 36 cm
Inv.no.763
When it was bought by Ippolito
Rosini in the later 19th century, the
portrait was said to represent the poet
Torquato Tasso. This identification
could not be maintained and it has
since been suggested that the sitter
was Ludovico Capponi on the basis of
a likeness to a painting of him at
Princeton.

5
Alessandro Allori
Florence 1535 – 1607 Florence
Self-portrait
Oil on panel, 60 × 46.5 cm
Inv.no.1689

1

2

3

1
Alessandro Allori
Florence 1535 – 1607 Florence
Hercules crowned by the Muses
Oil on copper, 39 × 29 cm
Inv.no.1544
The unusual subject of this small
painting is Hercules hailed by the
Muses on Mount Parnassus, with his
enemies lying crushed at his feet.

2
Jacopo Zucchi
Florence 1541? – 1589/90 Rome
or Florence
The Golden Age
Oil on panel, 50 × 38.5 cm
Inv.no.1548
The Golden Age was the third of the
series of the legendary Ages of the
world painted by Jacopo Zucchi for
Cardinal Ferdinando de' Medici. The
cardinal brought the series with him
to Florence for his coronation as
Grand Duke of Tuscany in 1587.

4

3
Giorgio Vasari
Arezzo 1511 – 1574 Florence
Self-portrait
Oil on panel, 100.5 × 80 cm
Inv.no.1709

4
Giorgio Vasari
Arezzo 1511 – 1574 Florence
Vulcan's forge
Oil on copper, 38 × 28 cm
Inv.no.1558

In the foreground Vulcan presents
armour to the goddess Minerva while
in the background, with its deep
perspective, elegant nudes are seen
working by the unearthly light of the
forge. The painting dates from before
1565.

1

2

3

1
Baccio Bandinelli
Florence 1488 – 1560 Florence
Self-portrait
Oil on panel, 72.5 × 58.2 cm
Inv.no.1725

2
After Giorgio Vasari
Arezzo 1511 – 1574 Florence
Portrait of Lorenzo the Magnificent
Oil on panel, 90 × 72 cm
Inv.no.1578

3
Giorgio Vasari
Arezzo 1511 – 1574 Florence
Portrait of Alessandro de' Medici
Oil on panel, 157 × 114 cm
Inv.no.1563
Vasari's portrait was intended to be
read on several levels. The highly
reflective armour showed Alessandro
not only as a military leader but as a
'mirror of virtue', while other elements
of the painting are also to be read
symbolically: the *'broncone'* or
sprouting branch was a Medici
symbol of renewal while the burning
helmet was a sign of peace.

4
Francesco Salviati
Florence 1510 – 1563 Florence
The Adoration of the Shepherds
Oil on panel, 85 × 108 cm
Inv.no. Galleria Palatina 114
There has been much controversy as
to the attribution of this painting, the
provenance and date of which are not
known. However, the Florentine
characteristics of the work have
favoured an attribution to Salviati.

5
Francesco Salviati
Florence 1510 – 1563 Rome
Charity
Oil on panel, 156 × 122 cm
Inv.no.2157

4

5

Florentine painting of the 17th and 18th centuries

1

1
Andrea Boscoli
Florence *c*1560 – 1606/07 Florence
St Sebastian
Oil on panel, 45.5 × 26 cm
Inv.no.6204

In 1940 a large exhibition of the sixteenth century in Tuscany brought about a reappraisal of this period, and the same theme was explored in even greater detail in the 1980 Medici exhibitions which proved a great success with the public and managed to give a complete picture of the opulence and multiplicity of the arts that flourished under the first Grand Dukes. Little work had been carried out in the meantime on seventeenth-century Florentine art until finally, in 1987, after a period of fervid research, it was made the subject of an exhaustive exhibition. Before this, in 1974, there had been another large-scale exhibition entitled *The Last Medici*, which concentrated on the late Baroque period in Florence, from 1670 to 1743.

Undoubtedly, during this period Florentine painting could no longer boast its former primacy, having lost the high profile it had maintained over the centuries at least up to and including Bronzino. This was due among other things to a certain atmosphere of restraint that had overtaken Florence in these years. This preference for reasonableness without risks was expressed in an almost over-scrupulous propriety and in attitudes of timidity and reluctance towards the more extremist tendencies of the seventeenth century and the Baroque style. Florentine seventeenth-century (and eighteenth-century) art has remained poorly represented at the Uffizi, most of the works having been moved to the Palazzo Pitti in 1928.

A reappraisal of the art of these two centuries is already underway, however. If the reform (begun around 1580) led by Cigoli was moderate, it did nevertheless succeed in loosing the tethers with Mannerism and introducing a gentle sensuality and sentimentality. The work of Boscoli is animated by a new energy; the otherwise serene Jacopo Chimenti da Empoli is weighted down by a certain material heaviness (visible in his appetizing *Still life*); Cristofano Allori developed his own brand of intense romanticism (as did Bilivert). In addition, there is the vivacity of Giovanni da San Giovanni, the sensual lure of Furini, the candour of a Lorenzo Lippi, the devotional intensity of Dolci. To the eighteenth century belongs the orderly composure of a Gabbiani, or the Rococo grace of Ferretti's *Rape of Europa*.

For Florence, this is the glorious period of Galilean experimental science, while in literature and art caution and moderation were the keynotes. Indeed, Florence stood apart from the rest of Italy in her resistance to the Baroque. Galileo was a great admirer of Cigoli, but not of Caravaggio or the Carracci, nor, one might imagine, of their successor Pietro da Cortona.

2
Ludovico Cardi da Cigoli
Cigoli 1559 – 1613 Rome
The martyrdom of St Stephen
Oil sketch on paper glued to canvas,
27 × 22 cm
Inv.no. GDSU 19171

This is a sketch for a large-scale
painting commissioned for the church
of Montedomini in Florence. The
making of oil sketches in preparation
for larger paintings became increas-
ingly common from the 17th century
onwards and the sketches themselves
were often of a quality to be con-
sidered collectable objects.

2

1
Andrea Boscoli
Florence c1560 – 1606/07 Florence
The Wedding at Cana
Oil on canvas, 127.5 × 191 cm
Inv.no.8025

1

2
Carlo Dolci
Florence 1616 – 1686 Florence
St Mary Magdalen
Oil on canvas, 73.5 × 56.5 cm
Inv.no.768
Dolci's painting belongs to the genre
prevalent from the 16th century which
represented the penitent Magdalen as
a beautiful and often voluptuous
young woman, recognisable as the
Magdalen only by her attribute of the
flask of oil with which she had anoin-
ted Christ's feet.

3
Carlo Dolci
Florence 1616 – 1686 Florence
Still life with flowers
Oil on canvas, 70 × 55 cm
Inv.no.Imperiale 440

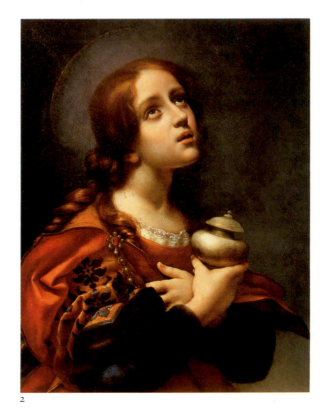

2

3

4

5

4
Carlo Dolci
Florence 1616 – 1686 Florence
Self-portrait, signed and dated 1674
Oil on canvas, 74.5 × 60.5 cm
Inv.no.1676
The inscription in the corners of the
drawing held by the artist indicates
that the work was painted for Cardinal
Leopoldo de' Medici. The unusual
portrait within a portrait shows the
artist applying his meticulous painting
technique.

5
Carlo Dolci
Florence 1616 – 1686 Florence
Ainolfo de' Bardi, signed and dated
1632
Oil on canvas, 149.5 × 119 cm
Inv.no.9298
The Florentine sitter is shown in
fashionable Hungarian hunting attire
which provides a pretext for the
unusual outdoor setting.

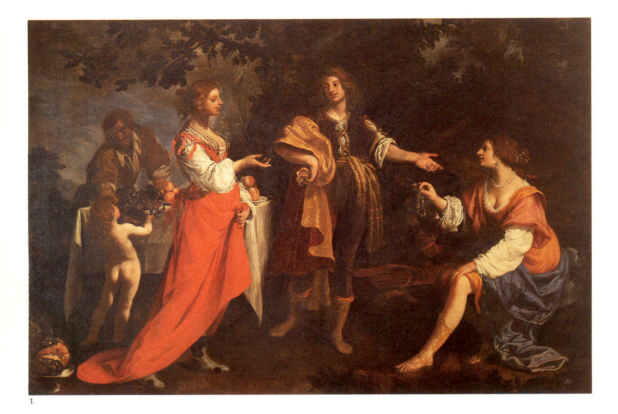

1

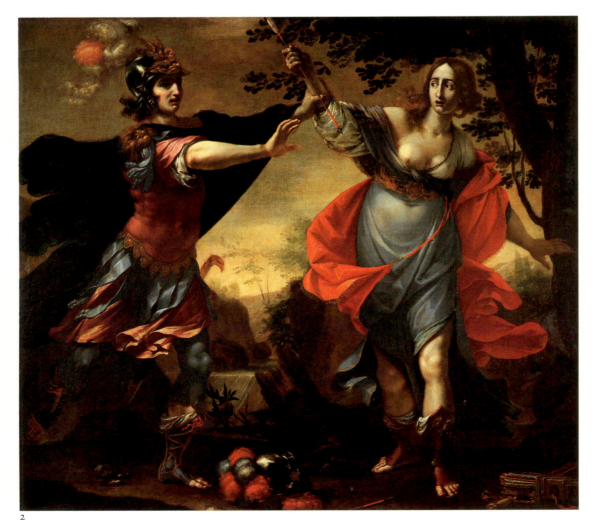

2

1
Orazio Fidani
Florence c1610 –
after 1656 Florence
Angelica and Medoro, signed and dated
1634
Oil on canvas, 230 × 340 cm
Inv.no.3559
The subject is taken from Ariosto's
romantic epic *Orlando Furioso* and
shows Angelica and her lover Medoro
saying farewell to the shepherds who
had harboured them during their
flight. This elegant pastoral scene was
painted for Don Lorenzo de' Medici
for the Medici villa at Petraia where it
remained until the later 18th century.

2
Cesare Dandini
Florence c1595 – 1658 Florence
Rinaldo and Armida
Oil on canvas, 130 × 303 cm
Inv.no.3823
At about the same time that Fidani's
painting was commissioned for the
Medici villa at Petraia, Cardinal Carlo
de' Medici was commissioning a series
of paintings by various artists of
similar poetic subjects for the Medici
Casino, his town palace. This scene
from the series, showing Rinaldo
stopping the dagger of Armida, is
taken from Tasso's *Gerusalemme
Liberata.*

3
Giovanni Domenico Ferretti
Florence 1692 – 1768 Florence
The rape of Europa
Oil on canvas, 147 × 205 cm
Inv.no.5447
This painting may be connected with
a series of designs for tapestries
undertaken by Ferretti for the Medici.
The series of the Four Elements, of
which this would have represented
Water, was never completed.

4
Vincenzo Mannozzi
Died in Florence 1657
Hell
Oval 'touchstone' on wood,
43.5 × 58.8 cm
Inv.no.4973
The artist has used the stone of the
support as a medium tone against
which he has painted his theatrical
lighting effects in *chiaroscuro*. The
painting formed a pendant to Stefano
della Bella's *Burning of Troy,* also
commissioned by Don Lorenzo de'
Medici.

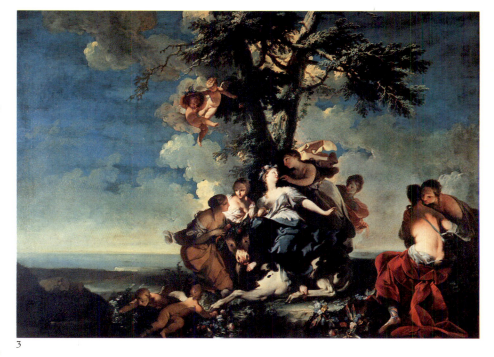
3

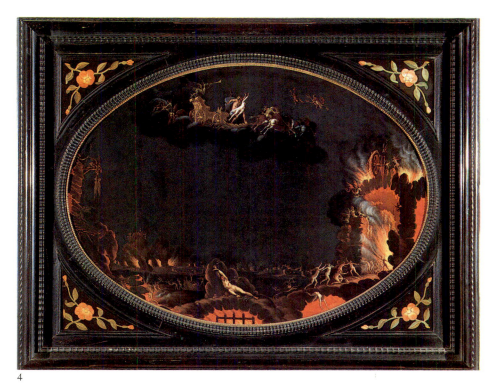
4

1

1

Anton Domenico Gabbiani
Florence 1652 – 1726 Florence
The rape of Ganymede
Oil on canvas, 123 × 173 cm
Inv.no.2176
Painted in 1700 for Ferdinando de'
Medici, the composition of Gabbiani's
picture derives partially from a famous
chalk drawing by Michelangelo of the
same subject.

2

Cristofano Allori
Florence 1577 – 1621 Florence
Susannah
Oil on canvas, 49 × 34.4 cm
Inv.no.7605
Another of the oil sketches belonging
to Cardinal Carlo de' Medici, this
evocative work shows the biblical
Susannah repelling the advances of
the Elders who had been watching her
bathe.

3

Jacopo Chimenti da Empoli
Florence 1551 – 1640 Florence
Still life, signed and dated 1624
Oil on canvas, 119 × 152 cm
Inv.no.8441

2

3

4

4
Attributed to Antonio Cioci
Active in Florence 1722–92
Still life: objects and self-portrait
Oil on canvas, 67 × 58 cm
Inv.no.9459

The portrait involves a play on the
skill of the painter/sitter who has
indicated his ability by the virtuoso
display of still-life objects that appear
on the desk in front of him.

1A

1B

1

Gentile da Fabriano
Fabriano *c*1370 – 1427 Rome
The Adoration of the Magi, signed and
dated 1423
Tempera on panel, 173 × 220 cm
Inv.no.8364

1A
Detail of the predella of *The Adoration
of the Magi: The Nativity*

1B
Detail of the predella of *The Adoration
of the Magi: The Flight into Egypt*

The Uffizi possesses few examples of Trecento painting from outside Tuscany; its collection is virtually limited to two small panels by Paolo Veneziano, the leading artist in Venice in the first half of the fourteenth century, which formed part of the Contini Bonacossi bequest. The next artist of importance from outside Tuscany whose work is represented in the Uffizi belongs already to the early fifteenth century: Gentile da Fabriano, who was active in the Marche and in Venice before moving to Florence (from about 1419 to 1425) and thence to Siena and Rome. An extremely sophisticated practitioner in the so called International Gothic style, which he had brought to an outstanding peak in the Marche, but had also enriched with influences from Lombardy, Siena and Venice, Gentile was the natural choice for a man like Palla Strozzi, the richest merchant in Florence, who commissioned him to paint the Uffizi's *Adoration.* Originally adorning the altar of Strozzi's family chapel in Santa Trinita, Gentile's *Adoration of the Magi,* contemporary with the revolutionary 'theses' of Masaccio, is one of the greatest monuments of the late Gothic culture which lingered long in Italy and elsewhere. It shows an extremely high order of skill and technical accomplishment, conveying a courtly, otherworldly vision of its subject. Though it lacks a rational or schematic perspective, it produces an effect of space by overlapping planes and juxtaposing distinct scenes, as well as by faithful and fascinated reproduction of naturalistic and narrative details. The worldly pomp of the main scene is enhanced by the many orientalizing details and the lavish sprinkling of gold, which the patron was well able to afford. The mood of the narratives in the predella panels is more informal, as is the case again in the Quaratesi polyptych, of which four panels are preserved in the Uffizi.

In the second half of the century, the diffusion of the Renaissance in the painting of North Italy constantly shows 'foreign' influences working through without any loss of local identity, so that a series of distinct regional 'schools' emerge, Venetian, Paduan, Ferrarese, Lombard ... Donatello, Piero della Francesca and Antonello da Messina were the most important progressive influences on North Italy, especially the Venetian school, in a web of journeys, sojourns and commissions which ensured the circulation of ideas. Northern Italy also had greater access and a more direct appreciation of Netherlandish art. From Central Italy the Venetians absorbed clarity of perspective and a particular attention to the fall of light; from the North, styles of portraiture and the new technique of oil-glazes. Meanwhile in Padua and then in Mantua Mantegna emerged as a champion of sculptural vigour and enamel colouring, and of the passionate evocation of the classical past – as may be seen in the Uffizi's portrait by him of a cardinal, contrasting the somewhat forbidding sitter's deep expression with the delicate, inflamed pink colours of his robe. Mantegna's Uffizi triptych displays, in the *Adoration of the Magi,* the archaeological, even geological, aspect of his art, and in the *Circumcision* a feeling for classicizing architecture.

Mantegna's influence affected notably the Venetian Giovanni

This celebrated altarpiece was commissioned from Gentile during his three-year stay in Florence by Palla Strozzi to adorn one of the altars of his family chapel in Santa Trinita. The work clearly shows the influence of Gentile's training in northern Italy and was to have an immense impact on Florentine artists. The elaborate triple-arched frame helps to articulate the narrative of the procession which develops to a climax in the foreground, without using a Florentine perspectival construction. The exquisite use of gold and attention to a variety of light sources extends also to the predella scenes, with dawn breaking on the horizon of the *Flight into Egypt* and the *Nativity* scene lit by the glow emanating from the Christ Child.

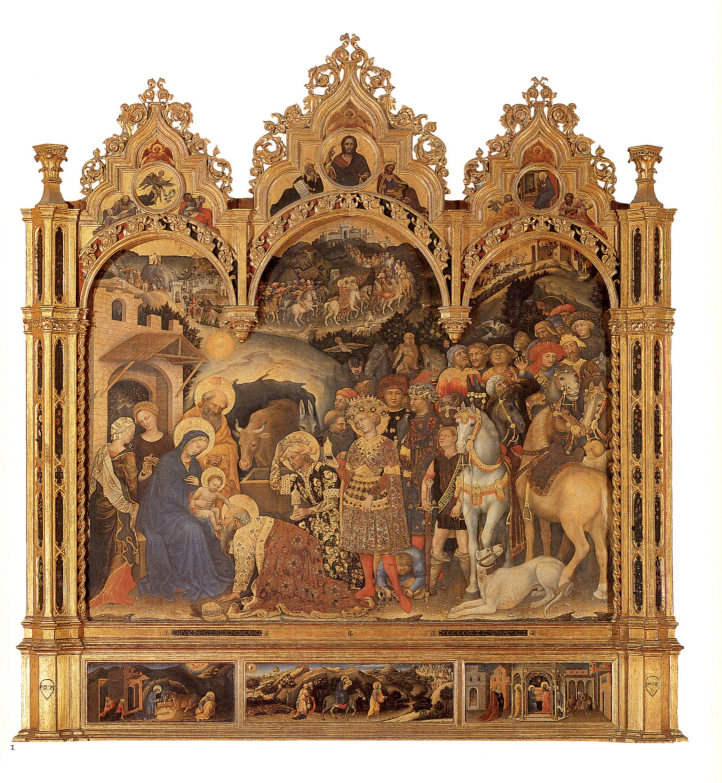

1

1

1

Paolo Veneziano
Active in Venice in the first half of
the 14th century
The charity of St Nicholas
Tempera on panel, 73 × 55 cm
Inv.no. Contini Bonacossi 7
Possibly this panel and the related
Birth of St Nicholas once formed part

2

Bellini, his brother-in-law, who achieved in his paintings, thanks also to the use of Netherlandish oil-paint techniques, a peculiarly Venetian mood and atmosphere. The perspective and structure of his work are concealed by the apparent naturalism with which he evokes his scenes, in which the diffused light combines and unites men and things, sky and mountains, drapery and trees. And so even the obscurities of the Uffizi's *Sacred allegory* do not detract from the physicality of the architecture and the freshness of the landscape, in which centaurs hobnob at ease with saints in armour, the wilderness is in harmony with human activity, and the rocks merge with a terrace of coloured marbles in the Venetian fashion. In the next generation, Cima da Conegliano offered a simpler, more direct and schematic version of Giovanni Bellini's style, and Carpaccio provided a modern setting on an elegant stage beneath a suggestive light in gorgeous costume for a miscellany of material such as mythology, court life and seafaring.

The capricious and disturbing art of the Early Renaissance Ferrarese school has a special place in Italian art. The Este court promoted to an extreme a style of glitteringly clear irrationalism, an example of which is the Uffizi panel of *St Dominic*, contorted and yet elegant, ascetic and at the same time affected, a masterpiece of drawing. Meanwhile Vincenzo Foppa's *Madonna and Child* will serve as an example of the direct and plain realism of the Lombard school: in it may also be discerned echoes of Bellini, also quite strong northern influence, also Paduan ... Foppa has rightly been called 'the father of the Lombard style'. Thanks to his activity as an architect, his compatriot Bernardino Zenale, though still under the spell of the local late Gothic tradition, achieved in his paintings an ambitious and solid perspective framework in which to indulge his predilection for complex and elaborately decorated backdrops.

of an altarpiece made by Paolo Veneziano in 1346 for the chapel of St Nicholas in the Doge's Palace in Venice. The scene shows St Nicholas coming to the aid of a poverty-stricken nobleman and his daughters by anonymously delivering gold for their dowry through their window.

2
Gentile da Fabriano
Fabriano *c*1370 – 1427 Rome
Four saints from the Quaratesi polyptych, signed and dated 1425
Tempera on panel, each panel 200 × 60 cm
Inv.no.887
Belonging, like the *Adoration of the Magi*, to Gentile's Florentine period,

these panels showing St Mary Magdalen, Nicholas, John the Baptist and George formed part of a polyptych for the Quaratesi family chapel in San Niccolò sopr'Arno. The altarpiece was dismantled in the 19th century and the predella panels dispersed while the central Virgin and Child is now in the National Gallery, London.

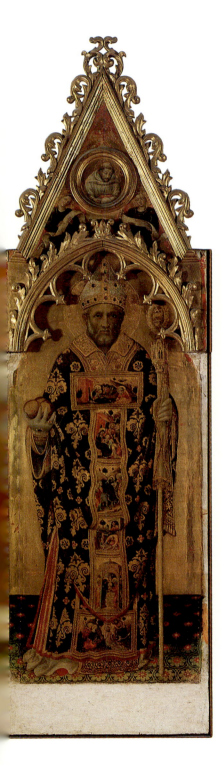
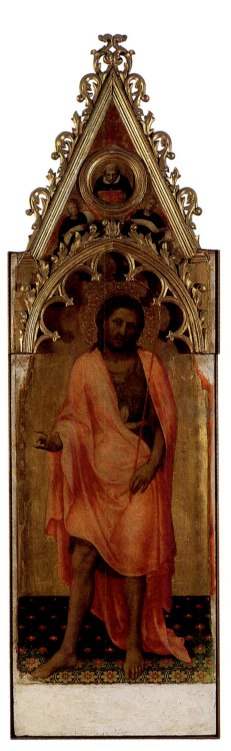
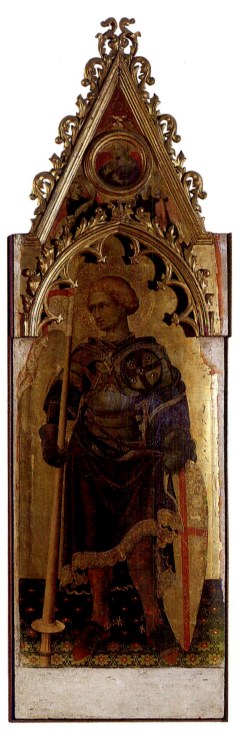

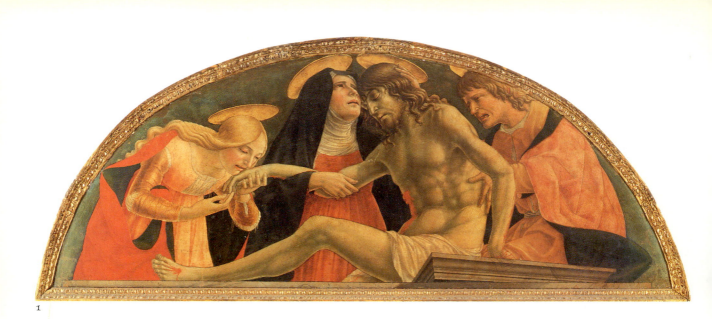

1

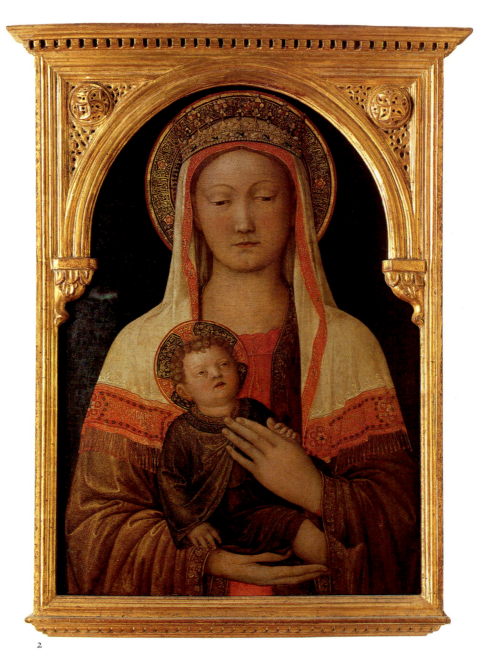

2

1

Lorenzo da Sanseverino
Sanseverino 1468 –
1503 Sanseverino
Pietà
Tempera on panel, 62 × 158 cm
Inv.no.3142
The steep perspective on the lid of
Christ's tomb indicates that this
arch-shaped panel was intended to be
seen from below. Indeed we know
that it originally formed the upper
part of an altarpiece of the *Mystic
Marriage of St Catherine*, now in the
National Gallery, London, from the
church of Santa Lucia in Fabriano.

2

Jacopo Bellini
Venice *c*1396 – 1470/71 Venice
Madonna and Child
Tempera on panel, 69 × 49 cm
Inv.no.3344
This restrained, hieratic image of the
Virgin and Child by the founder of the

great Bellini family of Venetian
painters is one of the few paintings by
his hand to survive. Jacopo worked
for some time in Florence, at the same
time as Gentile da Fabriano, and this
Madonna was bought early this
century from the Tuscan convent of
San Micheletto in Lucca.

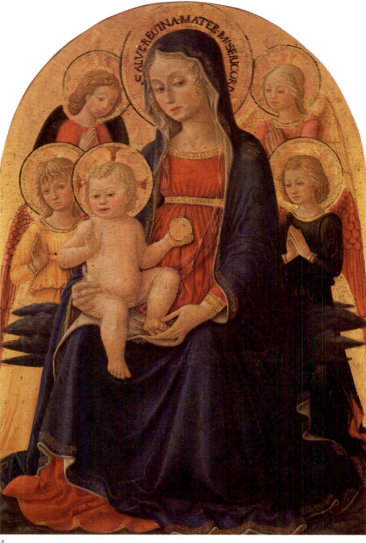

3

Antoniazzo Romano
Rome 1461 – 1508 Rome
Madonna and Child, dated 1482
Tempera on panel, 65 × 44 cm
Inv.no.2199
This small triptych with folding wings
opens to reveal the Virgin and Child
flanked by Sts Peter and Paul.
God the Father and scenes of the
Annunciation appear in the upper
angles.

4

Bartolomeo Caporali
Perugia *c*1420 – *c*1505 Perugia
Madonna and Child with four angels
Tempera on wood, 79 × 55 cm
Inv.no.3250

1

Andrea Mantegna
Isola of Carturo 1435 –
1506 Mantua
The Madonna of the Rocks
Tempera on wood, 29 × 21.5 cm
Inv.no.1348

The Virgin and Child in this small
panel have been elevated above the
landscape on a stone platform, the
traditional cloth of honour behind the
Virgin being replaced by a dramatic
rock formation enclosing a cave. The
mood of the painting is contempla-
tive, containing overtures of the Pietà.

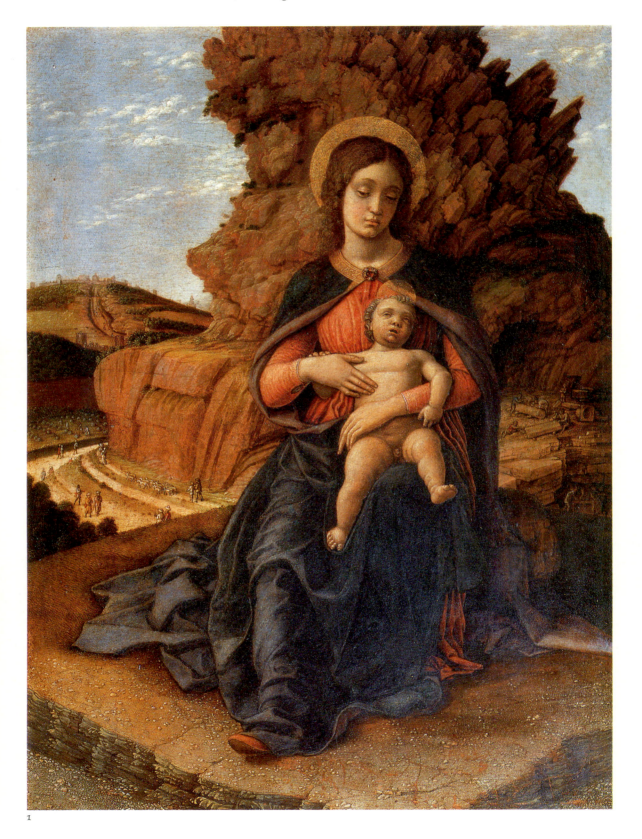

1

2, 2A

Andrea Mantegna
Isola di Carturo 1435 –
1506 Mantua
Triptych of *The Adoration of the Magi,*
The Circumcision and *The Ascension*
Tempera on panel, 86 × 161.5 cm
Inv.no.910

This exquisitely painted small-scale triptych is an early work by Mantegna demonstrating his virtuoso draughtsmanship, vivid use of colour and gilding to orchestrate the narrative, and admiration for the antique, particularly in the *Circumcision* panel to the right. The scale of the triptych

and its fine technique has led to the suggestion that it was painted for a private chapel in the Ducal Palace in Mantua. The painting has, however, lost its original frame and the incongruity in scale between the various panels is a problem.

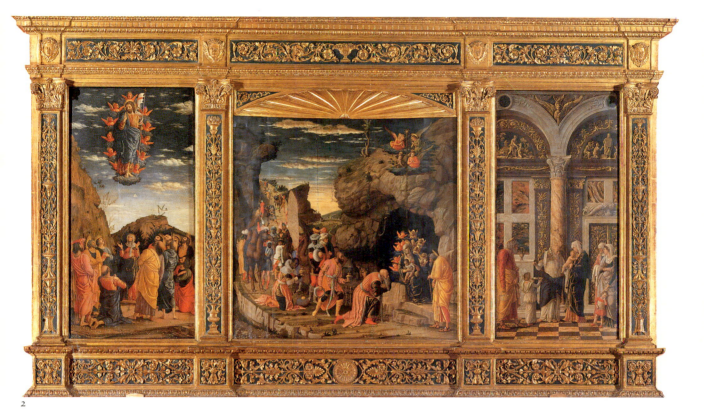

2

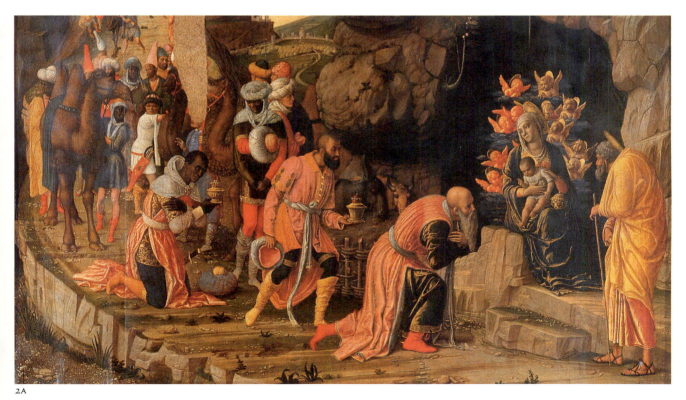

2A

129

1
Lorenzo Costa
Ferrara *c*1460 – 1535 Ferrara
St Sebastian
Tempera on panel, 55 × 49 cm
Inv.no.3282

2
Lorenzo Costa
Ferrara *c*1460 – 1535 Ferrara
Giovanni Bentivoglio
Tempera on panel, 55 × 49 cm
Inv.no.8384

3
Andrea Mantegna
Isola di Carturo 1435 –
1506 Mantua
Cardinal Carlo de' Medici
Tempera on wood, 40.5 × 29.5 cm
Inv.no.8540

1

2

4
Cosmè Tura
Ferrara 1432 – 1495 Ferrara
Fragment of a polyptych: *St Dominic*
Tempera on panel, 51 × 32 cm
Inv.no.3273
This beautifully drawn figure of St
Dominic in an attitude of prayer, by
the most accomplished Ferrarese
15th-century painter, has been
removed from a polyptych and cut
down at the bottom. The dismem-
bered altarpiece of which it originally
formed part has been variously
identified as one for the church of
Santa Lucia in Borgo in Ferrara or for
San Giacomo at Argenta.

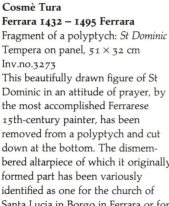

3

4

5

6

5
Vincenzo Foppa
Brescia 1427/30 – 1515/16 Brescia
Madonna and Child with an angel
Tempera on panel, 41 × 32.5 cm
Inv.no.9492

6
Bernardino Zenale
Treviglio c1456 – 1526 Milan
The archangel St Michael
Oil on panel, 115 × 51 cm
Inv.no. Contini Bonacossi 10

Vittore Carpaccio
Active in Venice 1472–1526
Group of soldiers and men in oriental costumes
Oil on canvas, 68 × 42 cm
Inv.no.901
The larger composition of which this lively fragment once formed a part has not been identified. The prominence of the piece of wood on which the foreground soldier is seated and the presence of the orientals has led to the suggestion that the composition may have represented the Discovery of the True Cross.

2

Cima da Conegliano
Conegliano c1460 –
1517/18 Conegliano
Madonna and Child
Tempera on panel, 66 × 57 cm
Inv.no.902
The painting follows a format extremely common to later 15th-century Venetian Virgin and Child compositions, with the cloth of honour behind the Virgin partially obscuring a landscape view.

3

Giovanni Bellini
Venice 1425/30 – 1516 Venice
Sacred allegory
Oil on panel, 73 × 119 cm
Inv.no.903
Though clearly illustrating biblical figures and saints, the presentation of the mysterious subject is far removed from a traditional devotional framework. Indeed the loose arrangement of the figures against a luminous landscape and the mystical, contemplative atmosphere of this panel has led historians to search for the source of the subject in allegorical poetry.

1

2

4
Giovanni Bellini
Venice 1425/30 – 1516 Venice
Lamentation over the Dead Christ
Tempera on panel, 74 × 118 cm
Inv.no.943

This beautiful late work by Bellini seems to refute the traditional association of Venetian art with colour alone and place him in the tradition of draughtsmanship to which the sketchbooks of his father Jacopo bear witness. Given the lack of colour, the suggestion of the glowing light that bathes the mourners is all the more remarkable.

3

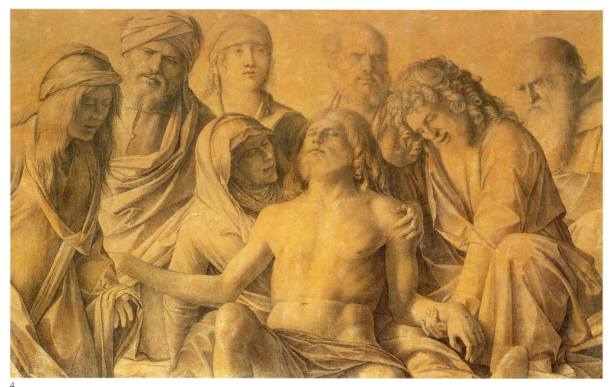

4

1

Il Francia
Bologna *c*1450 – 1517 Bologna
Evangelista Scappi
Tempera on wood, 55 × 44 cm
Inv.no.1444

The sitter can be identified from the
inscription on the letter he is holding.
The format of the portrait, with the
sitter seen full face against a landscape
background, as well as the soft
rendering of the flesh, indicate the
influence on Francia of Perugino and
the young Raphael.

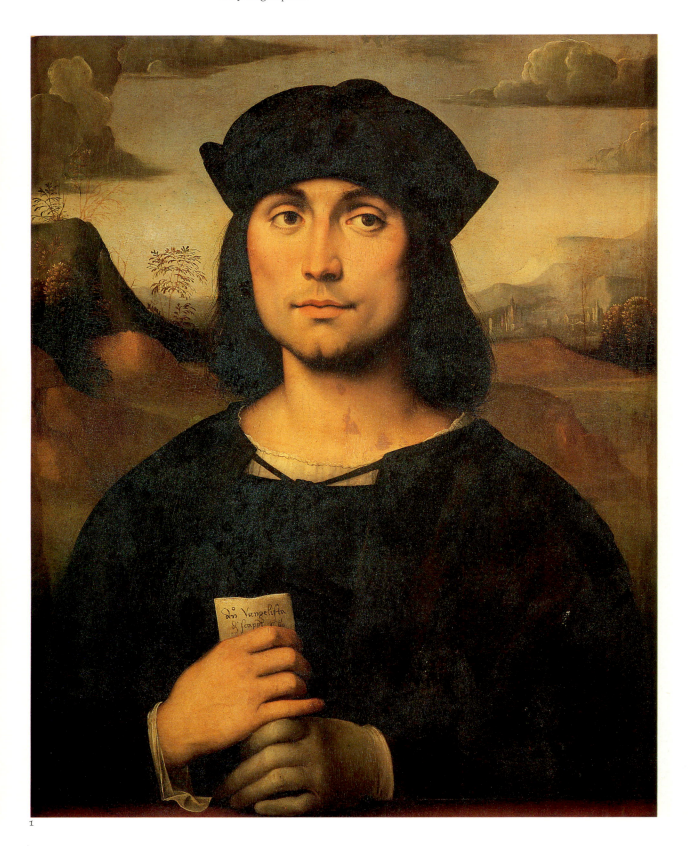

1

Bramantino
Milan *c*1465 – 1530 Milan
Madonna and Child with eight saints
Tempera on panel, 203 × 167 cm
Inv.no. Contini Bonacossi 3
Apparently much influenced by
Mantegna in his early career, Bra-

mantino's softer, less angular style in
this altarpiece for the church of Santa
Maria del Giardino in Milan indicates
a late date for the work. However, the
artist's architectural interests are
apparent in the conception of the
severe ionic loggia in the background.

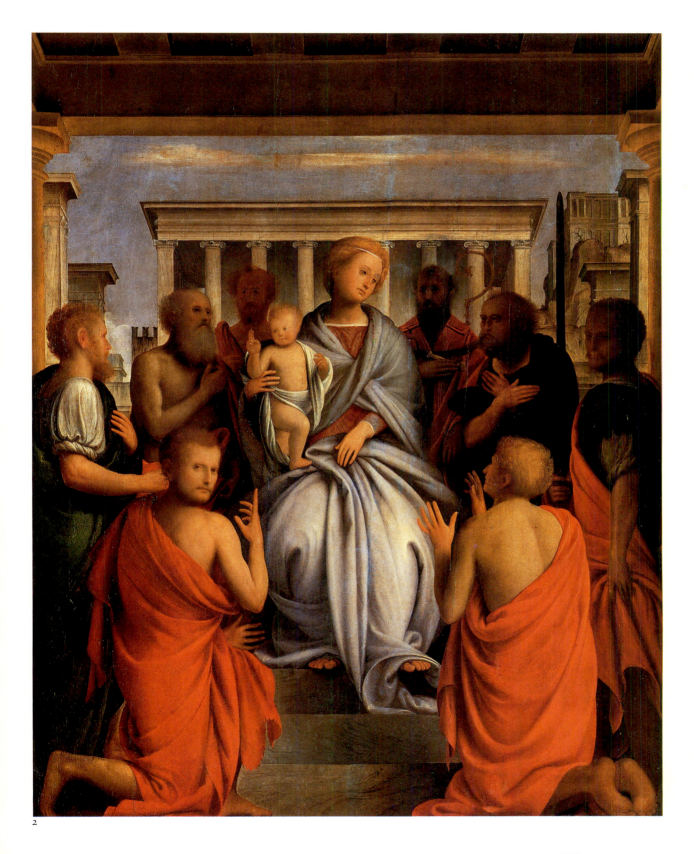

2

Italian painting
(outside Florence and Venice)
in the 16th century

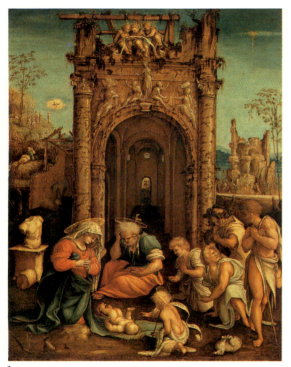

1

1
Amico Aspertini
Bologna c1474/75 – 1552 Bologna
The Adoration of the Shepherds
Oil on panel, 44.5 × 34 cm
Inv.no.3803

A great century for Italian art, the extraordinarily multi-faceted sixteenth century made no apparent break with the past – indeed it actively promoted and developed the ideas of the Early Renaissance; nevertheless it had to come to terms with a very different, and much more complex, cultural and political climate. A shared aesthetic ideal encouraged artists to experiment with new forms, new spatial relations and new, ever more ambitious compositions, but to the extent of compromising the rationalism and order that had prevailed in the Quattrocento.

Classicism, traditionalism, constant reference to the great masters of the past, coexisted with a new demand for artists to set and to be governed by their own ideas, terms and standards – it was just at this period that artists were finally removed from the estate of simple craftsmen, to which they had hitherto belonged – even to the point of alienation from the 'imitation of nature' in order to express their own feelings and identity, a process that would lead eventually to the involved and deliberately precious formalism of late Mannerism. Indeed it was also in this century that a movement of 'return to order' emerged in the shape of the Catholic Reformation of the Church, which extended its reaffirmed authority into the artistic realm as well.

Of the great artists of the sixteenth century, Raphael of Urbino shares a recognised supremacy with the Tuscans Leonardo da Vinci and Michelangelo. He, too, worked and observed in Florence, before making his career in Rome whence his exemplary harmony and grandeur, his perfectly balanced compositions and his cleverly attuned interpretation of the antique were diffused by a crowd of pupils and assistants who worked with him on the Vatican Loggie, first among them Giulio Romano. By Raphael, in the Uffizi, one finds a youthful work from the earliest days of his years in Florence, the *Madonna of the Goldfinch*, which owes much of its layered, pyramidal composition to Leonardo; the two Urbino portraits, showing their Umbrian provenance in form as well as subject; and his most mature work among those in the Gallery – in colour, in composition, in psychology – the portrait of Pope Leo X with his Cardinal heirs.

The 'diaspora' of artists consequent on the Sack of Rome in 1527 spread throughout Italy the new forms that had been precipitated in Rome, as in a crucible, by the influx of so many outstanding masters. Lombardy, of course, had already felt the wind of change thanks to the presence in Milan of Leonardo during the last twenty years of the fifteenth century; as a result of his stay, *leonardismo* became one of the essential strands making up the Milanese style, as is evident, for instance, in the work of Bernardino Luini in the Uffizi, *Salome with the head of St John the Baptist*. The art of the rest of Lombardy was open also to other influences, above all from Venice, and was enlivened and imprinted by the activity there of artists of the highest quality, such as Lorenzo Lotto in Bergamo and Savoldo, Moroni, Moretto and Romanino in Brescia and elsewhere. In accordance with the Lombard tradition, these artists developed and propagated a direct and plain naturalism which, in the case of Savoldo especially, with his interest in the depiction of light, anticipated Caravaggio.

2

Raphael
Urbino 1483 – 1520 Rome
*Pope Leo X with cardinals Luigi de' Rossi
and Giulio de' Medici*
Oil on panel, 155.5 × 119.5 cm
Inv.no. Galleria Palatina 40

Painted some time in 1517/18, after
Luigi de' Rossi was made a cardinal,
the portrait shows the first Medici
Pope Leo X with his two nephews in a
kind of ecclesiastical dynastic group
portrait of a highly original kind.
Commissioned shortly after a murder
plot among Leo's cardinals had been
uncovered, the portrait represents a
reassertion of the Pope's political
power and also shows him as a lover
of luxury objects such as the manu-
script before him on the table which
he has been examining with a
magnifying glass.

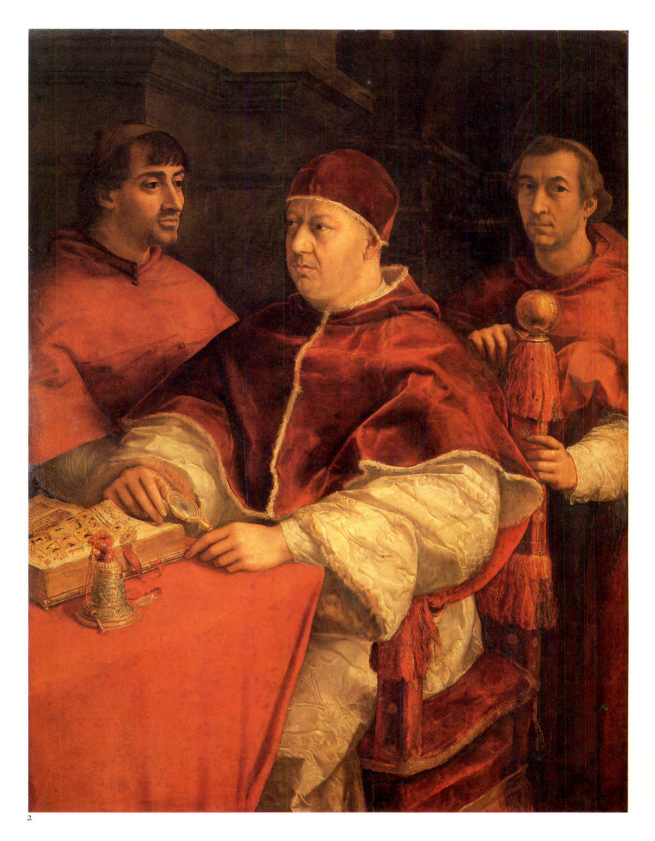

1
Raphael
Urbino 1483 – 1520 Rome
Self-portrait
Oil on panel, 47.5 × 33 cm
Inv.no.1706

2
Raphael
Urbino 1483 – 1520 Rome
Elisabetta Gonzaga
Oil on panel, 52.5 × 37.3 cm
Inv.no.1441
The sitter in this portrait, Elizabetta
Gonzaga, wife of Guidubaldo da
Montefeltro, Duke of Urbino, has

been immortalised in Castiglione's
famous *Book of the Courtier*, in which
she both presides over and regulates
the elegant activities of the court. In
this early work by Raphael, she is
shown in a hieratic frontal pose
enlivened by the asymmetric pattern
of her dress and the scorpion emblem
that she wears on her forehead.

1

2

Also in other regions artists were to be found capable of adapting
local traditions to the cultural leaps being taken in central Italy –
notably in Emilia. Here at the beginning of the century Correggio
successfully grafted the 'modern' style of Raphael on to a local stock
influenced chiefly by *leonardismo* and by Venice – so successfully that
the softness and yieldingness of his light, the gentleness of his
transitions and the delicacy of his touch earned him a large following,
both in Emilia and outside it. The Uffizi's *Adoration of the Child* is a
perfect illustration of this style.

In emulation of Correggio, Parmigianino, also from Emilia, but who
had worked in Rome, pursued his own interest in a more sophisticated
and intellectual art, sensual but cerebral, to create some of the most
precious works of the Mannerist style. The '*Madonna of the Long Neck*'
is a superb example: its cold materials built up in complex layers, the

Raphael
Urbino 1483 – 1520 Rome
Guidubaldo da Montefeltro
Oil on panel, 70.5 × 49.9 cm
Inv.no.8538
Depicted in about 1506, the sitter, Guidubaldo da Montefeltro, was son of the famous Federigo, Duke of Urbino, the subject of Piero della Francesca's profile portrait (p.44). Less decisive and effective than his father, Guidubaldo suffered the loss of part of the new ducal demesne. But cultural life still thrived and both Raphael and his father (also a painter) found patronage at Guidubaldo's court.

3

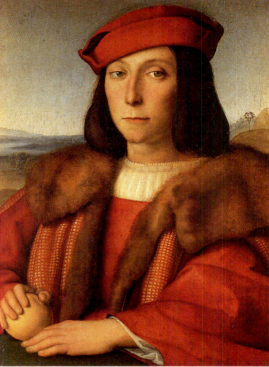

4

4
Raphael
Urbino 1483 – 1520 Rome
Portrait of a young man with an apple
Oil on panel, 48 × 35.5 cm
Inv.no.8760
Judging by his costume, the sitter must have been someone of high rank and is commonly identified as Francesco Maria della Rovere, Duke of Urbino. The pose and setting of the sitter reveal the influence of Raphael's teacher Pietro Perugino and the work has much in common with Perugino's portrait of Francesco delle Opere (p.81).

attenuated, spun-out, cylindrical limbs of its figures, are a world away from Correggio's gentle naturalism.

Also Ferrara produced a generation of artists acute and alert to the new aesthetic of the century, especially as represented by the works of Raphael there; otherwise these artists, such as Garofalo and the mysterious Dosso Dossi, full of vibrant colours and obscure significances, while not abandoning the eccentricities of local tradition, leaned chiefly towards Venice and Bologna. At the end of the century — indeed he lived more than a decade into the next — there must be mentioned Federico Barocci from Urbino, whose works in the Uffizi include several sensitive portraits and a grandiose *Madonna*: they show both a profound assimilation of Venetian Mannerist art and a surprising anticipation of the Baroque, in their colouristic richness and their compositional structure, which has more than a touch of the theatrical.

1

2

3

4

1
Raphael
Urbino 1483 – 1520 Rome
Madonna of the Goldfinch
Oil on panel, 107 × 77 cm
Inv.no.1447
Vasari tells us that this *Virgin and Child with St John the Baptist*, executed during Raphael's period in Florence, was made for Lorenzo Nasi. The complex pyramidal figure relationships indicate Raphael's study of Leonardo while the motif of the Christ Child between the Virgin's knees derives from Michelangelo's Bruges *Madonna*.

2
Francesco Melzi
Milan 1493 – 1570 Milan
Leda
Oil and resin on panel, 130 × 77.5 cm
Inv.no.9953

3
Raphael
Urbino 1483 – 1520 Rome
St John in the Wilderness
Oil on canvas, 165 × 147 cm
Inv.no.1446

According to Vasari this painting was commissioned by Cardinal Jacopo Colonna who gave it to his doctor Jacopo da Carpi. It dates from towards the end of Raphael's career which was cut short by his early death in 1520. The isolated figure of the Baptist, pointing to the coming of Christ and His crucifixion, provided Raphael with the opportunity of exploring a complex rhetorical pose, dominated by a graceful diagonal.

4
Giovanni Antonio Boltraffio
Milan 1467 – 1516 Milan
Girolamo Casio
Oil on panel, 51.5 × 37 cm
Inv.no. Contini Bonacossi 28
The poet Girolamo Casio, actually a member of the Pandolfi family, was named Bolognese Senator by Pope Leo X in 1513 and is depicted here in a sensitive portrait by one of Leonardo's most talented Milanese followers.

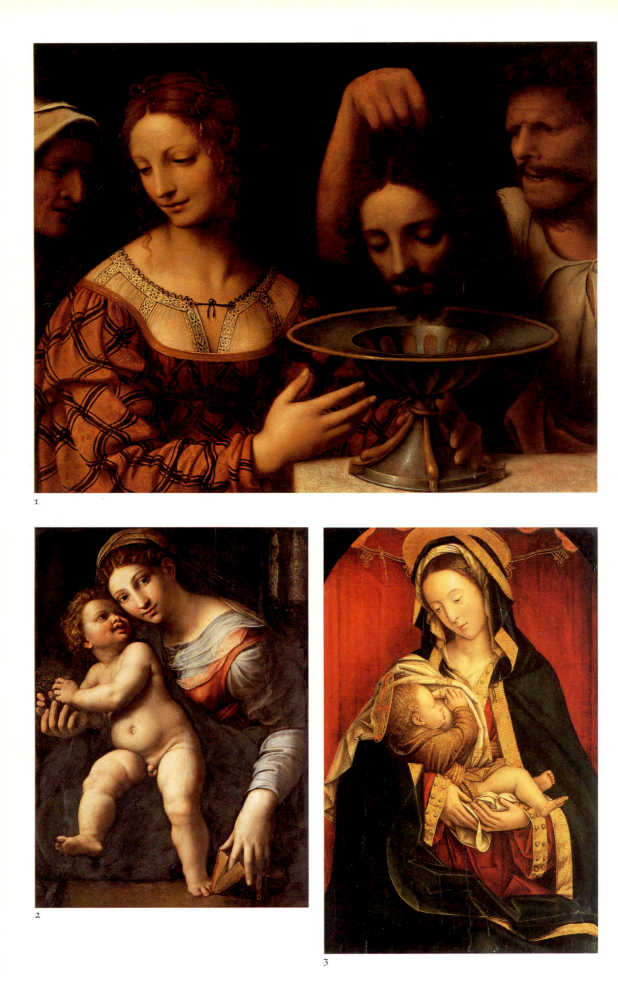

1

2

3

Bernardino Luini
Luino c1460 – c1532 Luino
Herodias
Tempera grassa on wood, 51 × 58 cm
Inv.no.1454
The woman's physiognomy, as well as
the graceful inclination of her head
against the turn of her body, owes
much to Leonardo.

2

Giulio Romano
Rome 1492/99 – 1546 Mantua
Madonna and Child
Oil on panel, 105 × 77 cm
Inv.no.2147
While Luini's picture shows the
influence of Leonardo on his Milanese
followers, this *Virgin and Child* by
Giulio Romano bears witness to the
close assimilation of Raphael's style
by one of his collaborators in Rome.
Giulio had worked alongside Raphael
on the Vatican Stanze and completed
some of the master's unfinished works.
This painting appears to date to his
late Roman period, before his move to
Mantua in 1524.

3

Defendente Ferrari
Active Chivasso 1510–31
Madonna feeding the Christ Child
Oil on panel, 75 × 48.5 cm
Inv.no. Contini Bonacossi 8
This unusual Virgin and Child of the
1520s shows the marked influence of
15th-century Flemish painting, not-
ably images of the Virgin feeding the
Christ Child by the Master of Flémalle
and Rogier van der Weyden.

4

Girolamo Genga
Urbino 1476 – 1551 Urbino
The martyrdom of St Sebastian
Oil on panel, 100 × 83 cm
Inv.no.1535
The composition of Genga's *Martyr-
dom*, with its company of archers
forming a triangle with its apex in the
figure of St Sebastian, derives ulti-
mately from an altarpiece by Pollaiolo
of the same subject. Nevertheless, the
pose of the saint and the colourful
attire of the bowmen suggest that
Genga was also familiar with another
by Signorelli of the same subject at
Città di Castello in his native province
of the Marche.

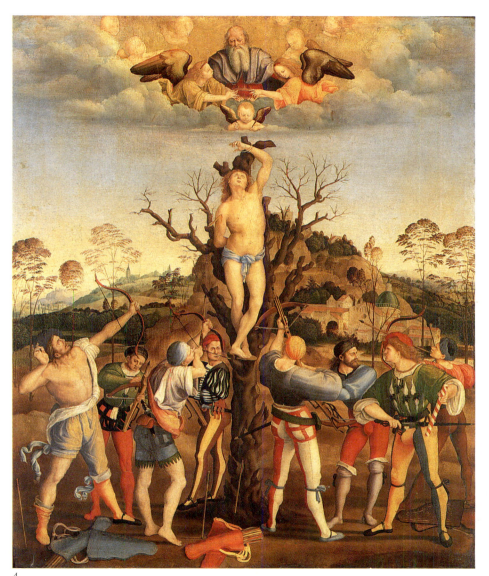

4

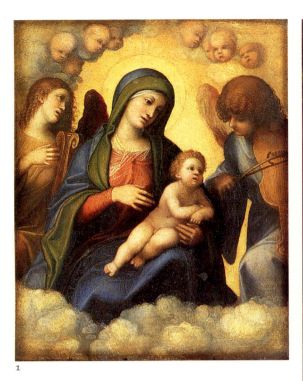

1

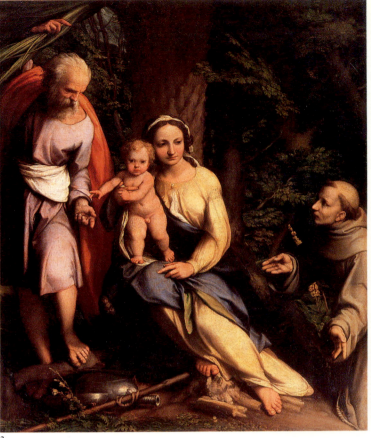

2

1
Antonio Correggio
Reggio Emilia 1489 –
1534 Reggio Emilia
Madonna and Child in glory
Oil on panel, 20 × 16.3 cm
Inv.no.1329
Correggio's small *Virgin and Child* is
reminiscent of Raphael's roughly
contemporary Sistine *Madonna* in the
removal of the holy figures from any
earthly context. However the artist
manages to maintain a sense of
intimacy through the interaction of
the Christ Child with the music-
making angels and through the playful
putto heads formed from clouds.

2
Antonio Correggio
Reggio Emilia 1489 –
1534 Reggio Emilia
The Rest on the Flight into Egypt
Oil on canvas, 123.5 × 106.5 cm
Inv.no.1455
The inclusion of the devotional figure
of St Francis kneeling at the Virgin's
feet is explained by the altarpiece's
original destination: it was made for
the Munari chapel in San Francesco in
the artist's home town of Correggio.

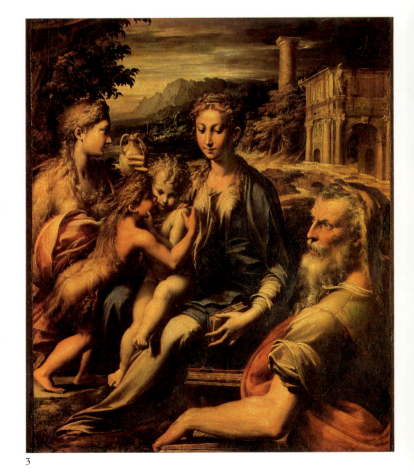

3

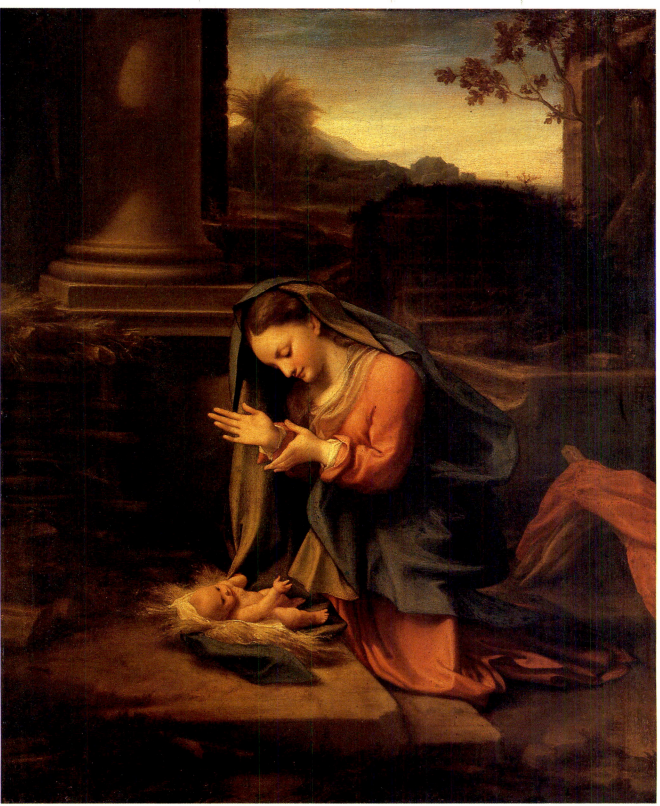

4

3
Parmigianino
Parma 1504 – 1540 Casalmaggiore
The San Zaccaria *Madonna*
Oil on panel, 75.5 × 60 cm
Inv.no.1328

The foreground of this extraordinary
composition is dominated by the bold
half-length figure of Zacchariah, father
of the young St John the Baptist, who
seems to occupy a different psycho-
logical space from the rest of the
group.

4
Antonio Correggio
Reggio Emilia 1489 –
1534 Reggio Emilia
The Virgin adoring the Christ Child
Oil on canvas, 81 × 77 cm
Inv.no.1453

1
Parmigianino
Parma 1504 – 1540 Casalmaggiore
'The Madonna of the Long Neck'
Oil on panel, 219 × 135 cm
Inv.no. Galleria Palatina 230
The commission for this altarpiece,
dating to 1534, came from one of the
most important families in Parma.
Eleana Taliafari ordered the painting
to adorn her husband's burial chapel in
the church of Santa Maria dei Servi in
Parma and, though never completed,
it was still installed there. The compo-
sition, for which the artist produced
many preparatory drawings, empha-
sizes the elongated, serpentine forms
of the foreground figures.

2
Benvenuto Garofalo
Ferrara 1481 – 1559 Ferrara
The Annunciation
Oil on panel, 55.2 × 76 cm
Inv.no.1365

3
Niccolò dell'Abate
Modena *c*1509 – *c*1571 France
Portrait of a young man
Oil on panel, 47 × 41 cm
Inv.no.1377
Perhaps best known for his fine
Mannerist landscapes, Niccolo dell'A-
bate was initially much influenced by
Correggio. In this striking portrait of
an unknown sitter, he concentrates on
the expression of the eyes which
appear to be caught by something
outside the picture to the right-hand
side, beyond the spectator.

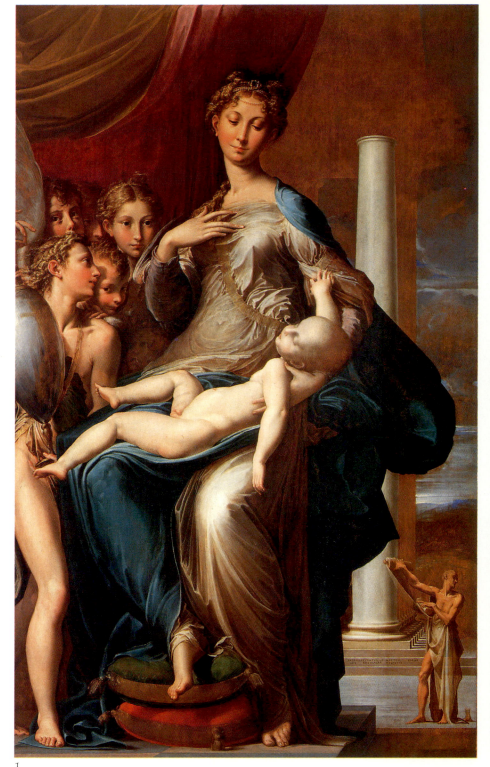

1

146

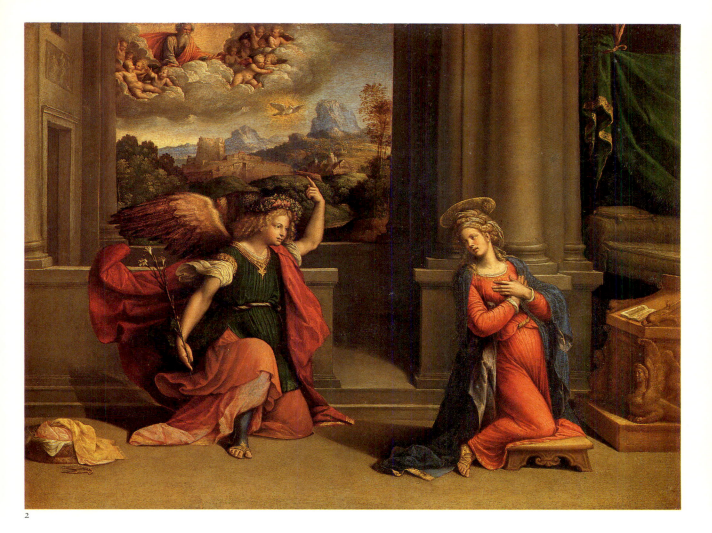

2

3

1
Dosso Dossi
Ferrara c1489 – 1542 Ferrara
The Rest on the Flight into Egypt
Tempera on panel, 52 × 42.6 cm
Inv.no.8382
The influence of Giorgione on the
work of the Ferrarese Dosso Dossi is
apparent in this painting in which the
figures are seated in a lush landscape
before a prominent copse of trees.

2
Dosso Dossi
Ferrara c1489 – 1542 Ferrara
Witchcraft or *Hercules and Omphale*
Oil on canvas, 143 × 144 cm
Inv.no. Galleria Palatina 148
A number of Dossi's secular paintings
are unusual in subject matter and this
work, thought to represent some kind
of magical practice, recalls Dossi's
painting of the witch Circe in Rome in
which the protagonist is surrounded
by mysterious occult objects.
Although the presence of the
voluptuous women and the man with
the spindle has led to the suggestion
that the scene might represent the
feminisation of Hercules under the
influence of Queen Omphale, it seems
more likely that the half nude figure
with the ball and rod is some kind of
magician.

3
Dosso Dossi
Ferrara c1489 – 1542 Ferrara
*The vision of the Virgin to St John the
Baptist and St John the Evangelist*
Oil on panel transferred to canvas,
153 × 114 cm
Inv.no. Depositi 7
This painting once hung in the church
of San Martino at Codigoro. The
monumental figures of the two Sts
John address their gestures to the
spectator while looking up at the
Virgin and Child in glory. St John the
Evangelist had been entrusted with
the care of the Virgin at the Cruci-
fixion, while St John the Baptist had
preached the coming of Christ.

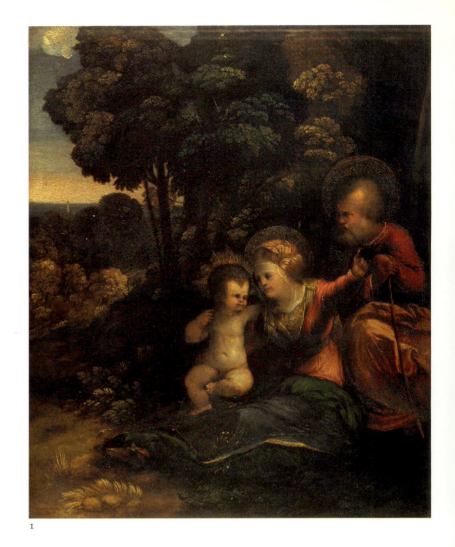

1

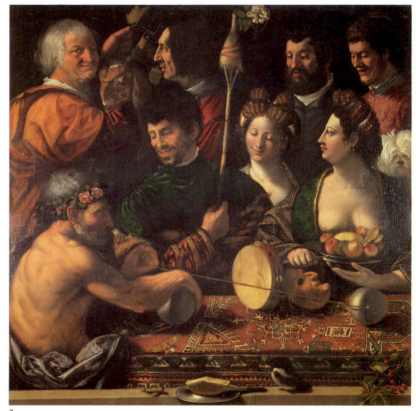

2

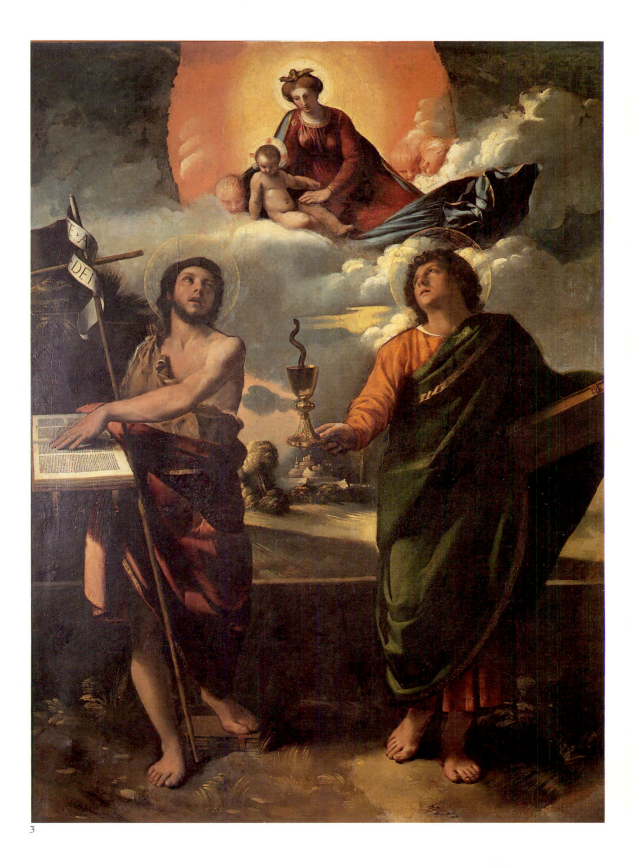

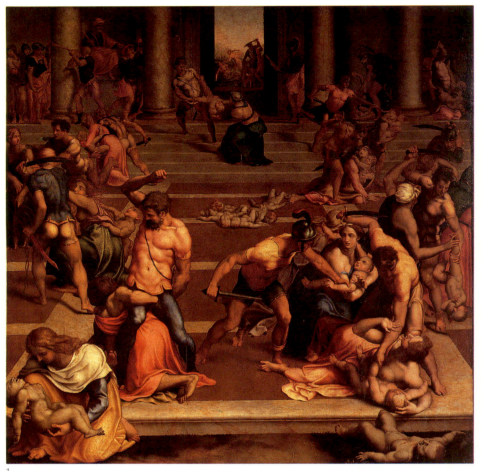

1

Daniele da Volterra
Volterra 1509 – 1566 Rome
The Massacre of the Innocents, c1557
Oil on panel, 51 × 42 cm
Inv.no.1429
This panel was painted for the church
of San Pietro in Volterra, the work
being paid for in October 1557. The
monumental symmetry of the setting
recalls Raphael's *School of Athens* while
the nude figures in action are directly
influenced by Michelangelo's *Last
Judgement* in the Sistine Chapel.

2

Federico Barocci
Urbino 1535 – 1612 Urbino
Portrait of Francesco II della Rovere
Oil on canvas, 113 × 93 cm
Inv.no.1438
This portrait is thought to have been
painted in Florence in 1572, shortly
after Francesco II's return from the
victory against the Turks at Lepanto.
The half-length format of the painting
with the prince shown in armour, one
arm stretched forward, deliberately
recalls the famous portrait of the
sitter's father by Titian (p.158).

3

Federico Barocci
Urbino 1535 – 1612 Urbino
The Madonna of Mercy, signed and
dated 1579
Oil on panel, 359 × 252 cm
Inv.no.751
The enormous scale and complexity
of this altarpiece involved Barocci in a
long series of preparatory drawings
that survive in the Uffizi collection.
The panel was made for the Con-
fraternity of the Madonna of Mercy in
Arezzo and was originally sur-
mounted by a lunette of God the
Father, still *in situ*. The altarpiece
shows the Virgin of Mercy interced-
ing with Christ for the people of the
town.

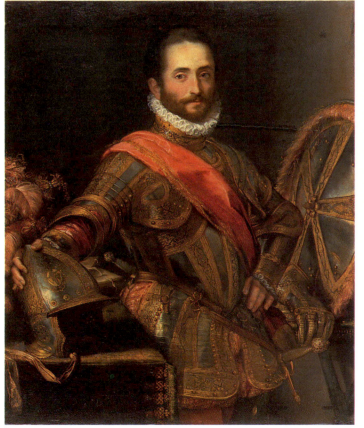

2

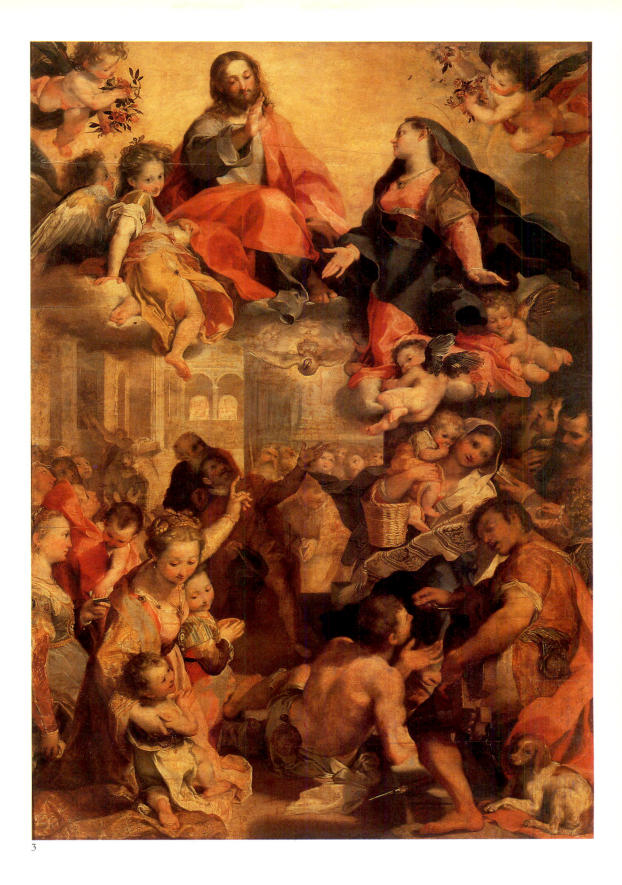

3

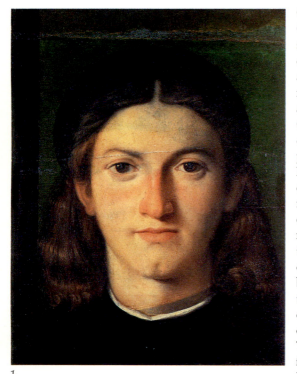

1

1
Lorenzo Lotto
Venice *c*1480 – *c*1556 Loreto
Portrait of a young man
Oil on panel, 28 x 22 cm
Inv.no.1481

2
Attributed to Giorgione
Castelfranco *c*1477 – 1510 Venice
Captain with a page
Oil on canvas, 90 × 73 cm
Inv.no.911
Although it is not known who
actually executed this picture, the
composition and many of the pictorial
ideas can be associated with Gior-
gione. The portrait type, a half-length
figure in armour, is reminiscent of
Giorgione's self-portrait as David,
while Vasari describes a lost painting
by Giorgione in which his painterly
skill is displayed partly through the
creation of illusionistic reflections in
armour.

Giorgione, developing intuitions and suggestions in the work of
Giovanni Bellini and Carpaccio, succeeded at the beginning of the
sixteenth century in establishing some of the fundamental
characteristics of Venetian art, in which colour would become an
autonomous means of expression and the fall of light on things, as
much as the things themselves, would be the object of the painter's
attention. In Titian, who began his career in close association with
Giorgione, Venetian painting achieved its definition, and the formation
of those original characteristics which set it almost in opposition to the
principles of form and composition of the Central Italian school.
Founded on the predominant values of light and colour, it was also
entirely governed by an aesthetic rooted in naturalism, in the truthful
response to the real and actual world, and in the fulsome and sensual
enjoyment of nature. His very long career, with its great religious and
mythological compositions and its portraits of all the great men of his
time, marks the stages of the evolution of Venetian art during the
century. In his extrovert maturity, he indulged a frank sensuality in
bright and sumptuous colours and forms, in the tender evocation of
the countryside familiar to him; then gradually he yielded to the more
opaque and troubled meditativeness of his last canvases, with a
concomitant darkening of the colours and dissolution of the forms.
The Uffizi has some fundamental works of different type and period,
from the authoritative grandeur of the portraits of the Duke and
Duchess of Urbino to the radiant carnality of the 'Venus of Urbino'.

Palma Vecchio, following in Titian's wake, opened out his forms
with comparatively rather contrived effect; meanwhile Sebastiano del
Piombo and Tintoretto, each pursuing their own paths, in their
different ways sought a synthesis of the contrasting values of the two
great schools of the mature Renaissance. The former, during the part
of his career spent in Rome, worked to assimilate Michelangelo's
weighty dynamic (as in the Uffizi's *Death of Adonis*); Tintoretto, on the
other hand, deliberately disrupted harmonies of tone and composition
in order to create an original, theatrical, forceful and visionary art that
introduces a kind of silver age into Venetian painting. Paolo Veronese,
however, in his great decorative fresco cycles (for instance the Villa
Barbaro, Maser) and in sumptuous canvases in which the material of
the paint seems shot through with light, remained faithful to High
Renaissance ideals, transmogrifying the solemn pageantry of the
Venetian republic into a colouristic fanfare. Works of this quality by
Veronese in the Uffizi include his *Annunciation* and a *Holy Family*.

The numerous works of Jacopo Bassano and his atelier also make up
an important element in Venetian painting: after serene beginnings
influenced by Titian he then became subject to Mannerist ferments
aroused by contact with Central Italian and especially Emilian art.
Though faithful to Venetian colourism, and with a distinctive, resonant
palette, Bassano was always open to change and alert to every
novelty, and was capable not only of originality but even of
anticipating trends.

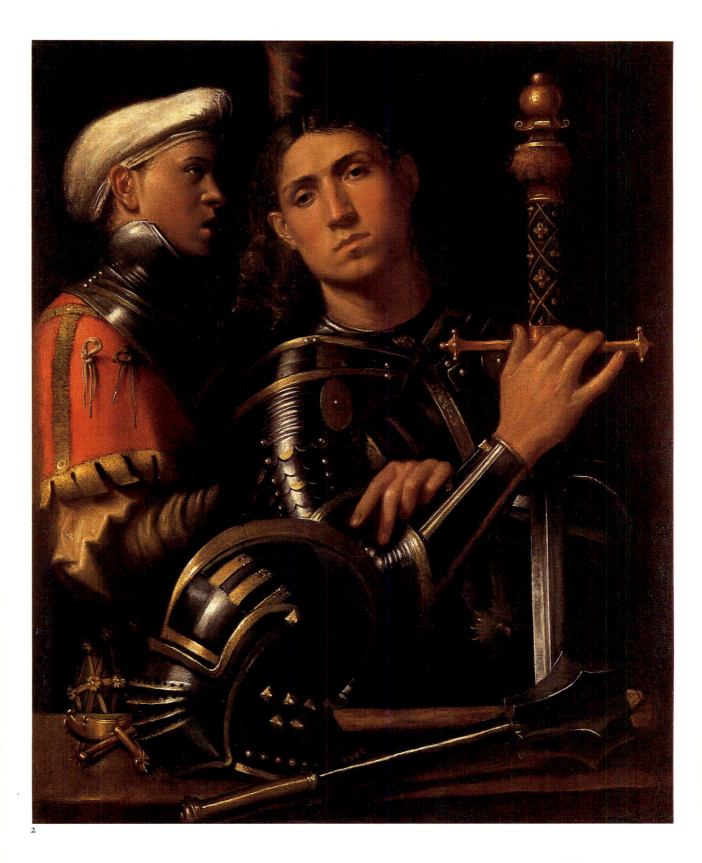

2

1
Giorgione
Castelfranco *c*1477 – 1510 **Venice**
The judgement of Solomon
Oil on panel, 89 × 72 cm
Inv.no.947
This panel and its pendant, *The trial of*

Moses, were attributed to Giorgione when they entered the Uffizi collection, though their date and the identity of assistants who may have contributed to the figures have been debated.

2
Giorgione
Castelfranco *c*1477 – 1510 **Venice**
The trial of Moses
Oil on panel, 89 × 72 cm
Inv.no.945

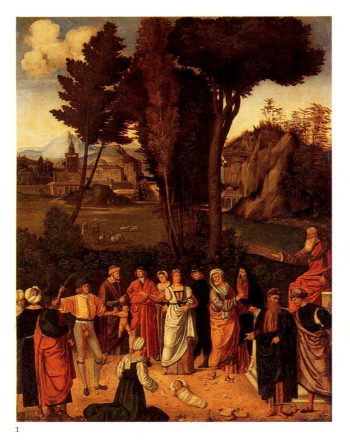

1

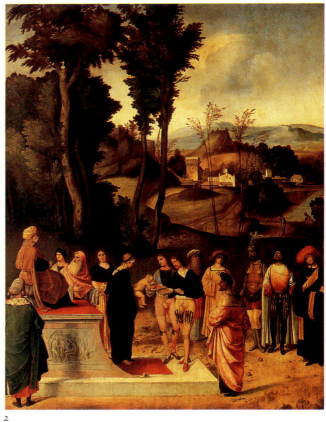

2

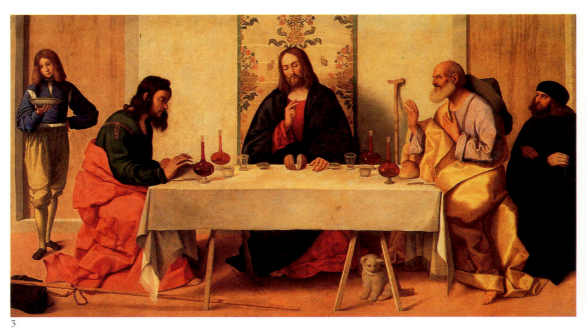

3

3
Vincenzo Catena
Venice *c*1480 – 1531 Venice
The Supper at Emmaus
Oil on canvas, 130 × 241 cm
Inv.no. Contini Bonacossi 15

4
Giovanni Savoldo
Brescia *c*1480 – 1548 Venice
or Brescia
The Transfiguration
Oil on panel, 139 × 126 cm
Inv.no.930
This composition, dividing the figures
of Christ and the Prophets on Mount

Tabor from the astonished figures of
the disciples thrown to the ground
below, is clearly related to Raphael's
late *Transfiguration* in the Vatican,
completed a few years previously.
Particular emphasis has been laid on
the complex poses and foreshortened
gestures of the disciples.

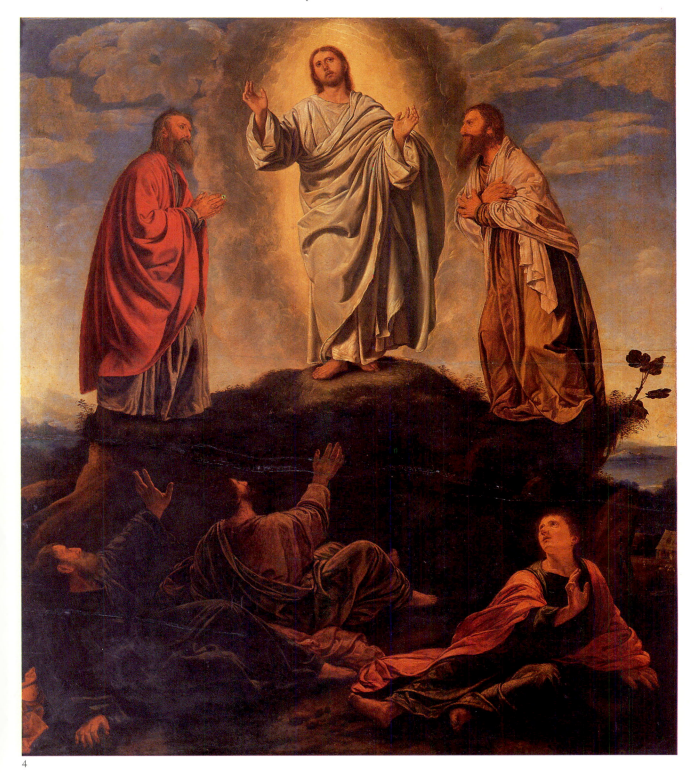

4

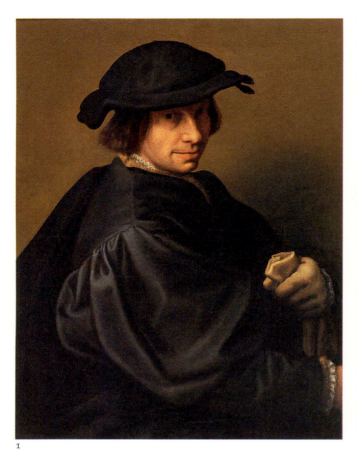

1

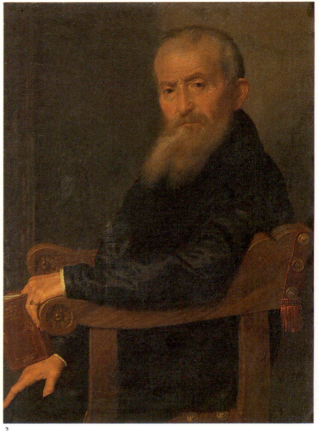

2

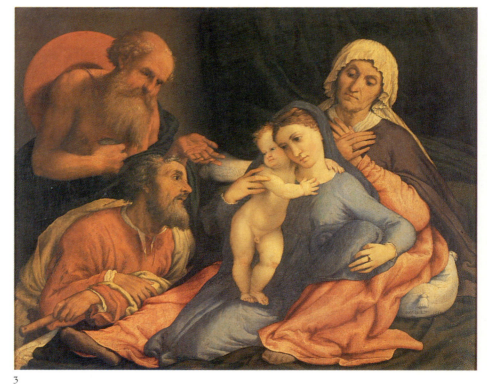

3

1
Giulio Campi
Cremona 1502 – c1572 Cremona
Galeazzo Campi
Oil on canvas, 78.5 × 62 cm
Inv.no.1628

2
Giovanni Battista Moroni
Albino 1529/30 – 1578 Bergamo
Giovanni Antonio Pantera
Oil on canvas, 81 × 63 cm
Inv.no.941
The sitter has been identified on the
basis of the copy of his popular
spiritual poem, the *Monarchy of Christ*,
that he holds in his left hand.
Moroni's tendency to diminish the
proportions of his sitters' bodies in
order to concentrate attention on the
head is particularly apparent in this
example.

3
Lorenzo Lotto
Venice *c*1480 – *c*1556 Loreto
The Holy Family with St Jerome, signed
and dated 1534
Oil on canvas, 69 × 87.5 cm
Inv.no.893

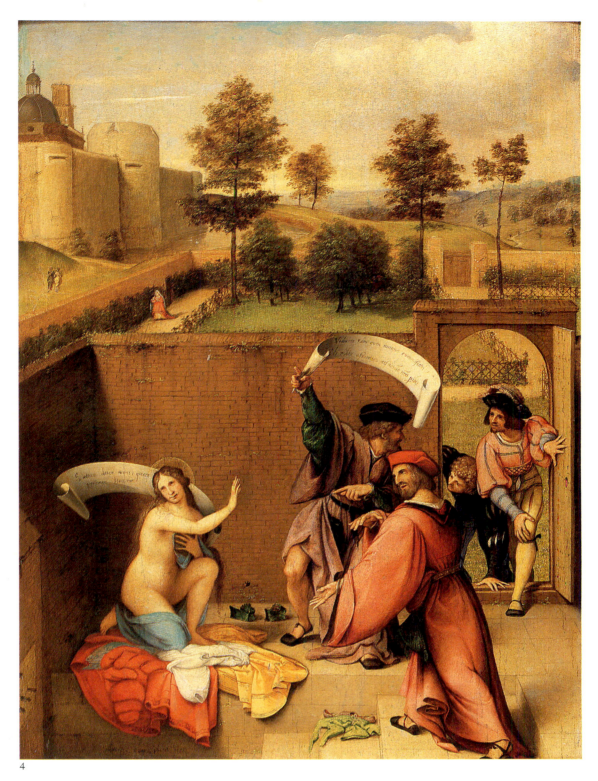

4

4
Lorenzo Lotto
Venice c1480 – c1556 Loreto
The chastity of Susannah, signed and
dated 1517
Oil on panel, 66 × 50 cm
Inv.no.9491
This painting is signed on the inside

wall of the pool where Susannah has
been bathing. The familiar Old Testa-
ment narrative of the lecherous Elders
who spied on the beautiful Susannah
is elucidated by the 'speech scrolls'
held by the protagonists, Susannah
exclaiming that she would rather die
than fall into sin.

1
Titian
Pieve of Cadore c1488 –
1576 Venice
Portrait of a man (*'Il uomo malato'*)
Oil on canvas, 81 × 60 cm
Inv.no.2183
The inscription along the top of this
painting records an early date of 1514
and the age of the unknown sitter as
twenty-three. The epithet attached to
the painting is due to the pale flesh
tones of his face, caught in a raking
light against the lush texture of his fur
collar. Noblemen were commonly
portrayed wearing gloves in this
period as they were considered a sign
of distinction.

2
Titian
Pieve of Cadore c1488 –
1576 Venice
Portrait of Francesco Maria della
Rovere
Oil on canvas, 114 × 103 cm
Inv.no.926
The Duke of Urbino is shown here in
his armour as captain of the papal
league. The highly inventive martial
pose devised by Titian was previously
used by the artist for the commander
directing troops with his baton in a
lost fresco for the Doge's palace. The
format was so successful that it was
later used by Barocci for the portrait
of the duke's son Francesco II (p.151).

3
Giovanni Battista Moroni
Albino 1529/30 – 1578 Bergamo
Portrait of Count Secco Suardo, signed
and dated 1563
Oil on canvas, 183 × 104 cm
Inv.no.906
This portrait is characteristic of
Moroni's full-length portraits of
noblemen – in the delicate silhouet-
ting of the figure against a neutral-
toned, often classicizing, architectural
backdrop. The sitter here is shown
pointing to a vase of flame, a symbol
of desire.

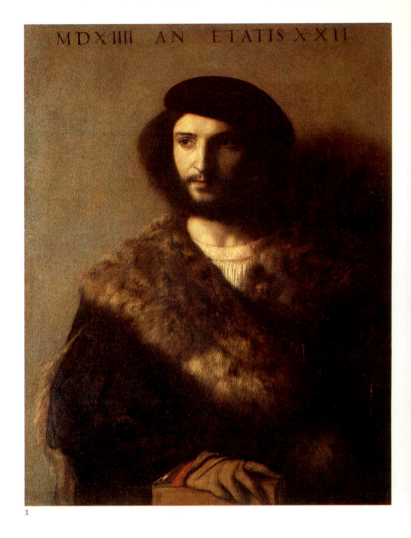

1

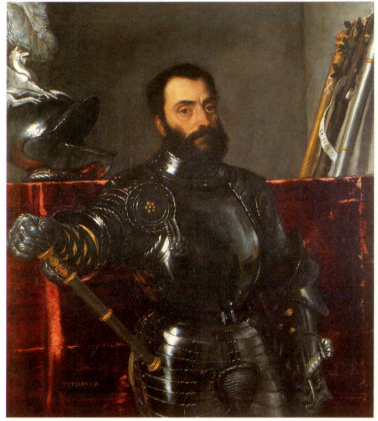

2

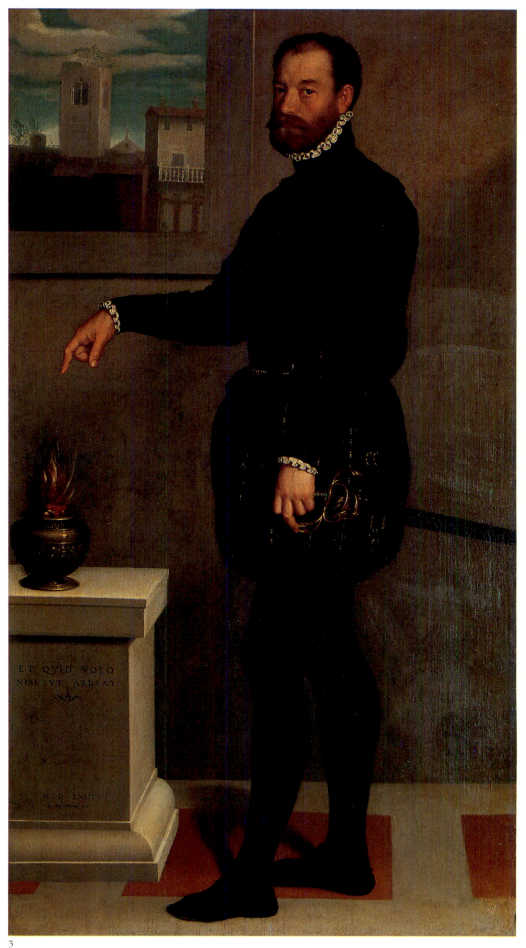

3

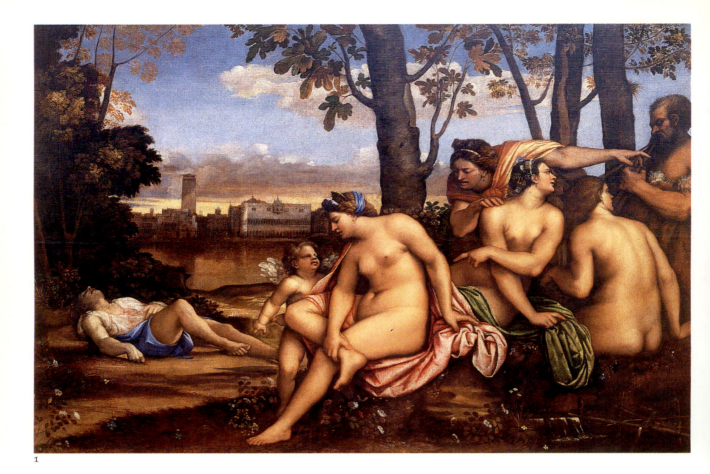

1

1

Sebastiano del Piombo
Venice *c*1485 – 1547 Rome
The death of Adonis
Oil on canvas, 189 × 285 cm
Inv.no.916
Probably dating to shortly after
Sebastiano's arrival in Rome in 1511,
this scene of Venus receiving the news
of the death of Adonis is Venetian in
its poetic mood and landscape setting,
but the monumental figures seem
already to show Roman influence.
Venus's lover, the young huntsman
Adonis, lies on the left having been
slain by a boar.

2

Sebastiano del Piombo
Venice *c*1485 – 1547 Rome
Portrait of a woman, dated 1512
Oil on panel, 68 × 55 cm
Inv.no.1443
The physiognomy of the sitter seems
to conform to an ideal type often
portrayed by Sebastiano. It is possible
therefore that the portrait conforms to
the Venetian genre of the beautiful
woman painting rather than represent-
ing a specific sitter.

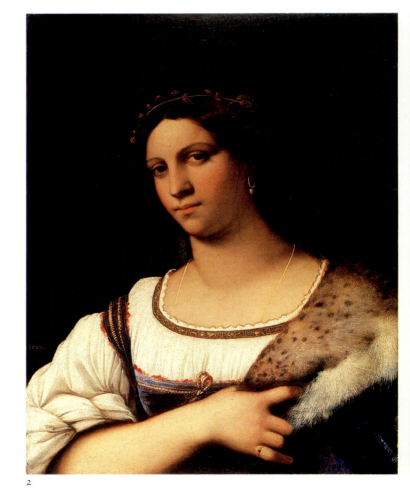

2

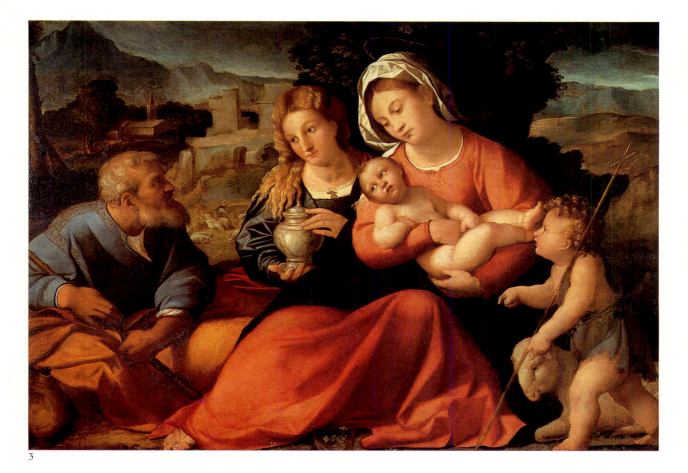

3

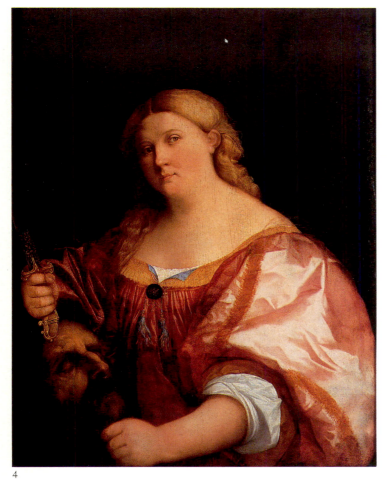

4

3
Palma Vecchio
Serina _c_1480 – 1528 Venice
_The Holy Family with St John and St
Mary Magdalen_
Oil on panel, 87 × 117 cm
Inv.no.950

4
Palma Vecchio
Serina _c_1480 – 1528 Venice
Judith
Oil on panel, 90 × 71 cm
Inv.no.939
Palma Vecchio painted a number of
similar compositions of beautiful
women. These 'portraits' of ideal
women are clearly inspired by con-
temporary Venetian fashion, with their
emphasis on sumptuous _decolleté_
gowns and blonde hair.

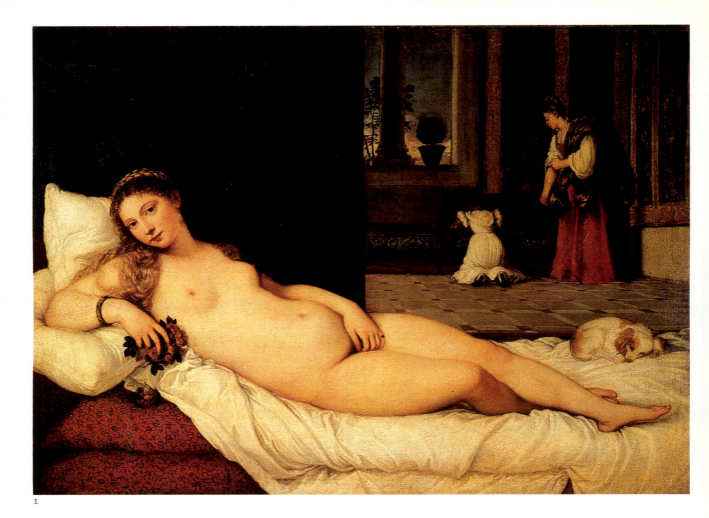

1

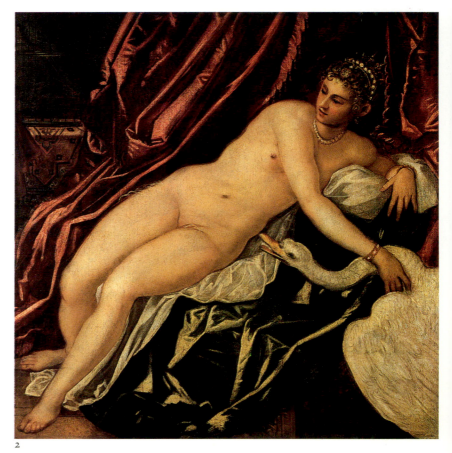

2

1
Titian
Pieve of Cadore c1488 –
1576 Venice
'The Venus of Urbino'
Oil on canvas, 119 × 165 cm
Inv.no.1437
The painting draws its title from the
fact that it was commissioned in 1538
by Guidubaldo della Rovere, Duke of
Urbino. It entered the Medici collec-
tions when Vittoria della Rovere,
heiress to the Urbino duchy, became
the wife of Duke Ferdinando II of
Tuscany.

2
Jacopo Tintoretto
Venice 1518 – 1594 Venice
Leda and the swan
Oil on canvas, 147.5 × 147.5 cm
Inv.no.3084
Tintoretto's *Leda and the swan* can
usefully be compared with Titian's
Venus to which it relates in type.
But while Titian's composition is
restrained and planar in effect, Tin-
toretto's conception is characteris-
tically more dramatic, with a dominant
diagonal.

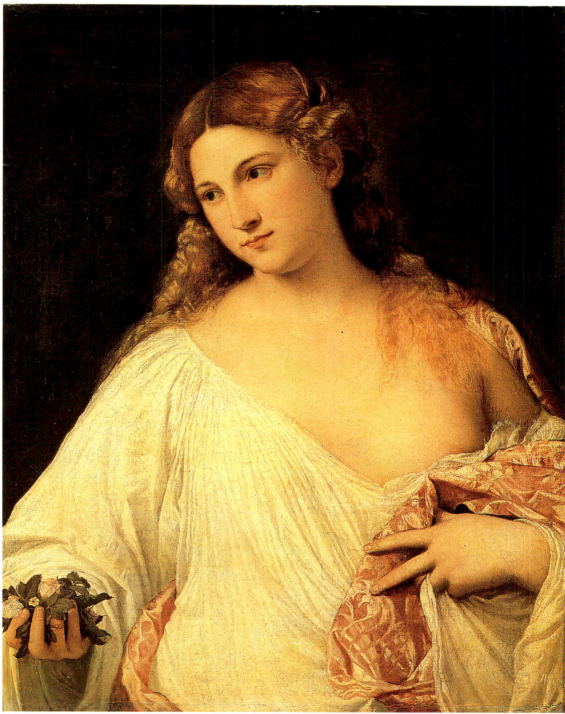

3

3
Titian
Pieve of Cadore *c*1488 –
1576 Venice
Flora
Oil on canvas, 79.7 × 63.5 cm
Inv.no.1462
Despite representing a goddess, this
half-length painting of a beautiful
woman in a state of *dèshabille* falls
within the same category of picture as
Palma Vecchio's *Judith* (p.161), which
it probably predates. Titian's skill in
suggesting the contrasting textures of
skin and fragile material gives the
subject a sensuous allure that formerly
caused the work to be considered the
portrait of a courtesan.

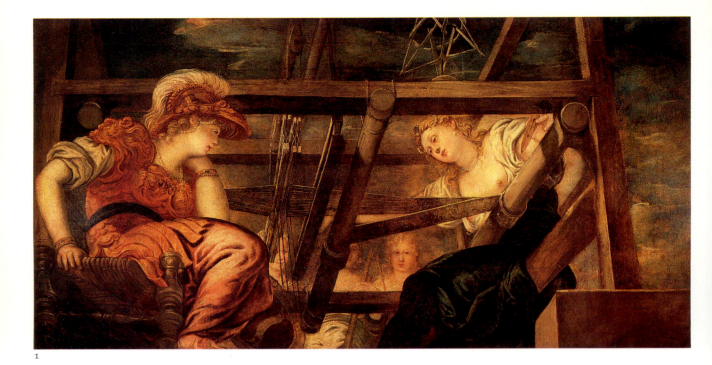

1

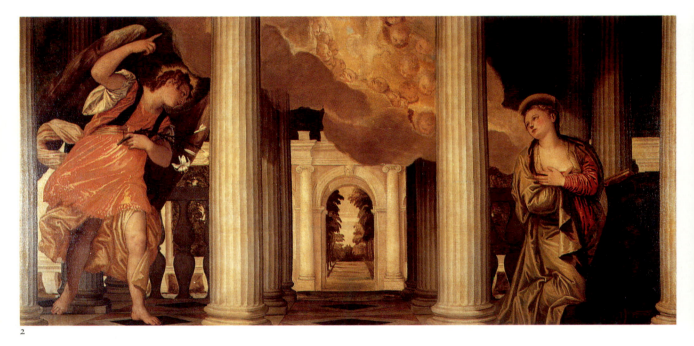

2

1

Jacopo Tintoretto
Venice 1518 – 1594 Venice
Athena and Arachne
Oil on canvas, 145 × 272 cm
Inv.no. Contini Bonacossi 35
This canvas, which may originally
have been octagonal, forms a pair
with Tintoretto's *Diana and Endymion*
(inv.no. Contini Bonacossi 34). The
very low angle from which the scene
is depicted suggests that it was
intended to decorate a ceiling.
Through the bars of a loom the scene
shows Athena looking on as the

mortal Arachne proves her skill as a
weaver. In her jealousy of the girl's ability,
Athena turned Arachne into a spider.

2

Paolo Veronese
Verona 1528 – 1588 Venice
The Annunciation
Oil on canvas, 143 × 291 cm
Inv.no.899
Various components of this highly
theatrical work occur in other paint-
ings by Veronese, notably in an
Annunciation in Padua, which predates
this version of the 1550s by a few

years, and in a later canvas in the
Accademia in Venice. The house of
the Virgin has been conceived as a
kind of Palladian stage set of which
the regularity renders more dramatic
the appearance of the vibrant angel
and the diagonal descent of the Holy
Spirit in a swirl of cloud.

3

Paolo Veronese
Verona 1528 – 1588 Venice
Giuseppe Da Porto with his son Adriano
Oil on canvas, 247 × 133 cm
Inv.no. Contini Bonacossi 16

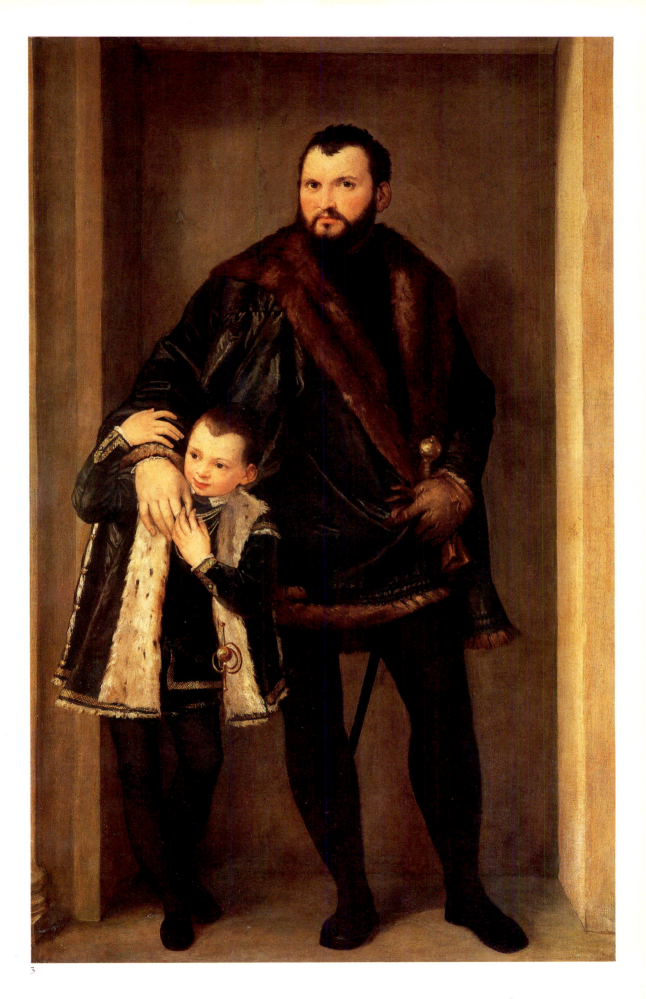

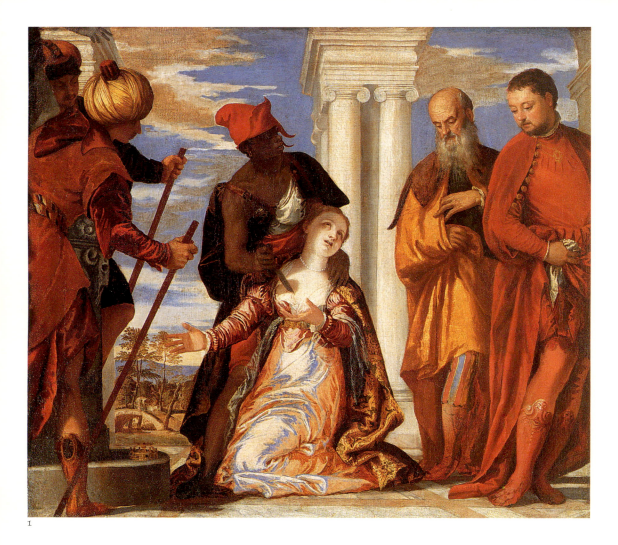

1

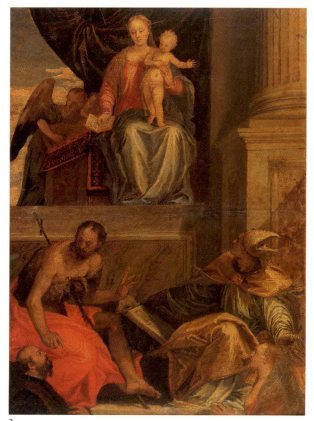

1

Paolo Veronese
Verona 1528 – 1588 Venice
The martyrdom of St Justine
Oil on canvas, 103 × 113 cm
Inv.no.946

2

Attributed to Paolo Veronese
Verona 1528 – 1588 Venice
*Virgin and Child enthroned with saints
and donors* (sketch for the Bevilacqua
altarpiece?)
Oil on canvas, 50 × 36 cm
Inv.no.1316

2

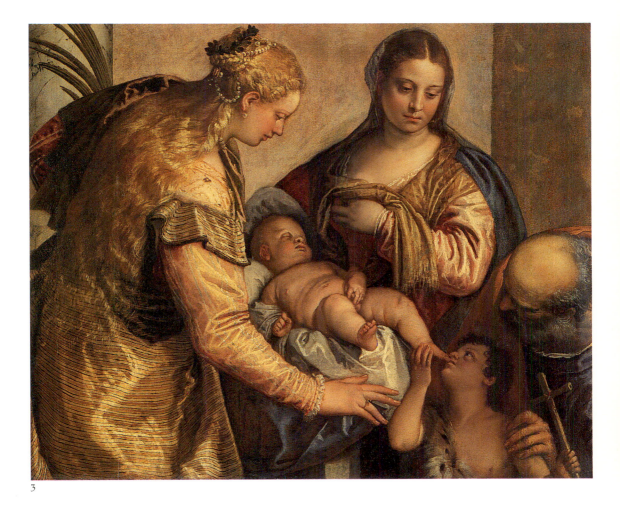

3

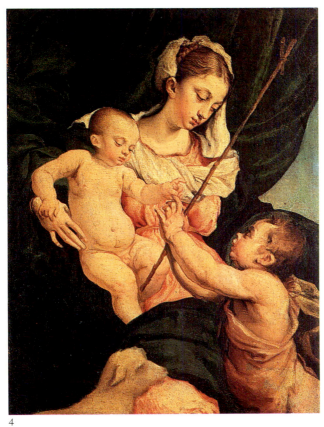

4

3
Paolo Veronese
Verona 1528 – 1588 Venice
Holy Family with St Catherine and the
young St John the Baptist
Oil on canvas, 86 × 122 cm
Inv.no.1433
Recent cleaning has restored its
original light-coloured background to
the painting.

4
Jacopo Bassano
Bassano c1515 – 1592 Bassano
Madonna and Child with the young
St John the Baptist
Oil on canvas, 79 × 60 cm
Inv.no. Contini Bonacossi 18

Painting in Italy (outside Tuscany) in the 17th century

1

2

From the Lombard tradition of plain realism, which had already led in the sixteenth century to interest in the effects of light, and which was by no means provincial in its cultural resources, Caravaggio forged a naturalistic vision that runs through the whole spectrum of Italian seventeenth-century art. His revision of the traditional means of expression is evident in all his work, whether his subject is from mythology, from the New Testament or is 'just' a still life — a genre he elevated to the rank of independent subject. One may see, for example, that in the Bacchus in the Uffizi the classical idealisation is minimal: he has used as a model a young boy from the street whose peasant features he has dressed up in drapery and a wreath of grapes. The fierce and firm light makes actual the physical existence of the figure as of the basket of fruit and the bottle, immortalising them like an ephemeral, but compelling, snapshot.

At the opposite pole, Annibale Carracci's *Venus* fully belongs to the world of myth, and is extraordinarily rich pictorially — a veritable 'summa' of sixteenth-century traditions, though the largest element is Venetian colourism. Its evocation of the antique is composed of a sensuality that is also Venetian, a studied elegance — even in the broad form of her powerful back — that is unmistakably Mannerist, and a new confidence and spirit that belong to the new century. This is an outstanding work, immediately recalling the richer and more complex decoration of Annibale's Farnese Palace frescos in Rome, illustrating how the Bolognese school of Annibale, his brother Ludovico and his cousin Agostino signalled an alternative way forward out of the impasse of Late Mannerist formalism.

In the wake of the Carracci, of Caravaggio and of the greatest representative in Italy of the 'high' Baroque, Pietro da Cortona (also represented in the Uffizi, as well as by his long activity painting in the Pitti Palace), there moved a large number of gifted and active artists who covered almost every region and pictorial 'school' of Italy. Among the Caravaggisti, there was Artemisia Gentileschi, recently 're-discovered' thanks to an important exhibition in Florence devoted to her, whose vicious and cruel *Judith and Holofernes* in the Uffizi is deeply charged with personal meaning; there was Bartolomeo Manfredi, in whose convivial candle-lit scenes the severity of the Caravaggesque message is diffused by flourishes of drapery and demonstrations of virtuosity; there were also the Neapolitan painters, chief among them Battistello and Cavallino, bewitched by the time they spent in Caravaggio's native Lombardy.

The Bolognese collaborators and followers of the Carracci are hardly less numerous or varied in their production, though they shared a common ground of well ordered, well studied classicism: Domenichino, Reni, Albani, Guercino — artists who at Rome would establish a lasting current of classical taste.

Thereafter comes a rich period, basking in the warm colours of Venetian painters such as Feti, Carpioni, Forabosco, Strozzi (from Genoa, but transplanted to Venice) and the German-born Liss (whose Rubensian *Toilet of Venus* in the Uffizi is luxuriously carnal); also the

1
Annibale Carracci
Bologna 1560 – 1609 Rome
Self-portrait in profile
Oil on canvas, 45.4 x 37.9 cm
Inv.no.1797

2
Annibale Carracci
Bologna 1560 – 1609 Rome
Man with a monkey
Oil on canvas, 68 x 58.3 cm
Inv.no.799

3

3
Annibale Carracci
Bologna 1560 – 1609 Rome
Venus, satyr and putti
Oil on canvas, 112 x 142 cm
Inv.no.1452
Justifiably one of Annibale Carracci's
most acclaimed paintings, the diagonal
sweep of the goddess's back has the
sensual appeal of Titian's *Venus and
Adonis* for Philip II, though here the
departing lover is replaced by the
lascivious attention of a satyr. Con-
sidered shocking in the 18th century,
it was covered with another canvas,
remaining in this state until 1812.

Genoese painters, Castiglione foremost among them, updated their
repertoire by reference to the new works that arrived there of the
Flemish and Dutch schools.

This is also the century in which the different genres of painting
became established: of landscape, for instance, evoked and idealised by
Claude (whose *Harbour scene with the Villa Medici* is in the Uffizi), but
also in views from the Bambocciati and from Codazzi of Roman ruins
and monuments enlivened by passing figures; battle-pieces, by
Borgognone and Salvator Rosa; still life, by Munari, Recco and others.
Portraiture flourished, in images of great authority and expressive
vigour – thanks also to the presence in Italy of foreign specialists of
the highest quality such as Van Dyck and Sustermans, and for a
moment at least of Rubens, the greatest representative of Baroque
painting in Europe.

1

Domenichino
Bologna 1581 – 1641 Naples
Portrait of Cardinal Girolamo Agucchi
Oil on canvas, 142 × 112 cm
Inv.no.1428
This splendid official portrait of the
newly elected cardinal Girolamo
Agucchi was made in the year of his
death, 1605. While creating an image
of ecclesiastical power, Domenichino
must also have had some familiarity
with the sitter, having established
connections with the Agucchi family
in Rome.

2

Guido Reni
Bologna 1575 – 1642 Bologna
The Madonna of the Snow
Oil on canvas, 280 × 176 cm
Inv.no.3088
This painting originally hung in the
chapel of the Madonna of the Snow in
Santa Maria di Corte Orlandini in
Lucca, together with a pendant paint-
ing of the *Crucifixion with St Julius and
St Catherine* that has remained in Lucca
in the Museum of the Villa Giunigi.

3

Francesco Albani
Bologna 1578 – 1660 Bologna
Putti dancing
Oil on copper, 31.8 × 41.2 cm
Inv.no.1314

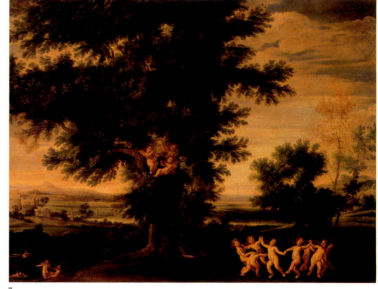

2

3

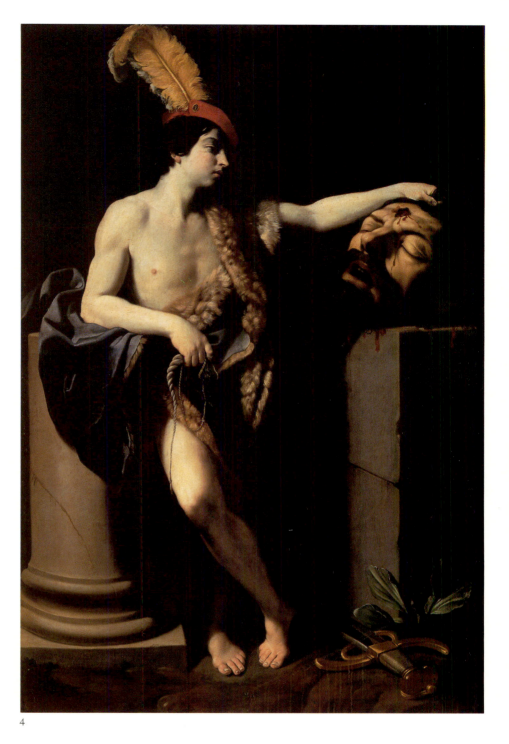

4

4
Guido Reni
Bologna 1575 – 1642 Bologna
The victorious David
Oil on canvas, 222 × 147 cm
Inv.no.3830
The painting is generally considered
to be an autograph variant of Reni's
David in the Louvre, though many
copies of the composition survive by
other hands. It demonstrates the
strong early influence on Reni of
Caravaggio.

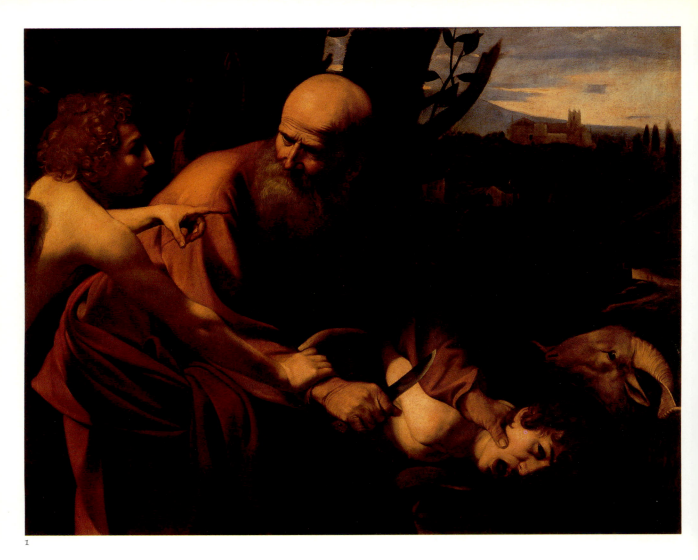

1

1

**Michelangelo da Caravaggio
Milano or Caravaggio 1570/71 –
1610 Porto Ercole**
The Sacrifice of Isaac
Oil on canvas, 104 × 135 cm
Inv.no.4659
This may be a work for which
Caravaggio was paid in Rome in
1603, and it is kin to those saints he
painted for altarpieces there that were
rejected by the churches for their
excessive naturalism. Abraham sets
about sacrificing his son with the
crude expertise of a peasant, and the
muscular effort of holding him back is
such as to register even in the angel's
features.

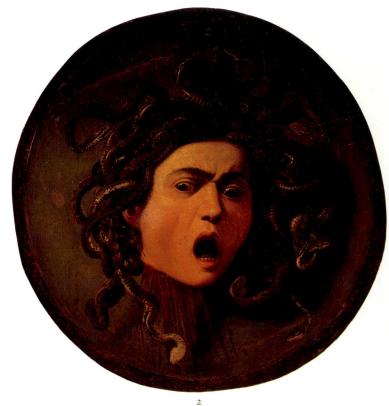

2

3

2
**Michelangelo da Caravaggio
Milano or Caravaggio 1570/71 –
1610 Porto Ercole**
Medusa
Oil on canvas over panel,
diameter 55 cm
Inv.no.1351

The facial distortion of the slain
Medusa is emphasized by the slight
misplacement of the features such
that, although the head is seen at an
angle, the mouth is seen from the
front. The shield was probably painted
in 1600.

3
**Michelangelo da Caravaggio
Milano or Caravaggio 1570/71 –
1610 Porto Ercole**
Bacchus
Oil on canvas, 95 × 85 cm
Inv.no.5312

1

1
Bartolomeo Manfredi
Ostiano *c*1587 – 1620/21 Rome
Concert
Oil on canvas, 130 × 189.5 cm
Inv.no. Depositi 155

2
Guercino
Cento 1591 – 1666 Bologna
Concert in the country
Oil on copper, 34 × 46 cm
Inv.no.1379

2

3

3
Artemisia Gentileschi
Rome 1593 – 1652 Naples
Judith and Holofernes
Oil on canvas, 199 × 162.5 cm
Inv.no.1567
Daughter of the painter Orazio
Gentileschi, also a follower of

Caravaggio, Artemisia is probably
best known for this surprisingly
graphic rendering of the death of
Holofernes. The composition is
known in several versions, and it is
unclear whether the Uffizi or the Pitti
example was that painted in Florence
for Duke Cosimo II.

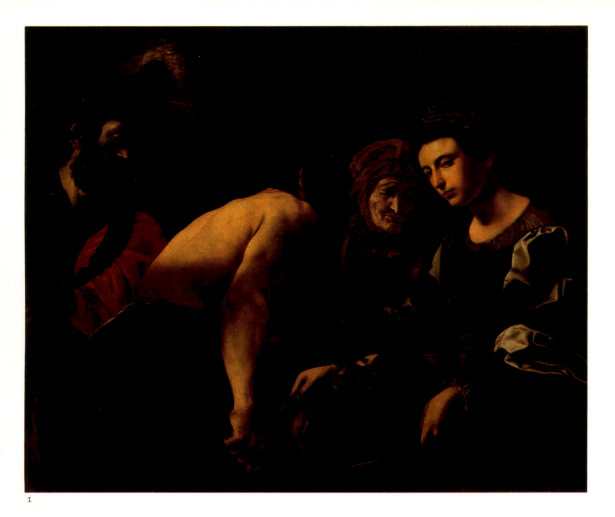

1

Battistello
Died Naples 1637
Salome
Oil on canvas, 132 × 156 cm
Inv.no. Depositi 30

2

Pietro da Cortona
Cortona 1596 – 1669 Rome
St Filippo Neri curing Clement VIII of gout
Oil on canvas, 60 × 73 cm
Inv.no. Castello 483
Filippo Neri, who founded a reforming religious order and was later canonised, was said to have been able to relieve Pope Clement's chronic gout. This was painted during the 1640s, while the artist was in Florence.

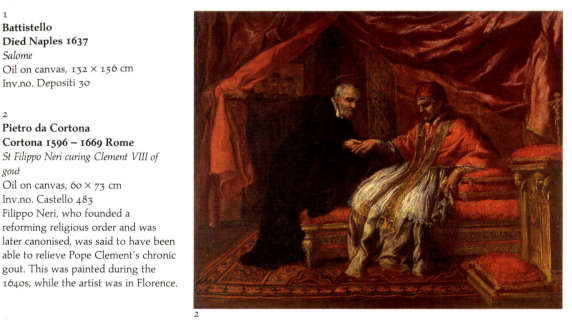

2

3
Giovan Battista Sassoferrato
Sassoferrato 1609 – 1685 Rome
or Florence
The sorrowing Virgin
Oil on canvas, 62 × 58 cm
Inv.no.773

4
Il Baciccio
Genoa 1639 – 1709 Rome
Portrait of Cardinal Leopoldo de'
Medici
Oil on canvas, 73 × 60 cm
Inv.no.2194

5
Bernardo Cavallino
Naples 1616 – 1656? Naples
Esther before Ahasuerus
Oil on canvas, 76 × 102 cm
Inv.no.6387

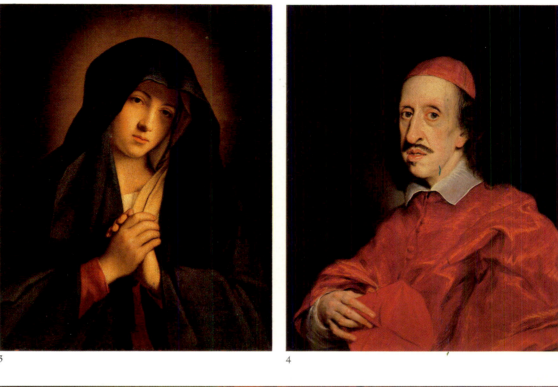

3

4

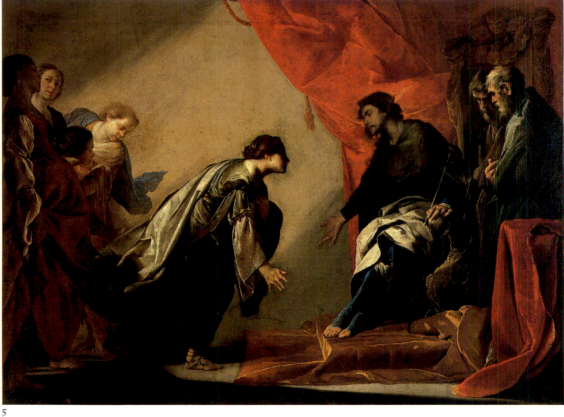

5

1
Viviano Codazzi
Bergamo 1604 – 1670 Rome
Architectural view with two arches
Oil on canvas, 73 × 98 cm
Inv.no.774
This painting forms a pendant to
another view of classical ruins by

Codazzi (inv.no.773). This genre of
painting combines imaginatively
devised Roman ruins – in this case a
column and part of a pier with a
coffered vault – with the apparently
realistic contemporary accretions of
17th-century buildings and people.

1

2
Mattia Preti
Taverna 1613 – 1699 Malta
Vanity
Oil on canvas, 93.5 × 65 cm
Inv.no.9283
The figure has been seen as an alle-
gory of Vanity on the basis of her
mirror and the beads lying on her
table.

2

178

3
Salvator Rosa
Naples 1615 – 1673 Rome
Battle scene
Oil on canvas, 95 × 145 cm
Inv.no.8385
The painting is signed by the artist on

the cornice of the temple to the
right-hand side. Painted during the
1640s when he was in Tuscany, it is
not clear whether a specific conflict is
being represented or simply a generic
battle scene congenial to the artist's
love of the dramatic.

3

4
Giuseppe Recco
Naples 1634 – 1695 Alicante
Fish and tackle on the beach, signed and
dated 1691
Oil on canvas, 127 × 153 cm
Inv.no.4862
This still life seems to have entered
the collection of Ferdinando de'
Medici shortly after it was painted, at
the end of the 17th century.

4

179

1

2

3

1
Alessandro Magnasco
Genoa 1667 – 1749 Genoa
Gypsy meal
Oil on canvas, 56 × 71 cm
Inv.no.8470
The decay of the surroundings and
the weird light is used to complement
the chaotic and uncouth behaviour
visualised by the artist in this fantasy
scene.

2
Giovanni Benedetto Castiglione
Genoa c1600 – 1663/65 Mantua
Circe
Oil on canvas, 182 × 214 cm
Inv.no.6464
Predating Magnasco's painting by
some 50 years, Castiglione's painting
of the witch Circe shares something of
the same fascination with the gro-
tesque. Nonetheless, the spectator is
distracted from the more occult aspects
of the painting by the accumulation of
still-life interest in the foreground.

3
Johann Liss
Oldenburg c1595 – 1629 Venice
The Sacrifice of Isaac
Oil on canvas, 88 × 69.5 cm
Inv.no.1376
This lush, Rubensian composition was
painted by the German painter Liss
while living in Venice. It provides a
marked contrast to the contemporary
work of the Caravaggisti and particu-
larly with Caravaggio's own *Sacrifice of
Isaac* (p.172).

1

1
Giulio Carpioni
Venice 1613 – 1679 Vicenza
Neptune pursuing Coronis
Oil on canvas, 67 × 50 cm
Inv.no.1404

2
Domenico Feti
Rome c1589 – 1623 Venice
Ecce Homo
Oil on canvas, 136 × 112 cm
Inv.no.6279
The drama of this painting of Christ
presented as prisoner before the
people is partly achieved through the
direct engagement between Christ
and the spectator. Yet perhaps even
more important to its effect is the
masterly use of focused lighting,
which strikes Christ's face from the
side while leaving his captors in
shadow.

3
Girolamo Forabosco
Padua 1604 – 1679 Padua
A courtesan
Oil on canvas, 66.5 × 53 cm
Inv.no.2513
This painting is one of three pictures
by Forabosco in the Uffizi all repre-
senting young women in richly
embroidered contemporary dress.
Their rather *décolleté* costume, ringlet-
ted hair and intimate gestures has led
them to be considered portraits of
courtesans.

2

3

Italian painting
of the 18th and 19th centuries

1

1

Francesco Guardi
Venice 1712 – 1793 Venice
Capriccio with arch and bridge
Oil on canvas, 30 × 53 cm
Inv.no.3358
Guardi is most famous for his views of
Venice, with their vibrant brushwork
distinguishing them from those of his
contemporary Canaletto. This paint-
ing, however, is a *capriccio* or imagina-
tive scene, creating a pleasing effect of
picturesque decay.

2

Giovanni Battista Tiepolo
Venice 1696 – 1770 Madrid
Erection of a statue to an emperor
Oil on canvas, 420 × 175 cm
Inv.no.3139
This large-scale ceiling painting
originally formed the centrepiece of a
series by Tiepolo for the archepiscopal
seminary in Udine. The whole ceiling
complex, which also included four
oval canvases, was paid for in
1735/36. The spectator has the
sensation of looking up from far
beneath the plinth on which a statue is
being placed while, higher still, angelic
figures look down on the operation.

Of the Italian 'schools' where work of real importance was produced in
the eighteenth century, Venice presents the greatest diversity, variety
and vitality. Thanks to repeated journeys and sojourns abroad, its
leading artists contributed in significant measure to the new currents of
European art, to the formation of international taste and even, in germ,
to elements of French art in the nineteenth century. These artists,
however, were very different one from another. Some, like Piazzetta or
Sebastiano Ricci or Giovanni Battista Tiepolo, who may be called the
last practitioner of the 'grand style' of decoration, clearly belong to a
late phase of Baroque. Tiepolo's *Raising of the statue of an emperor* in the
Uffizi shows an art rich in theatrical effects, attained with a truly
extraordinary virtuosity in colour and technique. At their side, the
vedutisti or view-painters seem perhaps more awake to the new cultural
climate of Enlightenment: the Guardi, with all their flair and fluency,
their rapid technique, and their tendency to invest their landscapes
with atmosphere, in a responsive 'interpretation'; Canaletto, with all
the objectivity of a meticulous perspective method given life by
touches of light that evoke the spell of the Venetian scene. Thanks
particularly to his work in England, he established himself as the
leading view-painter in Europe.

Pietro Longhi, too, in his modest and ingenuous way, has a place in
the international movement of the eighteenth century towards the
observation, sometimes in a critical spirit, of social mores, a task he
performed elegantly and wittily, as in his exquisite *Confession* in the
Uffizi. His son Alessandro owed his fame above all to his portraits:
that of an unknown magistrate, which entered the Uffizi with the
Siviero paintings, combines psychological analysis with delicate colour

contrasts to achieve an imposing sober elegance. Rosalba Carriera was also known especially for her portraits, perfectly executed in the difficult medium of pastel; at the same time she enjoyed a European fame and reputation, thanks to much time spent abroad, particularly in France. Even more than Alessandro Longhi, for all his elegance, she had a feminine eye for just the right touch, and knew how to render the features of a large number of illustrious personages with informal accuracy and occasional shafts of realism, savouring the finer points of contemporary fashion and flattering where necessary the duller faces.

Among a number of similar artists who were indeed mostly indebted to him, the Bolognese Giuseppe Maria Crespi was a sensitive and even dramatic and forceful painter of religious themes, and an affectionate as well as sharp and almost 'northern' observer of low-life genre. *The flea, The scullion, The fair at Poggio a Caiano,* illustrate well enough this vein of his art. Such caprices, executed rapidly and with movement, found particular favour with the Grand Prince Ferdinando de' Medici, one of the last great patrons of his illustrious family.

Lombard art of the period, realistic and at turns dramatic, is not well represented at the Uffizi; but there are several good specimens of Neapolitan art, among them canvases by Giaquinto and Solimena.

The Roman school at this period was rather backward in its taste, keeping within the mould of the classicism of which it had been a torch-bearer in the seventeenth century. Within these limits, it was capable of inspiring such spirited works by Pompeo Batoni of Lucca as his two *Stories of Achilles*. Though the subject is traditional, the painting has a rare elegance and anticipates aspects of nineteenth-century taste.

For the nineteenth century, the Uffizi possesses a rich collection of self-portraits which were added to the famous collection initiated in the seventeenth century by Cardinal Leopoldo de' Medici, and now amount to some 1280 items. All the major schools of the nineteenth century are represented, from Canova to the purist Tommaso Minardi, from the society portraitist Hayez to the Tuscan Bezzuoli, Ussi and others, including Fattori. Included are Romantics, academicians, avantgardistes, such as Gordigiani, Lega, Mussini, Palizzi, Pellizza da Volpedo, continuing to the present with Guttuso, Greco, Manzù, Morandi and others.

2

Sebastiano Ricci
Belluno 1659 – 1734 Venice
Allegory of Tuscany
Oil on canvas, 90 × 70.5 cm
Inv.no.3234

The honoured personification of
Tuscany is shown seated on clouds,
her identity partially elucidated by the
inclusion of the Florentine lily near her
throne. The painting was made in
preparation for an unexecuted project,
a ceiling decoration for the Palazzo
Gaddi in Florence.

1

Francesco Trevisani
Capodistria 1656 – 1746 Rome
The banquet of Antony and Cleopatra
Oil on canvas, 65 × 63 cm
Inv.no.6242

This canvas is said to have been given to Ferdinando de' Medici by the artist himself. It is the sketch model for a painting made for Cardinal Fabbrizio Spada-Veralli but seems to be little smaller in size than the final work. The scene shows Cleopatra about to dissolve a pearl in wine – a famous example of her extravagance.

2

1

1
Giuseppe Maria Crespi
Bologna 1665 – 1747 Bologna
The fair at Poggio a Caiano, 1709
Oil on canvas, 116.7 × 196.3 cm
Inv.no.Depositi 26

2
Giuseppe Maria Crespi
Bologna 1665 – 1747 Bologna
The flea
Oil on copper, 46.3 × 34 cm
Inv.no.1408
This anecdotal painting of a pretty
working girl at her toilet shares many
of the qualities of Dutch genre paint-
ing. The presence of her dog and the
rosary hanging next to her bed
provide clues to her sentimental life.

3
Rosalba Carriera
Venice 1675 – 1757 Venice
Portrait of a woman (*Flora*)
Pastel on paper, 48.5 × 33.5 cm
Inv.no.820
The low-key voyeurism of Crespi's
painting can be contrasted with the
much more idealizing and obviously
sensual appeal of this nubile goddess
drawn in the soft medium of pastel.

2

3

5

4

4
Pietro Longhi
Venice 1702 – 1785 Venice
Confession
Oil on canvas, 61 × 49.5 cm
Inv.no.9275
Pietro Longhi specialised in scenes of
fashionable life in 18th-century
Venice. This humorous painting
formed one of a series of the *Seven
Sacraments* influenced by Crespi's
paintings on the same theme.

5
Alessandro Longhi
Venice 1733 – 1813 Venice
Portrait of a magistrate
Oil on canvas, 97 × 78 cm
Inv.no.9989
Son of Pietro Longhi, Alessandro is
known principally as a portraitist.

1

1
Corrado Giaquinto
Molfetta 1703 – 1765 Naples
The birth of the Virgin
Oil on canvas, 72 × 103 cm
Inv.no.9166

2
Francesco Solimena
Nocera 1657 – 1747 Barra
Self-portrait
Oil on canvas, 130 × 114 cm
Inv.no.1758
Several versions of this self-portrait
by Solimena exist. This painting was
given to the Uffizi gallery in the year
after its completion by Anna Maria
Luisa de' Medici, while the version
painted for the Grand Duke is
believed to be that in the Museo di
San Martino in Naples. Solimena
depicts himself as a dashing and
elegant figure with one of his easel
paintings prominent behind him.

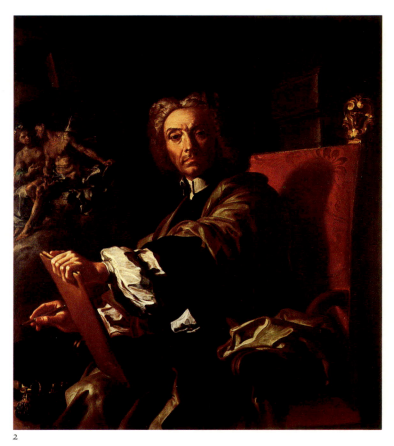

2

3

3
Pompeo Batoni
Lucca 1708 – 1787 Rome
Achilles at the court of Lycomedes, signed
and dated 1746
Oil on canvas, 158.5 × 126.5 cm
Inv.no.544
The scene is one of a pair by Batoni in
the Uffizi illustrating episodes from
the life of the Greek hero Achilles. In
this painting Achilles is shown dis-
guised as a girl among the daughters
of Lycomedes. He had been hidden
with them by his mother Thetis to
avoid being sent to replace his father
Peleus in the army gathering to sail
against Troy, whence she knew he
would never return.

German painting

1

1
Albrecht Dürer
Nuremberg 1471 – 1528 Nuremberg
Detail of *The Adoration of the Magi* (see
p.194): A magus

2
After Albrecht Dürer
Nuremberg 1471 – 1528 Nuremberg
Self-portrait, signed with the artist's
monogram and dated 1498
Oil on panel, 52 × 42 cm
Inv.no.1889
Dürer's enthusiasm for chronicling
events, particularly of his own experi-
ence, helps to explain his interest in
making several self-portraits at differ-
ent periods in his life, the earliest
being a drawing made when he was
13. In this portrait, an old copy after
the original in the Prado, Dürer
presents himself not in artist's garb,
but as an elegant and successful figure,
carefully noting that he is 26 years old
at the time of the portrait.

German painting on the cusp between the fifteenth and sixteenth
centuries was pulled in two directions, between its roots in the late
Gothic tradition and the strong pull of the Italian Renaissance. Within
these terms, the greatest artists of the period evolved their individual
solutions, each giving fascinating proof of the different ways in which
the two elements could be combined.

Albrecht Dürer, who has been called at once 'the most German and
the most universal of German artists' (Salvini), achieved in his
paintings as in his prolific production of engravings, drawings and
watercolours a complex synthesis of fantasy and realism, of
craftsman's skill and theoretician's rationalism. His portrait of his father
in the Uffizi, painted before he undertook the series of voyages that
brought him to Italy for the first time in 1494, may seem no more than
a careful likeness but already is more ambitious than those of his
German contemporaries. As a result of his time spent in Venice,
Mantua and elsewhere in north Italy, his *Adoration of the Magi* bears
reminiscences of Mantegna, Bellini and Leonardo (seen perhaps in
Milan); its spatial organization and its composition are clearly based on
Italian models, although its itemisation of each and every object with
the same care is typically northern. In 1505 Dürer returned to Italy,
staying to work in Venice and travelling south as far as Rome.

Dürer's contemporary Lucas Cranach was more open to
Netherlandish influence, but he, too, combined Gothic tradition with
Renaissance principles of composition, a thrilling imagination with the
most minute depiction of detail. His forms are less harmonious than
Dürer's, and often verge towards mannerism; his female nudes, for
example, like the *Adam and Eve* and the little *Venus in a hat* in the
Uffizi, are, though elegant and proportionate in 'humanist' terms,
emphatically linear – both decorative and disturbing. Even the
portraits, like those of Martin Luther and his wife, convey a certain
nervousness of touch and more introspection than Dürer's more
balanced images, for all their realism.

Among other artists who appear in the rooms devoted to German
painting, Albrecht Altdorfer, a master both of freakish line and of
subtle miniaturism, is represented by two panels formerly belonging to
a now dismembered polyptych from the church of St Florian near Linz.
These combine startling effects of light with vertiginous suggestions
of space, alternating agitated figures in resonant colours in the
dramatic *Martyrdom* with an almost romantic sensationalism in the
moonlight of the *Leave-taking*.

The Uffizi holds a masterpiece by Hans Holbein the Younger, who
migrated to England to become the court painter of Henry VIII. His
portrait of Richard Southwell, English ambassador to the Tuscan court,
is a work of his maturity. One finds once again a microscopic realism
and the care for detail typical of the German school combined with a
balance and harmony in the control of the design that bears witness to
Holbein's travels in north Italy.

2

1

Albrecht Dürer
Nuremberg 1471 – 1528 Nuremberg
The Apostle Philip, signed with
monogram and dated 1516
Tempera on canvas, 45 × 38 cm
Inv.no.1089

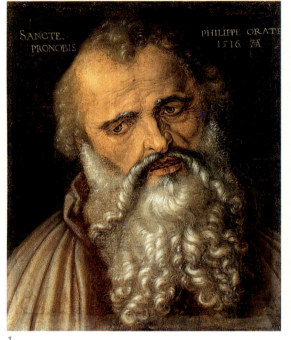

1

2

2

Albrecht Dürer
Nuremberg 1471 – 1528 Nuremberg
Portrait of Dürer's father, signed with
monogram and dated 1490
Oil on panel, 47.5 × 39.5 cm
Inv.no.1086

3

Albrecht Dürer
Nuremberg 1471 – 1528 Nuremberg
The Adoration of the Magi, signed with
monogram and dated 1504
Oil on panel, 99 × 113.5 cm
Inv.no.1434
Made in the year before Dürer's
second trip to Italy, this painting
seems to register an awareness,
among others works, of Leonardo's
great design for the same subject
(p.71). The elaborate fanciful architec-
ture follows a rigorous perspectival
construction that helps to orchestrate
a central compositional triangle,
despite the Virgin's placement to the
side of the picture.

3

4

Lucas Cranach the Elder
Kronach 1472 – 1553 Weimar
Adam, signed and dated 1528
Oil on panel, 172 × 63 cm
Inv.no.1459

5

Lucas Cranach the Elder
Kronach 1472 – 1553 Weimar
Eve, monogrammed and dated 1528
Oil on panel, 167 × 61 cm
Inv.no.1458

4

5

Albrecht Altdorfer
*? c*1480 – 1538 **Ratisbon**
The leave-taking of St Florian
Oil on panel, 81.4 × 67 cm
Inv.no. Depositi 5

1

Albrecht Altdorfer
? c1480 – 1538 Ratisbon
The martyrdom of St Florian
Oil on panel, 76.4 × 67.2 cm
Inv.no. Depositi 4

These paintings formed part of a series of seven surviving panels that probably formed part of a polyptych in the Collegiate church of St Florian in Linz. This panel shows the martyr-dom of the Roman saint who lived in lower Austria under the persecution of Diocletian. He was thrown into the river Enns for his profession of faith before the praetor Aquilinus.

2

Hans Holbein the Younger
Augsburg 1497/98 – 1543 London
Portrait of Sir Richard Southwell,
dated 1536
Oil on panel, 47.5 × 38 cm
Inv.no.1087
One of the finest portraits of Hol-
bein's second English period, this
painting was completed on 10th July
1536 when the sitter was 33. At this
time Southwell was taking an active
part in the dissolution of the monas-
teries under Henry VIII. A beautiful
drawing for the picture survives at
Windsor and there is a replica of the
painting in the Louvre.

1

2

Hans Baldung Grien after Dürer
Schwäbisch Gmünd 1484/85 –
1545 Strasbourg
Adam
Oil on panel, 212 × 85 cm
Inv.no.8433

This panel and the *Eve* are exact
copies of Dürer's *Adam* and *Eve* panels
of 1507 in the Prado, testifying to the
popularity of Dürer's paintings during
his lifetime. The animals which have
been added next to the figures are not
part of the original compositions but
seem to have been based on Dürer's
drawings.

3

Hans Baldung Grien after Dürer
Schwäbisch Gmünd 1484/85 –
1545 Strasbourg
Eve
Oil on panel, 212 × 85 cm
Inv.no.8432

2

3

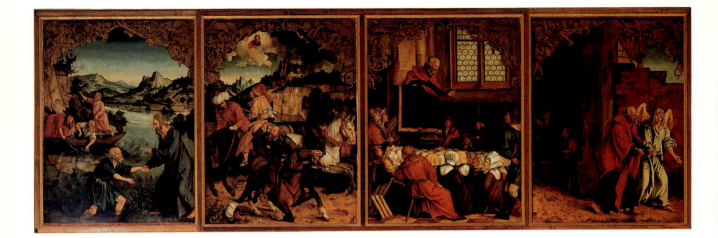

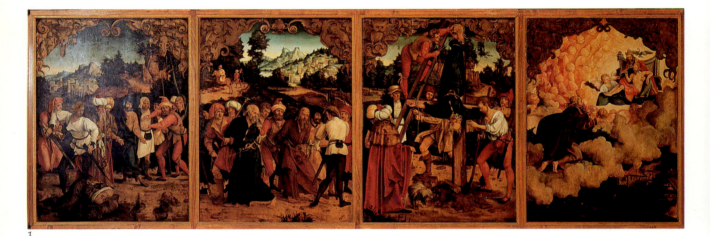

1

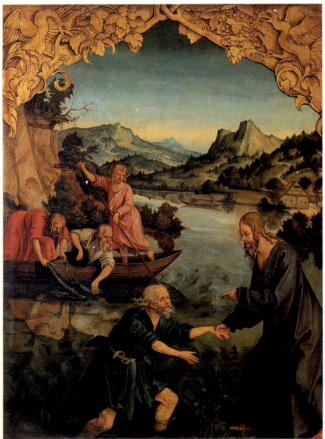

1A

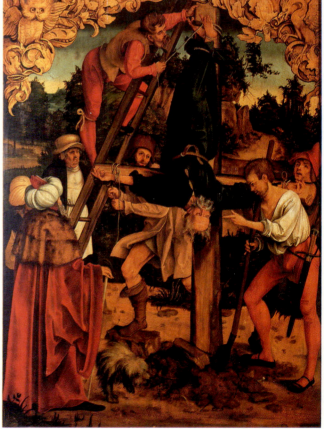

1B

1
Hans Süss von Kulmbach
Kulmbach c1480 – 1522 Nuremberg
Polyptych with the *Lives of St Peter and St Paul*
Oil on canvas, 261 × 382.5 cm
Inv.nos.1034, 1020, 1060, 1047, 1071, 1030, 1044, 1058
The eight Uffizi panels with scenes from the lives of Sts Peter and Paul by Hans von Kulmbach originally formed part of a polyptych with folding wings.

1A
Detail of Kulmbach's polyptych: *The calling of St Peter*

1B
Detail of Kulmbach's polyptych: *The crucifixion of St Peter*

2
Angelica Kauffmann
Coira 1741 – 1807 Rome
Self-portrait, signed and dated 1787
Oil on canvas, 128 × 93.5 cm
Inv.no.1928
Although the Uffizi already owned a small self-portrait by Kauffmann, the artist produced this portrait specifically for the collection while she was in Rome in 1787. She apparently holds on her knee one of her small-scale, finely painted classizing panels that were often used to decorate furniture.

3
Anton Raphael Mengs
Aussig 1728 – 1779 Aussig
Self-portrait, signed and dated 1773
Oil on panel, 97 × 72.6 cm
Inv.no.1927
The reverse of this painting, formed of two panels of cherry wood, bears a long inscription reading 'Antonio Raffaello Mengs born in the city of Ausig in Bohemia on March 12th 1728 has painted this portrait for this capital of Florence in the month of October of 1773'.

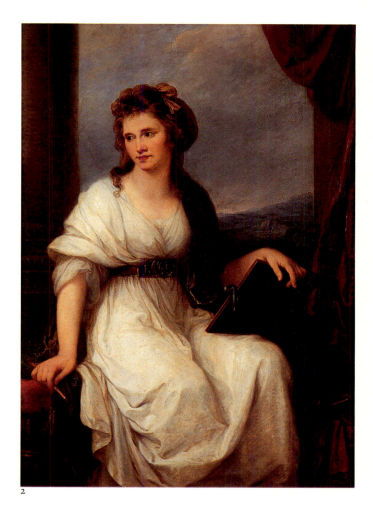

2

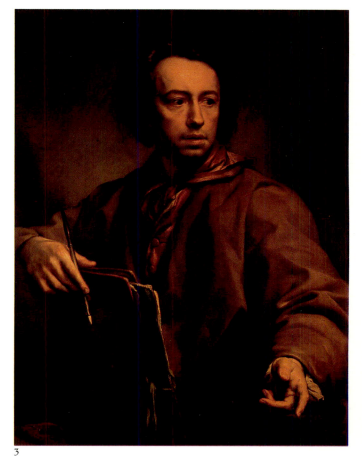

3

Early Netherlandish painting

1

1

Hugo van der Goes
Ghent c1440 – 1482 Audergem
Detail of the Portinari triptych (see
pp. 204–205)

The progress of Netherlandish painting in the fifteenth and sixteenth centuries is well enough represented in the Uffizi to give an adequate opportunity to compare its achievement with that of Italy: both 'schools' underwent profound renewal and development in the period, though obviously very different in character and in very different social and political contexts. There were, however, important contacts and influences in both directions between the two nations: one need only cite the enormous impression that Hugo van der Goes's Portinari triptych excited when it arrived in Florence. It had been executed by the artist around 1475 in Bruges for Tommaso Portinari, agent for the Medici there, and he shipped it back by sea in 1483 to be placed on the altar of his family chapel in Sant'Egidio. Hugo's meticulous analysis of details and materials, the penetrating directness of his portraits, his drive to reproduce observed reality with almost hallucinatory intensity, these qualities could not fail to impress and inspire Florentine artists (especially Ghirlandaio), who even borrowed passages from it to insert within the well ordered perspectival frames of their own painting. In comparison to the Italian school, where painting was dictated by reason and principle, the Netherlanders were ruled by the eye alone; not too concerned with the rational organization of pictorial space, they were content with comparatively archaic composition and founded all their art on a retinal perception of the world.

With its silken stuffs of precious cut, its foreground still lifes, its brutish shepherds (for all their human curiosity in the event), the bare terrain of its countryside seen raw and unfiltered by 'atmosphere', the Portinari triptych is undoubtedly the greatest masterpiece of Hugo van der Goes and a landmark in Netherlandish painting.

Rogier van der Weyden's *Deposition*, also in the Uffizi, testifies to influence in the other direction: here it is the experience of Italian art that has contributed to the logical disposition of the space, the coordination of the composition and the sympathetic portrayal of the mourning figures, for all that they are richly dressed in bold colours and drapery cascading in the Netherlandish convention. In fact Rogier probably undertook a journey to Italy in the Jubilee year of 1450, travelling to Ferrara, Florence and Rome – one among the many journeys made by the artist, who was official painter to the city of Bruges.

Hans Memling, contemporary of Hugo van der Goes and active in the same city of Bruges, where he also worked for the Portinari, was principally responsible for the diffusion in Florence of a certain type of portrait in which the figure is seen half-length, soberly dressed, looking out against an exquisitely painted landscape background. Several of his portraits reached Florence at an early date.

x

2
Rogier van der Weyden
Tournai c1400 – 1464 Brussels
The Entombment of Christ
Oil on panel, 110 × 96 cm
Inv.no.1114

This finely painted small panel is attributed to Rogier van der Weyden and may have been influenced by the *Entombment* in the predella of Fra Angelico's San Marco altarpiece. Rogier could have seen this painting during a trip to Italy in the jubilee year of 1450. The centralised composition in front of the tomb with the cross-like presentation of Christ's body is certainly close to Fra Angelico.

2

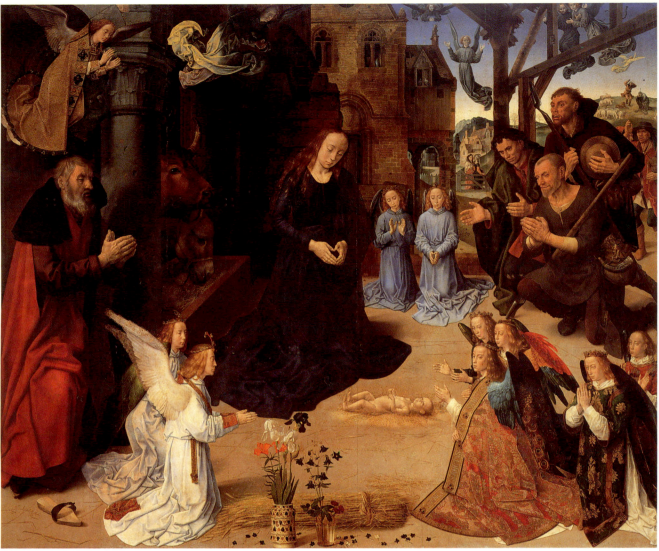

1

1, 1A

Hugo van der Goes

Ghent *c*1440 – 1482 Audergem

The Portinari triptych: *The Adoration of the Shepherds*

Oil on panel, 253 × 304 cm

Inv.no.3191

The Portinari triptych was commissioned by the Florentine Tommaso Portinari while he was head of the Bruges branch of the Medici bank. His portrait and those of his wife, sons and daughter appear on the wings together with their patron saints. The altarpiece arrived in Florence in 1483 and was placed on the high altar of the church of Sant'Egidio in the hospital of Santa Maria Nuova where it caused an immediate stir. The impact of this major Flemish oil

1A

2

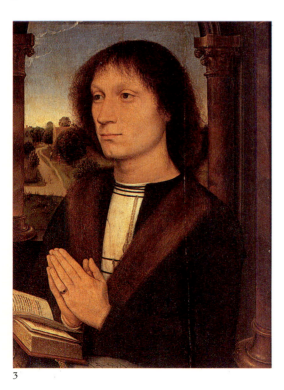

3

painting can be recognised in the
work of a number of important
Florentine artists who were impressed
by its devotional intensity and tech-
nique. In particular the crude enthusi-
asm and rough, peasant-like
appearance of the shepherds pausing
at the entrance to the stable impressed
Domenico Ghirlandaio, who sought a
similar effect in the shepherds of his
Adoration of 1485 in the Sassetti
chapel in Santa Trinita.

2
Hugo van der Goes
Ghent *c*1440 – 1482 Audergem
The wings of the Portinari triptych:
Tommaso Portinari and his sons Angelo
and Pigello with St Thomas and St
Anthony Abbot; Maria Bonciani and her
daughter Margaret with St Margaret and
St Mary Magdalen
Oil on panel, each 253 × 141 cm
Inv.nos.3192–3

3
Hans Memling
Seligenstadt *c*1435 – 1494 Bruges
Portrait of Benedetto di Tommaso
Portinari, dated 1487
Oil on panel, 45 × 34 cm
Inv.no.1090

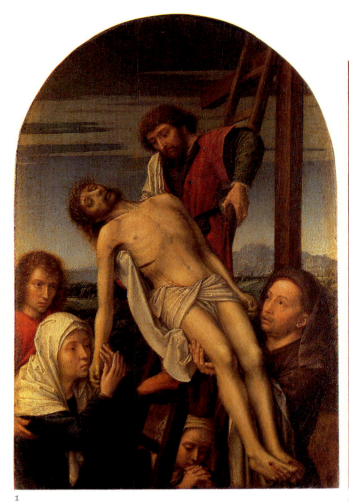

1

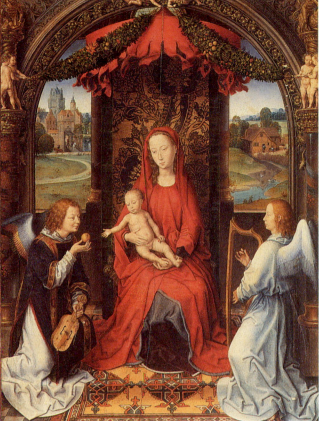

2

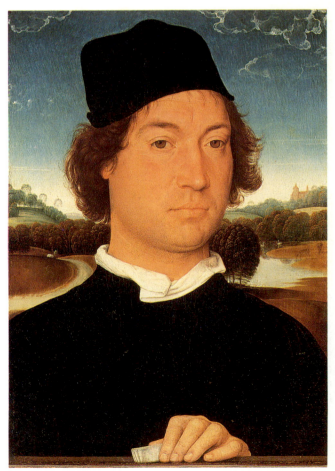

3

1
Gerard David
Oudewater *c*1460 – 1523 Bruges
The Deposition
Oil on panel, 20 × 14 cm
Inv.no.1152

2
Hans Memling
Seligenstadt *c*1435 – 1494 Bruges
Madonna and Child with two angels
Oil on panel, 57 × 42 cm
Inv.no.1024
Memling produced numerous varia-
tions on the theme of the Virgin and
Child with angels of which this is one
of the most exquisite examples. The
motif of the smiling angel who offers
the Christ Child an apple recurs in
several paintings including one in the
Prado. The framing elements in the
Uffizi picture are particularly elaborate
with classicizing alabaster columns
surmounted by sculptures of Hercules
in combat.

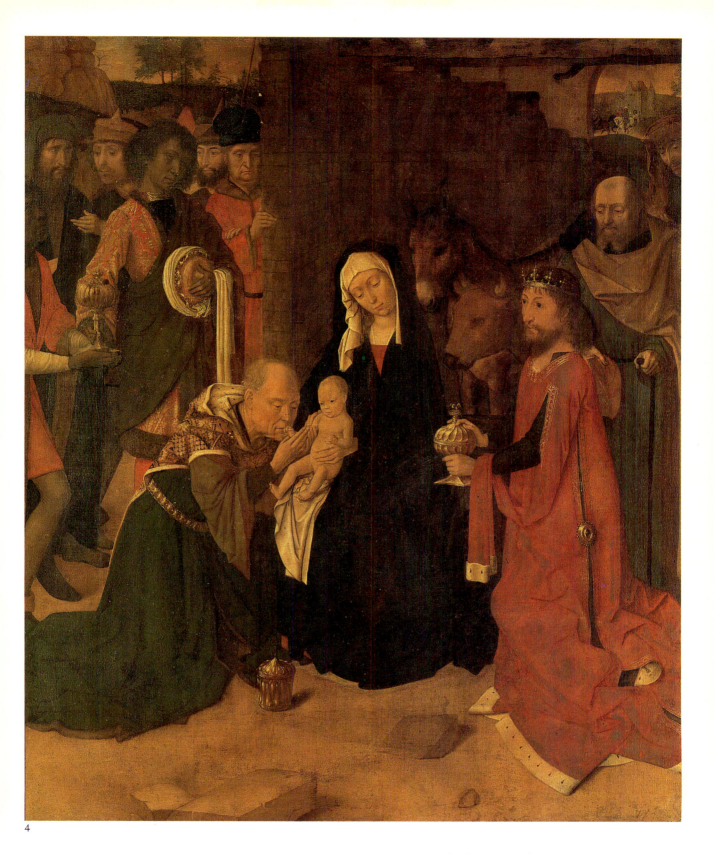

4

3
Hans Memling
Seligenstadt *c*1435 – 1494 **Bruges**
Portrait of an unknown man
Oil on panel, 35 × 24.5 cm
Inv.no.1123

4
Gerard David
Oudewater *c*1460 – 1523 **Bruges**
The Adoration of the Magi
Tempera on canvas, 95 × 80 cm
Inv.no.1029
A relatively early work by David, this

painting has been executed on canvas
in a tempera medium. Although this
technique was not uncommon in
15th-century Netherlandish practice,
the fragility of the support has meant
that comparatively few works of this
type survive.

1

Master of the Virgo inter Virgines
Active in Delft 1470 – *c*1500
The Crucifixion
Oil on panel, 57 × 47 cm
Inv.no.1237

2

3

2
Herri Met de Bles
Bouvignes *c*1480 – 1550 Ferrara?
The copper miners
Oil on panel, 83 × 114 cm
Inv.no.1051
Herri Met de Bles was a pivotal figure
in the development of 16th-century
Netherlandish landscape painting. In
this fine early example of the genre,
the landscape, which is apparently
influenced by experience of the Alps,
has been given a fantastic grandeur
that seems to render insignificant
the efforts of the miners in the
foreground.

3
Joos van Cleve
Antwerp *c*1485 – 1540/41 Antwerp
Portrait of a woman, signed and dated
1527
Oil on panel, 57 × 42 cm
Inv.no.1644
This portrait of a young woman forms
a pair with a portrait of a man. The
sitter is depicted devoutly telling her
rosary and, following established
convention, she is turned towards her
husband who is given the more
honourable position to her right on
the 'dexter' side of the pairing.

Flemish and Dutch painting

1

1
Jan van Kessel
Antwerp 1626 – 1679 Antwerp
Still life with fruit and sea food, signed
and dated 1653
Oil on canvas, 31 × 44 cm
Inv.no.1119

2
Peter Paul Rubens
Siegen 1577 – 1640 Antwerp
Self-portrait
Oil on panel, 85 × 61 cm
Inv.no.1884

3
Anthony Van Dyck
Antwerp 1599 – 1641 London
Charles V on horseback
Oil on canvas, 191 × 123 cm
Inv.no.1439

4
Peter Paul Rubens
Siegen 1577 – 1640 Antwerp
Portrait of Isabella Brant
Oil on panel, 86 × 62 cm
Inv.no.779

The Uffizi possesses several first-rate works by those Flemish masters who contributed so much to the formation of the international Baroque style of the seventeenth century, above all Rubens. The room devoted to him contains, besides his affectionate and frankly sensual portrait of his wife Isabella Brandt, two of his enormous, richly colourful and figurative allegories typical of the sumptuous, expansive, theatrical and dynamic style of his official work for state patronage. It was a style well suited to a cycle of canvases commissioned by Maria de' Medici celebrating the triumphs of the career of her husband Henry IV of France, of which these were the only works painted. Beside such weighty testimonials of the Baroque, Anthony Van Dyck's contribution may almost seem in a minor key, but his portrait of Margaret of Lorraine demonstrates the extraordinary ability of this most gifted of Rubens's pupils, whose palette is as rich as his master's even though the pomp is subdued.

The Uffizi is well endowed with works of Dutch art from the seventeenth century, because Grand Duke Cosimo III, who travelled throughout Europe, was an *aficionado* especially of the 'little masters' or *Feinmaler* of the Dutch school. They painted vivid little pictures of genre, landscape and still life, often on copper, in a consummate miniaturist's technique. These are the subjects predominantly to be found in the room devoted to the Dutch school: Paul Bril and Herman van Swanevelt stand out with their Italianate landscapes, so does Gerrit Berckheyde, faithful to his native scenery in his sparkling *Groote Markt at Haarlem.*

Frans Mieris was perhaps the most prolific and acute observer of genre scenes: his *Two old men at a table* and *The family of the painter* are some of his most attractive and appealing works. Rachel Ruysch and Jan van Huysum show their ability in still lifes in which flowers and fruits and insects are depicted with meticulous brushwork but also with fascination for the quiddity of natural things. These works provide a sample of the varied and brilliant world of decoration by which the great Dutch traders were surrounded in their mansions, not by allegories full of symbolism so much as by insights into the material of their own daily lives, a fine bowl, the household wealth of a rich nation.

All this is on another plane from the art of Rembrandt van Rijn, perhaps the greatest Dutch painter of the century and one of the greatest in all Europe. Harking back to the lessons of Caravaggio in his preference for scenes lit up against the dark, Rembrandt undertook a much wider range of religious and history subjects, stamping them with the personal vision and feeling of which his style was so effective a carrier. Though it has no great biblical or secular pictures of the kind of the famous *Night Watch* in Amsterdam, the Uffizi's two self-portraits do reflect something of the long evolution of the artist's self-examination – the first outgoing, though melancholic, enlivened by the glitter of his metal neckband; the second more gloomily reflective, almost dissolving the material form under the weight of insistent shadows.

2

3

4

1
Peter Paul Rubens
Siegen 1577 – 1640 Antwerp
The triumphal entry of Henry IV into Paris
Oil on canvas, 380 × 692 cm
Inv.no.729

This enormous canvas of about 1630 formed part of a series of the life of Henry IV of France commissioned by Maria de' Medici which was never completed. These two canvases were acquired from the Abbey of St Sepulchre at Cambrai in 1686. Oil

sketches by Rubens for the *Triumph* are in the Wallace Collection, London, the Museé Bonnat, Bayonne, and the Metropolitan Museum of Art, New York.

1

2

2

Paul Bril
Antwerp 1554 – 1626 Rome
Landscape with wayfarers
Oil on canvas, 95.5 × 127 cm
Inv.no.598

Although born in Antwerp, Bril spent
most of his working life in Rome
where he came under the influence of
Elsheimer. This landscape, with its
sharp division of foreground, middle
and background is characteristic of his
romantic landscapes.

3

3

Gerrit van Honthorst
Utrecht 1590 – 1656 Utrecht
Supper with a lute player
Oil on canvas, 144 × 212 cm
Inv.no.730
Honthorst produced numerous com-
positions involving half-length figures
grouped around a table, often lit by
artificial light. This particularly fine
example is apparently that recorded as
having been painted for the Grand
Duke of Tuscany around 1620.

4

Cornelis van Poelenburg
Utrecht c1586 – 1667 Utrecht
Mercury and Battus
Oil on copper, 35.5 × 48 cm
Inv.no.1231
It seems likely that this oval painting
on copper was made during the
artist's stay in Florence 1620-22. The
scene is taken from Ovid's *Metamor-
phoses* and shows Mercury with the
herdsman Battus who was turned to
stone when he betrayed the god.

4

1

2

3

4

1
Hercules Seghers
Haarlem c1589/90 –
c1638 Amsterdam
Landscape with mountains
Canvas stuck on panel, 55 × 99 cm
Inv.no.1303

2
Rembrandt van Rijn
Leyden 1606 – 1669 Amsterdam
Self-portrait
Oil on panel, 62.5 × 54 cm
Inv.no.3890

3
Gerrit van Honthorst
Utrecht 1590 – 1656 Utrecht
The Adoration of the Shepherds
Oil on canvas, 338.5 × 198.5 cm
Inv.no.772

4
Rembrandt van Rijn
Leyden 1606 – Amsterdam 1669
Self-portrait, signed and dated 1665
Oil on canvas, 104 × 86 cm
Inv.no.8435

French painting

1

Painters from all schools from the sixteenth century to the present have added their self-portraits to the Uffizi collection, so that every nationality is represented in that way at least. The self-portrait collection includes not only representatives of the Old World – such as Swedish, Russian, Hungarian, English and Austrian artists – but also self-portraits acquired more recently of painters from the United States and South America, as well as Africa and Asia. Besides this, however, significant paintings from the French and Spanish schools form part of the picture gallery proper.

A variety of historical circumstances brought about the presence in the Uffizi of a number of French pictures of high quality (catalogued in detail in a special exhibition of 'French painting in Florentine public collections' [*Pittura francese nelle collezioni pubbliche fiorentine*] held in 1977). One was the alliance of France and Tuscany through the marriages of Christine of Lorraine with Ferdinando I de' Medici, and of Caterina and Maria de' Medici with French kings. Another was the dispersal of the rich collections at Parma, from which a substantial group of French paintings found their way to Florence. Also Grand Duke Ferdinando III personally acquired a number of French works of art.

The present collection includes works going back to the early Renaissance, for instance the late fifteenth-century triptych by Nicolas Froment, showing the influence of Northern painting, and portraits of the French court by François Clouet, of an enamel-like finish. With the Siviero paintings the Uffizi has also recently acquired a sophisticated and disquieting double female portrait from the School of Fontainebleau. The seventeenth- and eighteenth-century collections are, however, richer: works by Poussin, Claude, Simon Vouet in which the Italian influence is very clear, also by official court painters such as Charles Lebrun and Charles De La Fosse, arbiters of the taste of their time.

Of the lighter, more genial painting of the eighteenth century the Gallery has Nattier's portraits of the daughters of Louis XVI dressed as Flora and as Diana, gorgeous examples of Rococo; it also has some fresh, poetic and at the same time severe images by Chardin of children at play (*Girl with a shuttlecock, Boy with playing-cards*), some that are by comparison rather affected by Mignard, and some fine landscapes by Vernet and Parrocel. The self-portrait by Elizabeth Vigée-Lebrun is particularly impressive: it was painted as a final homage to her queen, Marie Antoinette, whose portrait appears on the easel in front of the artist.

1
School of Fontainebleau, last quarter 16th century
Women bathing
Oil on panel, 129 × 97 cm
Inv.no.9958

2
Nicolas Froment
Uzès *c*1435 – *c*1483 Avignon
The Resurrection of Lazarus, signed and dated 1461
Oil on panel, 175 × 200 cm in total
Inv.no.1065
Together with the Portinari altarpiece (pp.204–05), this was one of the most important early northern European altarpieces to be brought to Florence in the 15th century. Commissioned from Nicolas Froment by the papal legate in the Netherlands, Francesco Coppini, it was given by him to Cosimo il Vecchio de' Medici. Cosimo in turn gave it to the Observant Franciscans at Bosco ai Frati in the Mugello, whose convent he had endowed.

4
Jacques Stella
Lyons 1596 – 1637 Paris
Christ served by angels
Oil on canvas, 111 × 158 cm
Inv.no.996

The iconograph of this mid-17th-century French painting is highly unusual, representing not a biblical episode but a scene of Christ tended by angels in a romantic landscape.

François Clouet
Tours *c1510* **– 1572 Paris**
Francis I of France on horseback
Oil on panel, 27.5 × 22.5 cm
Inv.no.987

This tiny equestrian portrait of Francis
I has been attributed to François
Clouet, son of the portrait painter Jean
Clouet. The fine details of the King's
armour and the richly caparisoned
horse recall the technique of his
father's miniatures.

2

4

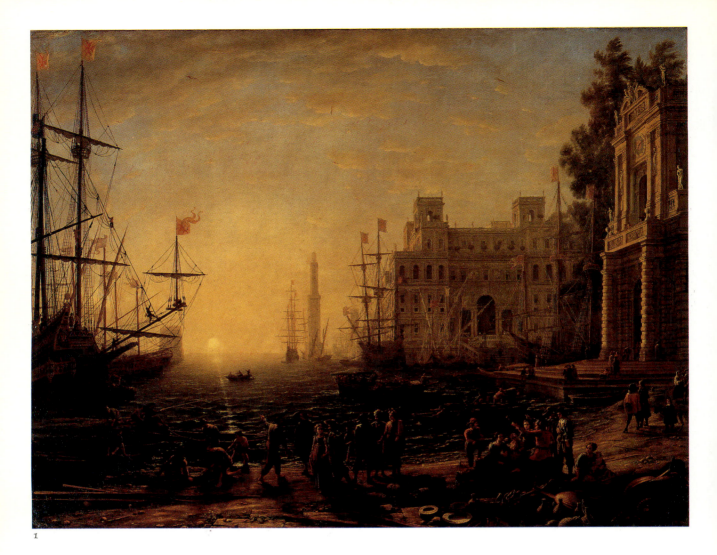

1

Claude Lorrain
Chamagne 1600 – 1682 Rome
Harbour scene with the Villa Medici,
signed and dated 1637
Oil on canvas, 102 × 133 cm
Inv.no.1096
Many copies of this composition
survive as well as a drawing for the
painting in Claude's *Liber Veritatis*, in
which he made a record of his work.
Claude's note on the drawing says
that the painting was made for Cardi-
nal Carlo de' Medici. In this roman-
ticized view of a Roman port Claude
creates the sensation of looking
straight into the evening sun, in the
glow of which the Villa Medici rises in
the middle distance.

2

2
Simon Vouet
Paris 1590 – 1649 Paris
The Virgin and Child in a landscape,
known as *The Madonna of the Basket*
Oil on panel, 132 × 98 cm
Inv.no.984

Vouet's *Virgin and Child* seems to have
been painted towards the end of his
time in Rome as it is close in style to
his *Rest on the Flight into Egypt* of 1626.
The placing of the seated Virgin and
Child within the landscape also recalls
the iconography of that work.

3
Jean-Baptiste-Siméon Chardin
Paris 1699 – 1779 Paris
Girl with a shuttlecock
Oil on canvas, 82 × 66 cm
Inv.no.9274

3

4

5

4
Jean-Baptiste-Siméon Chardin
Paris 1699 – 1779 Paris
Boy with a house of cards
Oil on canvas, 82 × 66 cm
Inv.no.9273

5
Elisabeth Vigée-LeBrun
Paris 1755 – 1842 Paris
Self-portrait
Oil on canvas, 100 × 81 cm
Inv.no.1905
This portrait was specifically
requested for the Uffizi self-portrait
collection. Although completed in
March 1790, the portrait was sent to
Florence from Rome the following
year. Despite the artist's engaging
smile, the picture carries lugubrious
overtones: she is shown in the act of
painting the ill-fated Marie-
Antoinette, queen of France.

Spanish painting

1

2

1
Francisco de Zurbarán
Fuente de Cantos 1598 –
1664 Madrid
St Anthony Abbot
Oil on canvas, 177 × 117 cm
Inv.no.Contini Bonacossi 23

2
El Greco (Domenikos
Theotokópulos)
Candia 1541 – 1614 Toledo
St John the Evangelist and St Francis
Oil on canvas, 110 × 86 cm
Inv.no.9493
The painting's emotional key is
heightened by the storm-tossed sky, a
common element in El Greco's work.

The Spanish collection is for the most part restricted to works of the
seventeenth century, but has two pictures by El Greco (*Sts Francis and
John* and a *Tears of St Peter*, the latter part of the Contini Bonacossi
bequest). In fervently Catholic Spain El Greco found the ideal terrain
on which to disseminate his combination of Byzantine mysticism,
imbibed in his native Crete, and the turbulent colours and dramatic
compositions of Venetian Mannerism. By Velázquez, the outstanding
representative of seventeenth-century Spanish painting, there are two
superb self-portraits and *The water-carrier of Seville*; by Zurbarán, a *St
Anthony Abbot* in his direct, simple, devotional style. Only relatively
recently the Uffizi also acquired two portraits by Goya: the first,
almost a sketch, represents Maria Teresa di Vallabriga on horseback,
and still harks back to the seventeenth century in composition and
colour; the second, of the Marquesa of Chinchón, is one of his most
characteristic full-length portraits, in which psychological penetration
in the face is accompanied by sensitive and refined colourism. Her
jewels, ribbons and feathery hair make her dazzle like an otherworldly
vision.

3
Alonso Berruguete
Paredes de Nava 1488 –
1561 Toledo
Salome
Oil on panel, 87.5 × 71 cm
Inv.no.5374

4
Francisco Goya y Lucientes
Saragozza 1746 – 1828 Bordeaux
Maria Teresa de Vallabriga on horseback
Oil on canvas, 82.5 × 61.7 cm
Inv.no.9485

3

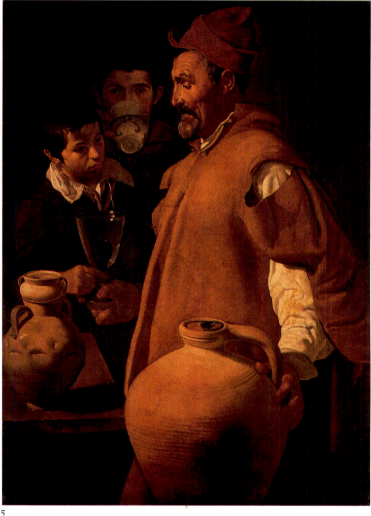

5

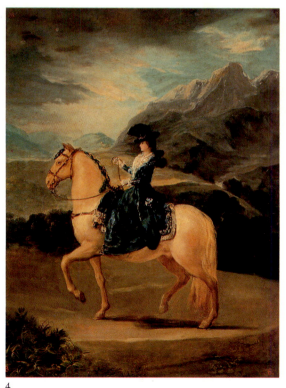

4

5
Diego Rodríquez de Silva y
Velázquez
Seville 1599 – 1660 Madrid
The water-seller of Seville
Oil on canvas, 104 × 75 cm
Inv.no. Contini Bonacossi 24
This famous composition is a replica
of a painting now hanging in the
collection of the Duke of Wellington
at Apsley House, London. The paint-
ing is characteristic of Velázquez's
early Caravaggesque style that he
cultivated as a painter of *bodegones*
(pictures of everyday life combining
still-life elements) before he moved to
Madrid in 1623.

Francisco Goya y Lucientes
Saragozza 1746 – 1828 Bordeaux
Portrait of the Countess de Chinchón
standing
Oil on canvas, 220 × 140 cm
Inv.no.9484
This painting is one of many portraits
by Goya of the Spanish aristocracy.
The subject here is Maria Teresa de
Borbón y Vallabriga, Countess of
Chinchón, who in 1797 married the
infamous Manuel Godoy, prime
minister to the king of Spain. The
painting is recorded among a group of
Goya's works which belonged to the
sitter's brother, Don Luis of Borbón, at
the end of the 18th century.

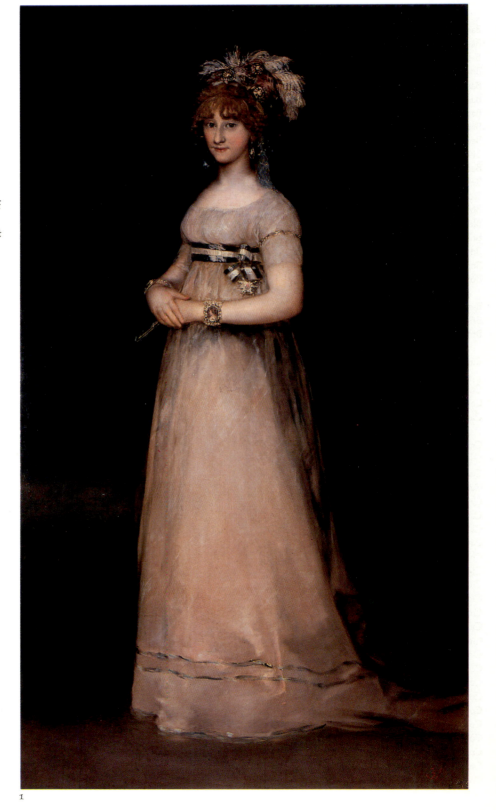

1

Index